BRITAIN AT WAR

IN COLOUR

Published by IWM, Lambeth Road, London SE1 6HZ
iwm.org.uk

ISBN 978-1-912423-36-1

A catalogue record for this book is available from the British Library

Printed and bound in Italy by Printer Trento
Colour reproduction by Zebra

All images © IWM unless otherwise stated
Front cover: TR 1443
Back cover: TR 1064

Every effort has been made to contact all copyright holders. The publishers will be glad to make good in future editions any error or omissions brought to their attention.

10 9 8 7 6 5 4 3 2 1

BRITAIN AT WAR
IN COLOUR

Ian Carter

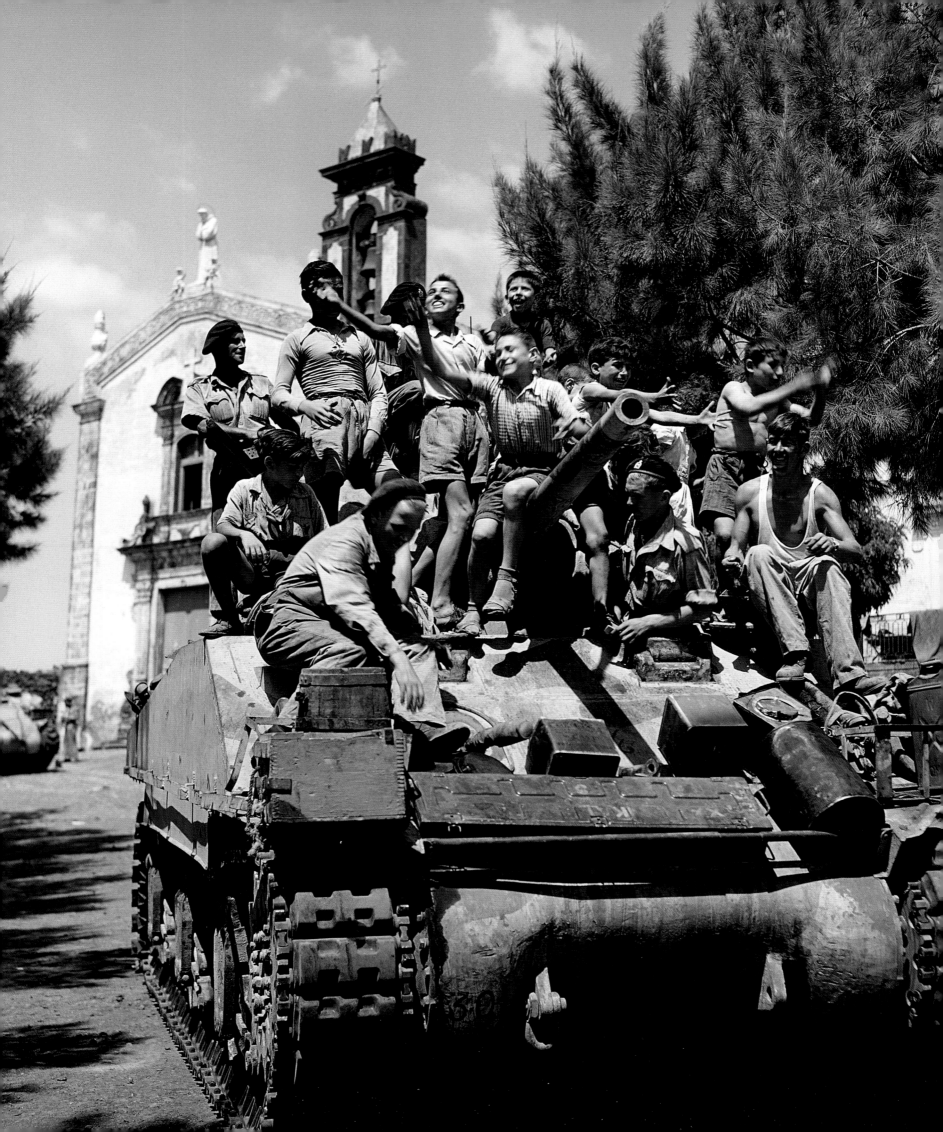

CONTENTS

INTRODUCTION

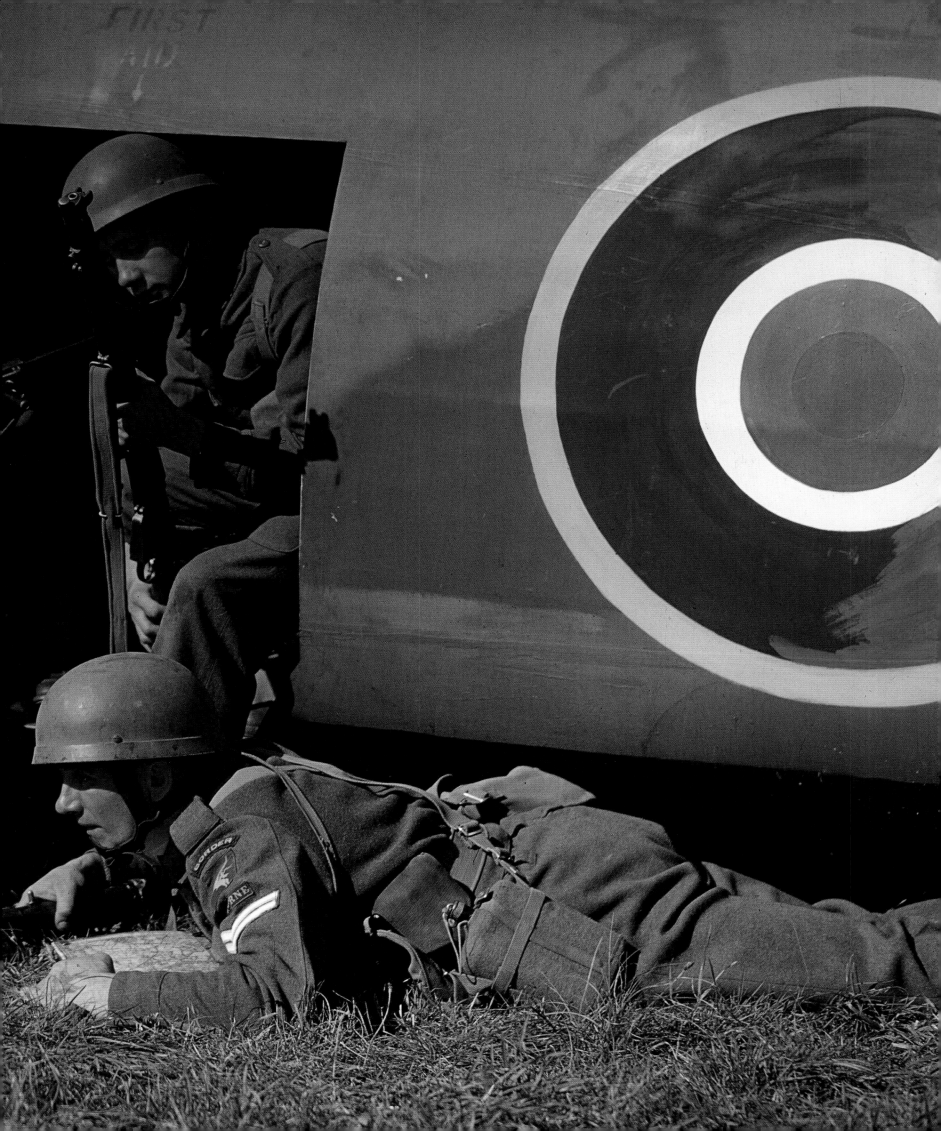

To most of us, the Second World War is a black and white war. Despite the advent of computer colourisation techniques in recent years, we are still accustomed to viewing the conflict through monochrome film and photographs. Colour film was a relatively rare commodity during the war, and that rarity was compounded further by the difficulty and high cost of reproducing it in printed works. But the images that were created have the power to impress even now. Their clarity and intensity is such that they might have been taken yesterday rather than 70 years ago. A selection are presented in this book, chosen from the extensive collection held in the Imperial War Museum's Photograph Archive.

There were experiments with colour photography in the nineteenth and early twentieth century, but it was not until 1936 and the introduction of a 35mm transparency film called Kodachrome by the Kodak Company in America that it became a viable and affordable process. Alongside this new product came advances in printing techniques which meant that colour images could be reproduced and published commercially. All of the images in this book were originally shot on this film.

The majority of the images presented here are the work of a select band of official photographers serving with the British armed forces. The Ministry of Information (MOI), which controlled the output of material to the press, was keen to obtain a selection of colour images for both record purposes and for inclusion in those publications able to reproduce colour, including magazines in the United States. In the end, some 3,000 images were taken, covering the period 1942–1945, but not all survived. Around 1,500 of them — those which had not been censored and been deemed fit for publication during the war — were passed to the IWM for preservation in 1949, and became what

is now referred to as the 'TR Series'. The rest have been lost.

The TR Series encompasses a wide variety of subjects, but coverage is by no means comprehensive and reflects changing priorities in the Ministry. Many photos had obvious propaganda value, while others were taken merely to test techniques in a process still untried in Britain. The film was a precious commodity and in many cases only one or two frames were exposed of any particular scene. The majority of images were taken on the Home Front, illustrating aspects of war production, agriculture and domestic life as well as the activities of the armed forces. The home-based Royal Air Force was particularly well photographed in the mid-war years, reflecting its importance in the defence of Britain and the expanding power of the bomber offensive against Germany.

Colour film was also used to record operations overseas, particularly in the Mediterranean theatre, where the role of the RAF was again well represented. The collection includes many striking shots of the campaigns in Tunisia, Sicily and Italy where azure skies, parched deserts and imposing mountains provide exotic backdrops. Unfortunately, the war at sea received much less attention, and the result is a disparate selection of images which afford us only a tantalizing glimpse into the Royal Navy's many and varied activities. The campaign in north-west Europe in 1944–1945 was similarly accorded only patchy coverage, despite its significance. Sadly, but perhaps understandably given the logistics of supplying the film and getting it processed in specialist labs, the war in the Far East was virtually ignored. Nevertheless, despite these yawning gaps the MOI's official colour series is an invaluable visual record. The images may on occasion appear stilted and posed — exposure times were still appreciably

slower than with black and white film — but they are invariably sharp, with well saturated colours. Although few in number, they give us an unusually candid view of Britain, her population and armed forces at war.

This book is by no means intended to be a comprehensive history of Britain's role in the Second World War. Some of the major themes and events are explored in the introductory texts to set the scene, but its content has for the most part been dictated by the availability of images. I have chosen a simple structure, with chapters focusing in turn on Britain's three armed services and the Home Front. The latter includes a look at the women's uniformed services. The involvement of women in the armed forces, as well as in civil defence, industry and agriculture, is of course one of the stand-out features of Britain's experience in the Second World War.

I have also included a selection of photographs from American sources. We are fortunate that US service personnel had much greater access to Kodachrome film, and restrictions on private photography were less severe than in Britain's armed forces. The IWM has an extensive collection of images taken by men of the United States Army Air Forces operating from Britain. Indeed, some of the most dramatic colour photographs of the war were taken by USAAF aircrew on combat missions. It seems appropriate to include some of these as a tribute to the close co-operation between Britain and the United States forces in the Allied war effort.

The captions have been expanded and newly researched, as the originals are invariably vague and incomplete. Wartime censorship meant that it was common for identities, dates and locations to be withheld, and this applies particularly with the colour material. However, on occasions colour photographs were taken alongside a more fuller

sequence shot in black and white, which allows for useful comparisons and information to be gleaned from the photographers' notes where available. Most importantly, all the images have been carefully and expertly digitised to ensure optimum clarity and colour accuracy.

Black and white photography puts a barrier between subject and viewer, no matter how graphic its content. It can be used to great effect for artistic purposes, of course, but can take away the immediacy required of a journalistic image. Colour photography restores that missing clarity and impact. As the most destructive war in history fades gradually from living memory this becomes ever more important. I hope that the selection of images in this book will take away its remoteness and bring the Second World War to life.

(Previous spread)
Airborne troops exit a General Aircraft Hotspur glider. The use of gliders to transport men and heavy equipment was deemed an essential component in the development of Britain's airborne forces. The all-wooden Hotspur was intended as an assault glider, able to carry two pilots and eight men, but was only ever used for training. Larger gliders, notably the Airpseed Horsa, were used operationally as they could carry twice as many men and required fewer towing aircraft.

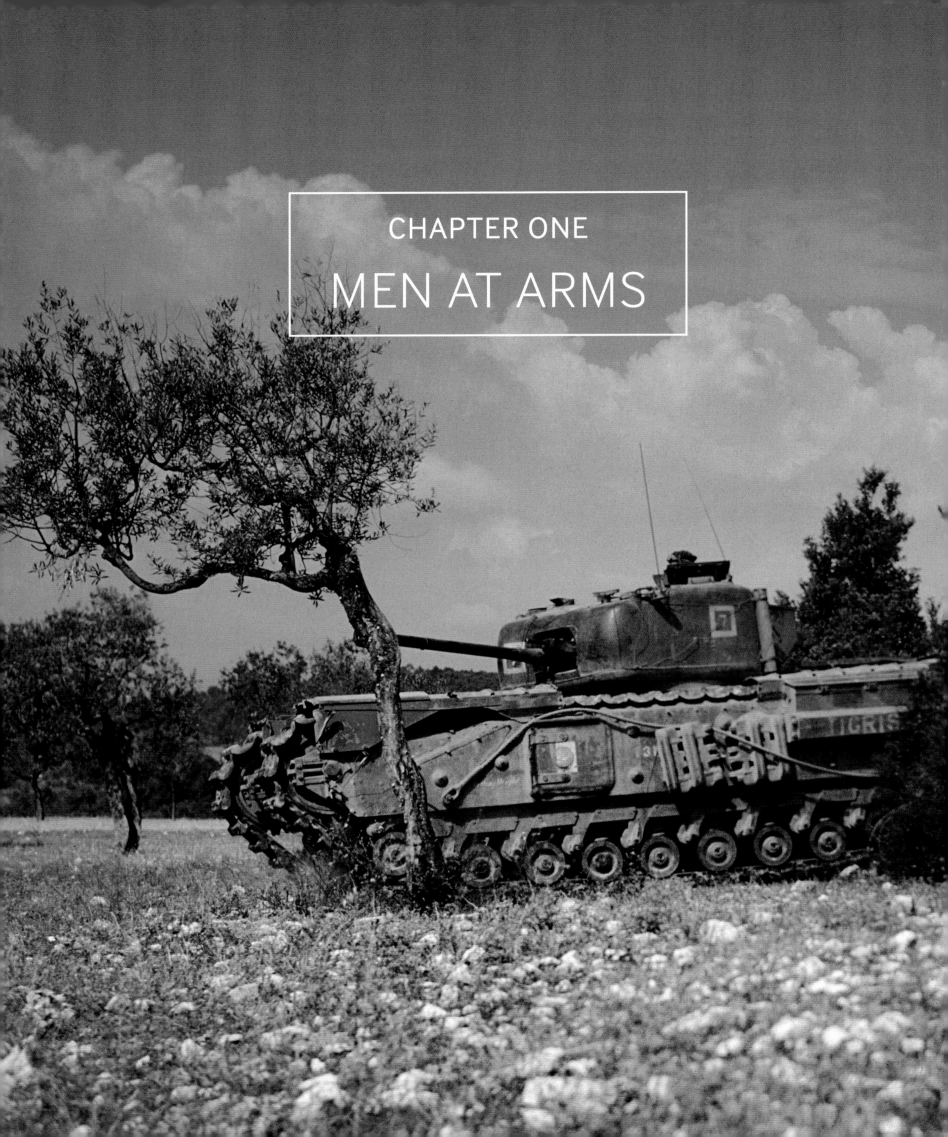

CHAPTER ONE
MEN AT ARMS

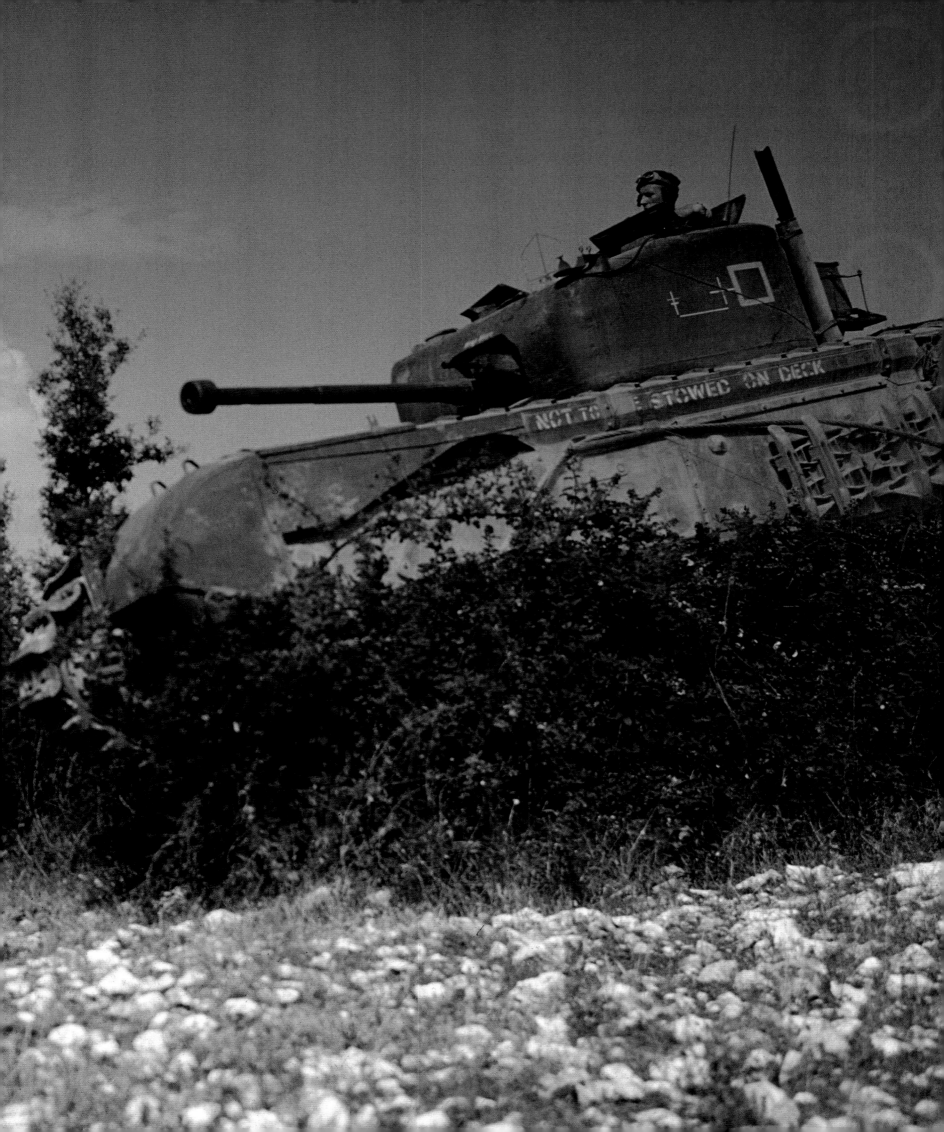

At the start of the Second World War the British Army was small and ill-equipped. While embracing the need for modernisation and mechanisation, it had lost out to the RAF and Royal Navy in the pre-war race for resources, which meant its tank arm in particular was weak. Its manpower comprised the Regular Army, mostly spread among the garrisons of Britain's imperial possessions, and the part-time Territorial Army. All told, less than one million men were initially available. The introduction of conscription in 1939 enabled a major expansion, to 3 million men at its peak in 1944, when the Army could field 34 infantry, 11 armoured and 2 airborne divisions.

In September 1939 an expeditionary force was despatched across the Channel to bolster French defences, but could do little to stop the German Blitzkrieg of May 1940. The survivors had to be rescued from Dunkirk and other ports, leaving their tanks, guns and vehicles behind. The rescue of a large part of Britain's army was seen by some as a deliverance, but Britain's new Prime Minister, Winston Churchill, warned that 'wars are not won by evacuations'. The surrender of France in June 1940 meant Britain and her Empire were suddenly alone.

After Dunkirk, the Army's immediate priority was to rebuild its strength. Countering a possible invasion of Britain was a big enough task, and any return to the continent of Europe seemed a long way off. But Hitler's Axis partner, Benito Mussolini, was keen to share in the spoils of apparent victory. In September 1940 the Italians invaded Egypt, but suffered a crushing defeat at the hands of the numerically smaller British Western Desert Force. They were pushed back 500 miles into Libya, with 130,000 men being taken prisoner.

Hitler's forces were not so easily defeated. The Germans moved into Greece, and then captured Crete, leading to further British evacuations. The 'Afrika Korps' was sent to Libya, under General Erwin Rommel, to shore up the faltering Italians. Rommel quickly pushed the British back into western Egypt, but failed to take the vital port of Tobruk which was now besieged. In December 1941, after months of bitter fighting, the British Eighth Army finally raised the siege of Tobruk and pushed Rommel back to where he had started from.

The see-saw campaign in North Africa continued into 1942. In June Rommel attacked again, and this time took Tobruk. From here he lunged at Egypt and was stopped only 150 miles from Cairo. It was a grim time for the British. On the other side of the world, Hong Kong and Singapore had been captured by the Japanese, and British troops forced to retreat from Burma. Morale was slumping and a victory was badly needed. A new desert commander was appointed – General Bernard Montgomery. In November 1942, 'Monty' delivered a decisive victory at El Alamein. The Germans and Italians retreated westwards, never to return. In the same month American troops landed in French North Africa. From now on the United States would provide an increasing and eventually overwhelming contribution to the Allied effort. Axis forces were sandwiched between the two armies in Tunisia and forced to surrender in May 1943.

British military strategy remained focused on the Mediterranean. The Americans wanted to put all available resources into an invasion of north-west Europe, but eventually agreed to an invasion of Sicily and then mainland Italy in a campaign designed to divert and wear down German forces. In July 1943, as the Allies advanced across Sicily, a discredited Mussolini was deposed by his own government and arrested. In September Italy sued for peace, but there was to be no rejoicing. Hitler ordered his troops to quickly take over and prepare for the Allied landings. The Italian campaign dragged on for the rest of the war, as British and Allied troops clawed their way northwards up the country's mountainous spine, overcoming a succession of fixed defensive lines in costly battles.

On 6 June 1944 the Allies carried out the largest amphibious assault in history. After months of preparation British, Canadian and American troops landed on the coast of Normandy, with massive air and naval support. It was the beginning of Operation 'Overlord' – the campaign to liberate north-west Europe from Nazi rule. The opening of the Second Front effectively sealed the fate of the Third Reich, now sandwiched between the western Allies and the Soviet Union, whose forces had already inflicted major defeats on the German army and were now advancing westwards.

D-Day was a dramatic success, but stiff German resistance meant Allied forces got bogged down in Normandy. The British in the east of the bridgehead bore the brunt of the fighting in battles to take the city of Caen. This enabled the Americans to finally break out from their sector into the French interior at the end of July. As the front fell apart, German forces began a full scale retreat from France, pursued by Allied units and harried all the while from the air. In August, Allied troops landed in southern France, and quickly captured huge swathes of territory.

In early September, British troops liberated Belgium, but with supply chains stretched to the limit the advance was halted. Montgomery proposed that all resources be concentrated for a push through the Netherlands, bypassing the main German defences of the 'Siegfried Line'. But his audacious plan ended with the destruction of a British Airborne division at Arnhem. The Supreme Allied Commander, General Eisenhower, switched to a broad front strategy. Allied armies now all fought alongside each other to close up to the borders of the Reich, with the British on the left flank. Operations were severely hampered by winter weather and a dogged German defence. There would be no quick end to the war.

In December, Hitler launched his last-chance gamble in the west, with a major counteroffensive through the forested and weakly held Ardennes region of Belgium and Luxembourg. The operation was doomed from the start, and after some fleeting initial success the Germans were contained. British troops attacked the salient from the north, helping to push the Germans back. The 'Battle of the Bulge' drained the last of Germany's manpower and equipment in the west, and opened up the way for further Allied advances.

In March 1945, after bitter fighting to clear areas west of the River Rhine, the Allies finally crossed this last great natural barrier barring access to the heart of the Reich. It had already been agreed that Soviet forces would take Berlin, and in April they launched their final offensive to capture the city. The ruined capital was fiercely defended, but finally fell after Hitler committed suicide. British troops reached Hamburg

and the Baltic coast at Lübeck. The war in Europe ended with an unconditional German surrender on 7 May 1945.

Victory was unfolding in the Far East too. After ignominious surrenders and retreat, a reconstituted British army went on to the offensive. A Japanese assault on India itself launched in March 1944 was decisively beaten at Imphal and Kohima. The British Fourteenth Army under General William 'Bill' Slim then embarked on a successful counteroffensive to reclaim Burma. The ensuing campaign proved to be one of Britain's greatest feats of arms during the Second World War, but one, sadly, that was not recorded in colour.

(Page 10 and page 16)
Churchill tanks of 'B' Squadron, 51st (Leeds Rifles) Royal Tank Regiment, 25th Tank Brigade, in Italy, July 1944. The Churchill had been due for retirement in 1943, but won a reprieve after proving its worth in Tunisia, where it coped well with the rugged terrain. 25th Brigade first saw action in Italy in May 1944 when its three regiments supported the Canadian 1st Division's attacks on the 'Hitler Line'. Between August and October 1944, the Churchill tanks were in the forefront of the Allied assault on the 'Gothic Line'.

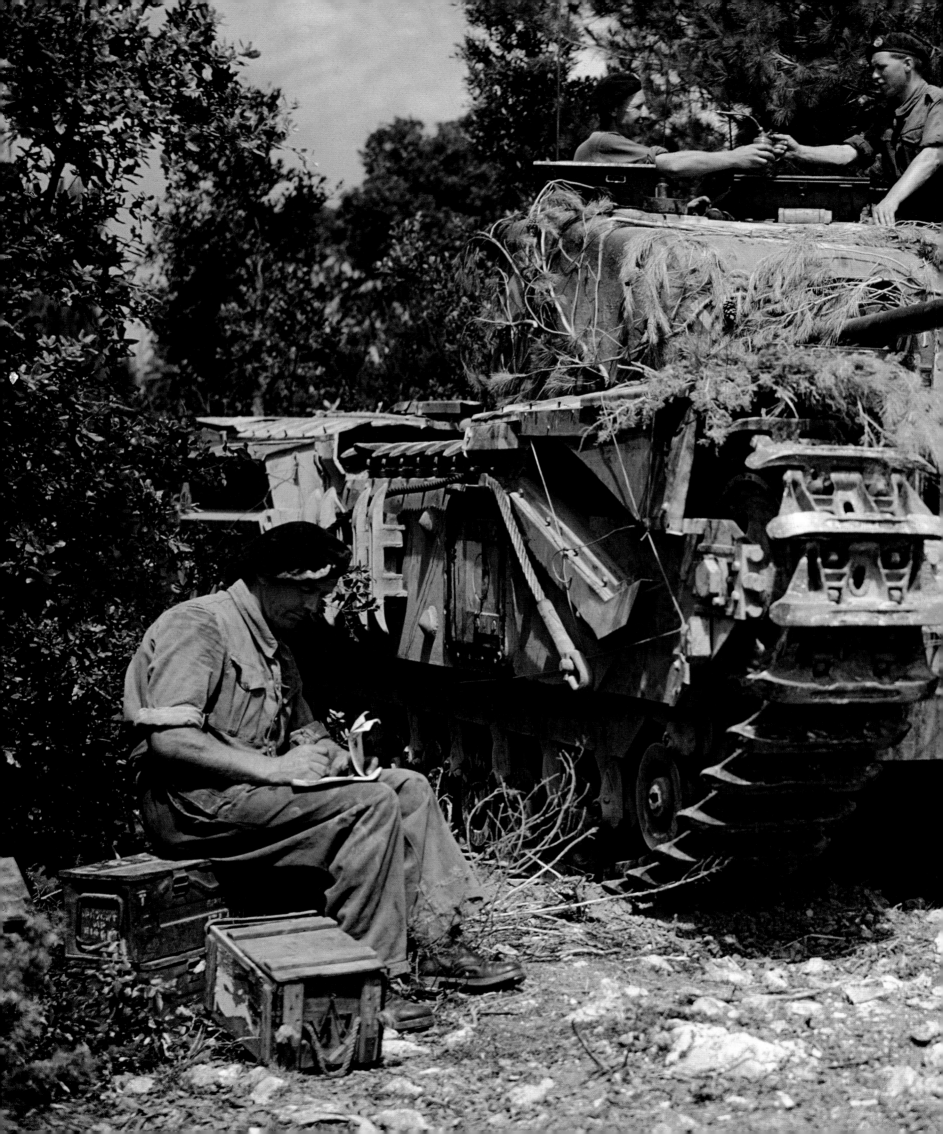

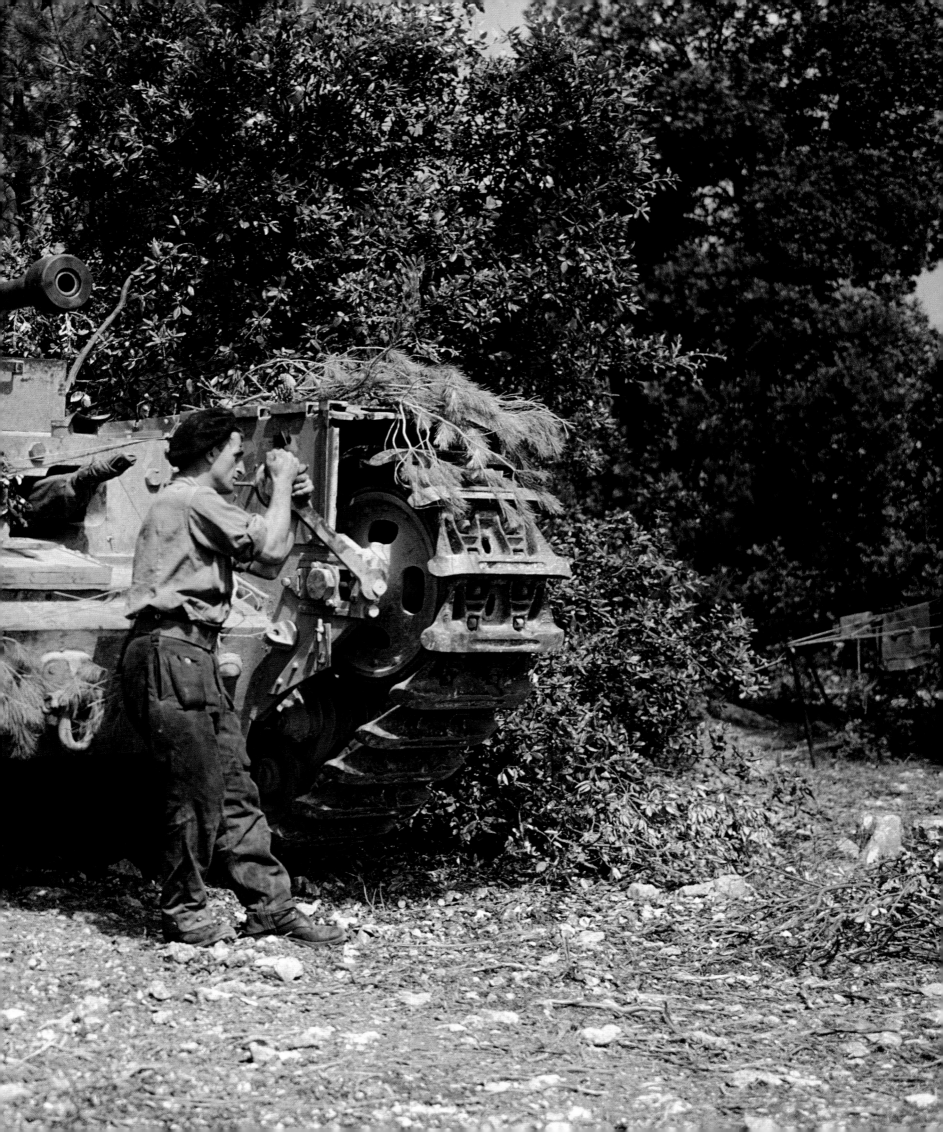

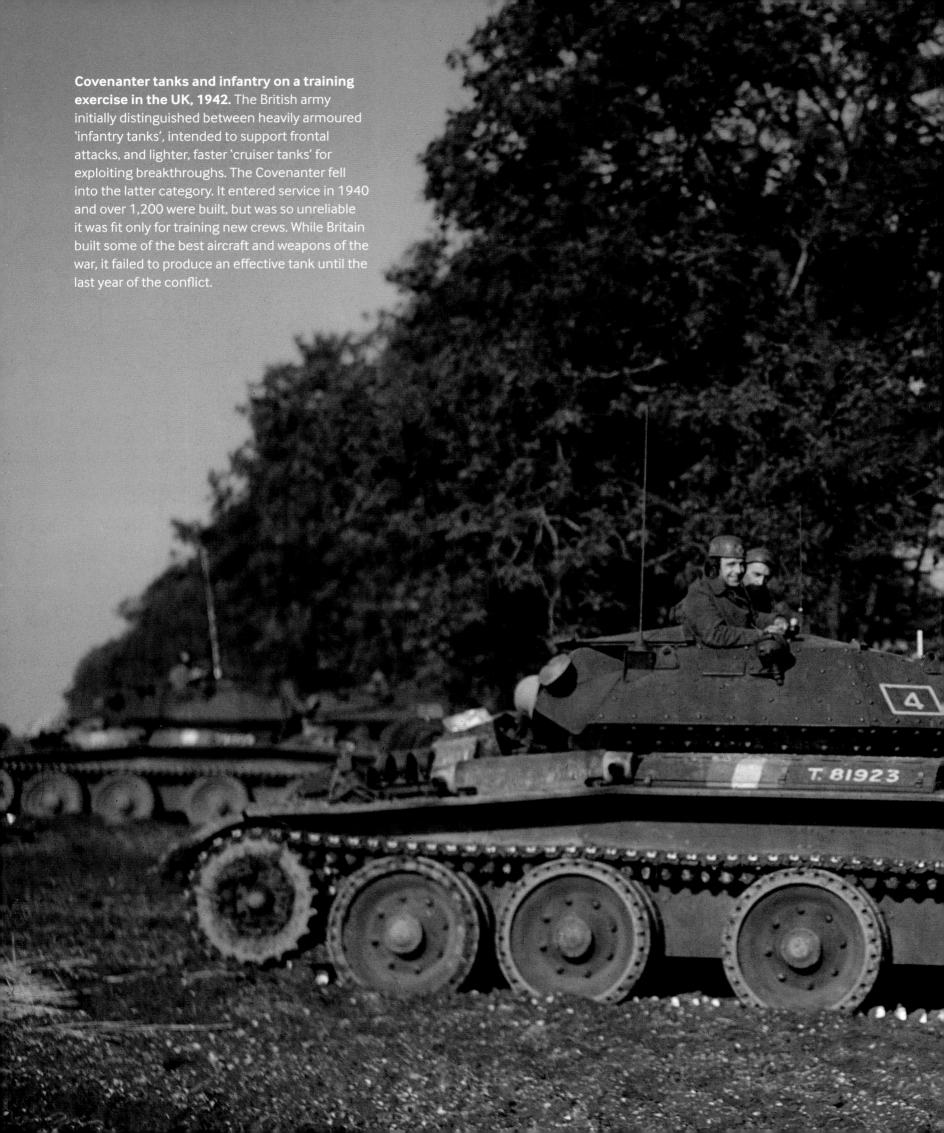

Covenanter tanks and infantry on a training exercise in the UK, 1942. The British army initially distinguished between heavily armoured 'infantry tanks', intended to support frontal attacks, and lighter, faster 'cruiser tanks' for exploiting breakthroughs. The Covenanter fell into the latter category. It entered service in 1940 and over 1,200 were built, but was so unreliable it was fit only for training new crews. While Britain built some of the best aircraft and weapons of the war, it failed to produce an effective tank until the last year of the conflict.

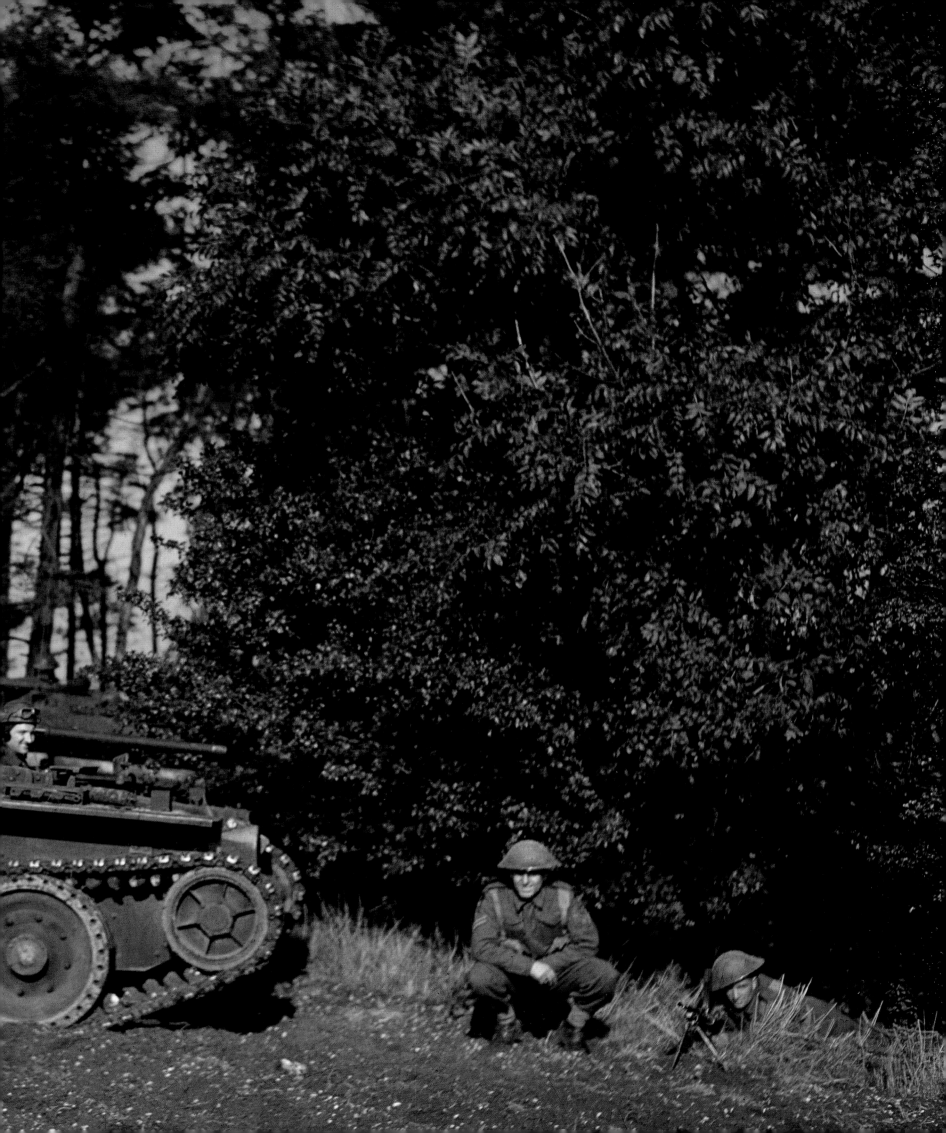

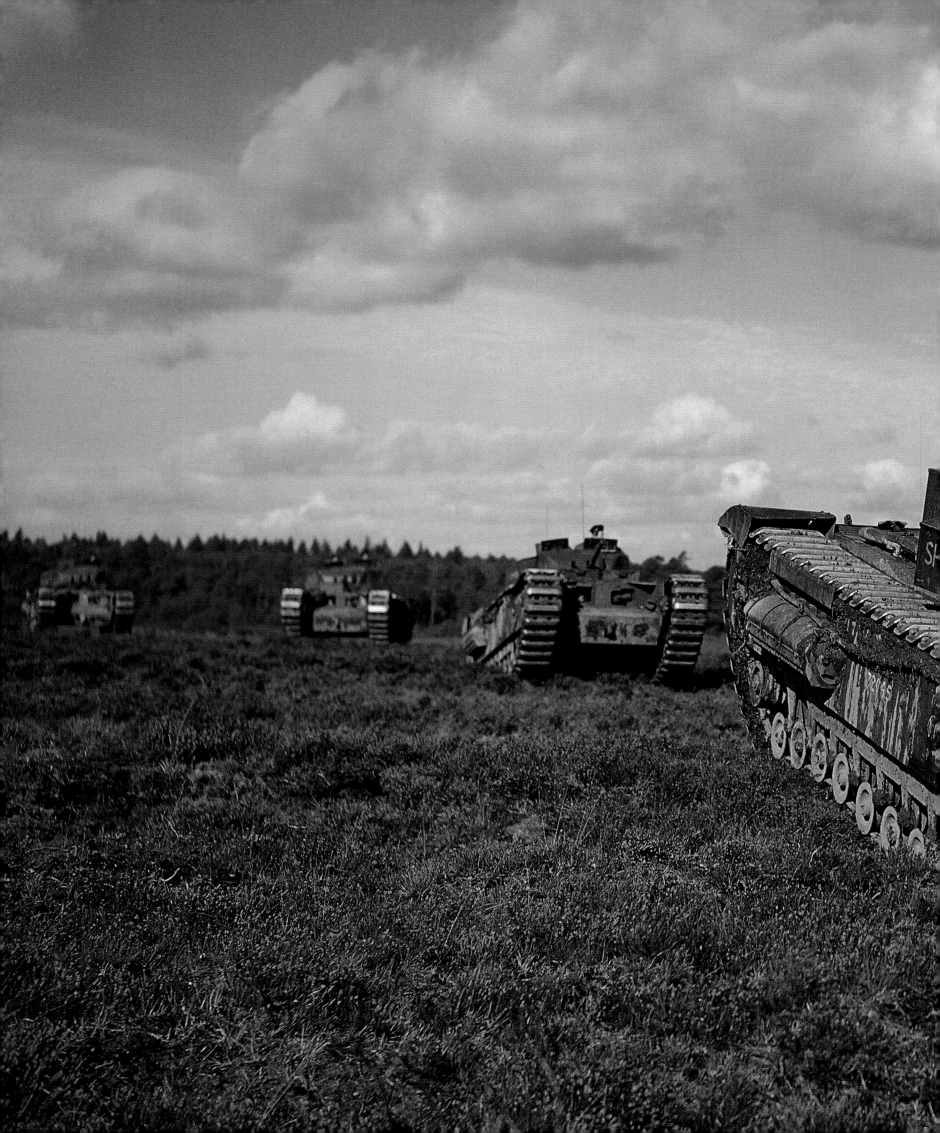

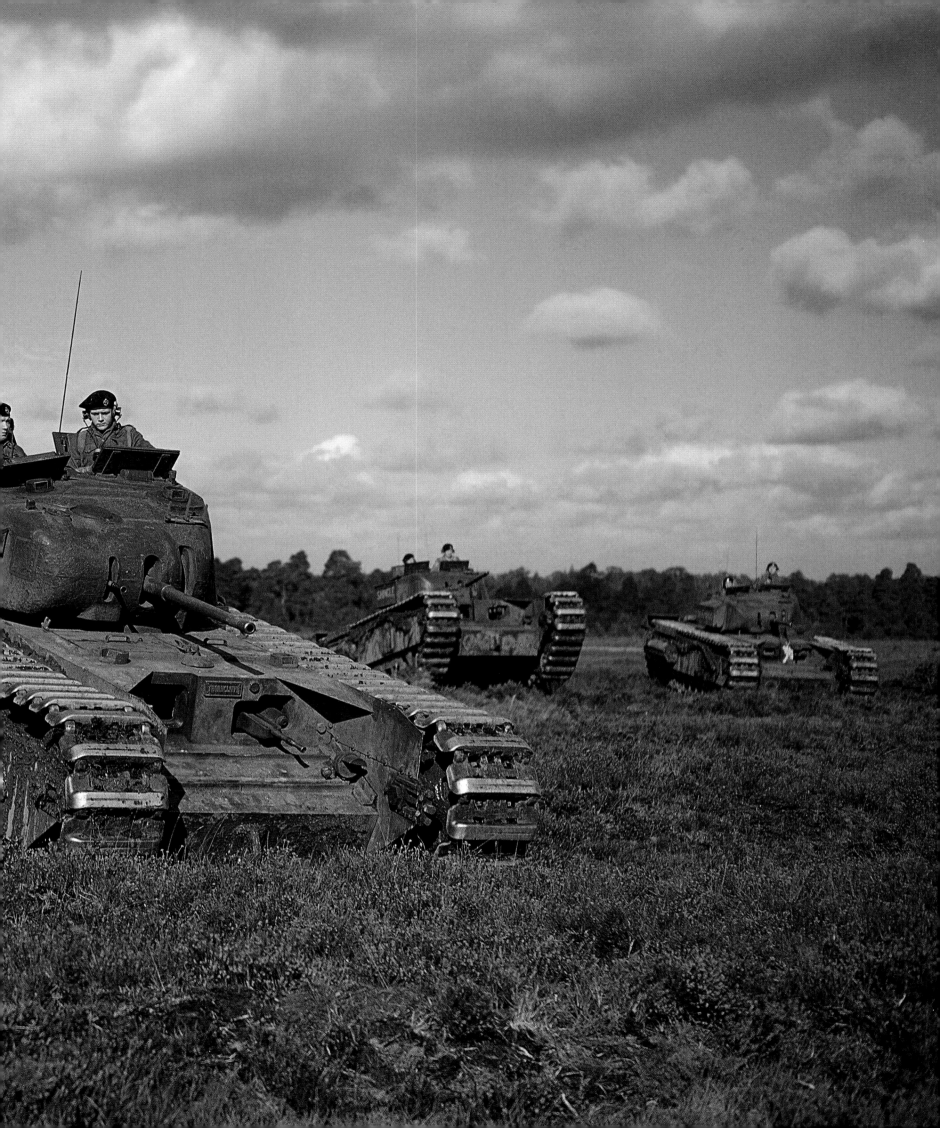

Churchill Mk II tanks and crews of 43rd Battalion, Royal Tank Regiment, on manoeuvres in the New Forest, Hampshire. The heavily armoured Churchill was designed as an 'infantry tank', but suffered from a range of teething problems before it was considered ready for combat. The Royal Tank Regiment, comprising 20 battalions and 18 cavalry regiments, together formed the Royal Armoured Corps. After the fall of France, many infantry battalions were converted to the armoured role as Britain sought to expand its tank force. The crews here are wearing their famous black beret, adopted by the original Tank Corps in the 1920s.

Paratroopers in front of a Whitley transport aircraft at RAF Netheravon in Wiltshire, October 1942. German successes with parachute troops early in the war inspired Winston Churchill to demand that Britain raise its own airborne forces, and training began in 1940. The Parachute Regiment was formed in August 1942, and would eventually comprise 17 battalions. By 1943, two airborne divisions had been created, each consisting of two brigades of parachute troops and an air-landing brigade with infantry carried into action by glider. These men are wearing an early type of parachute smock, based on a German design.

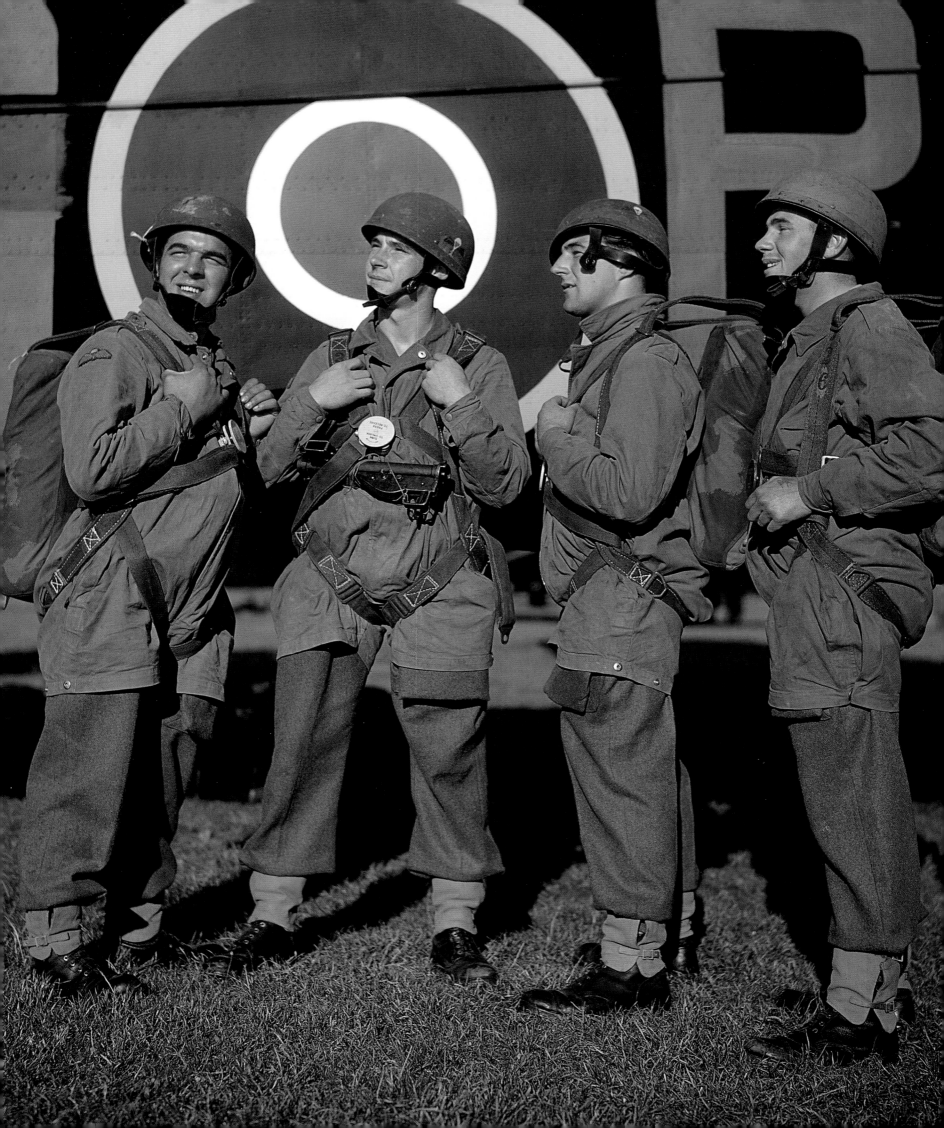

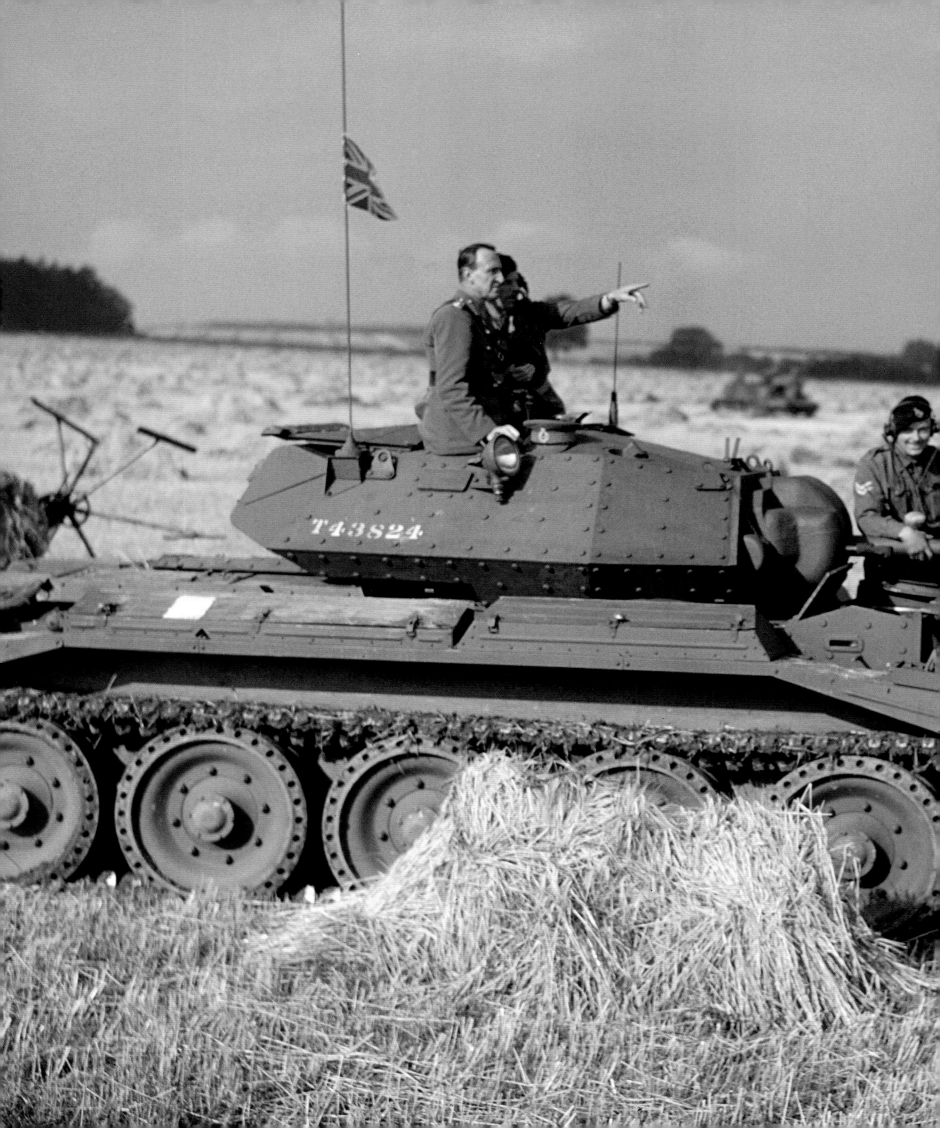

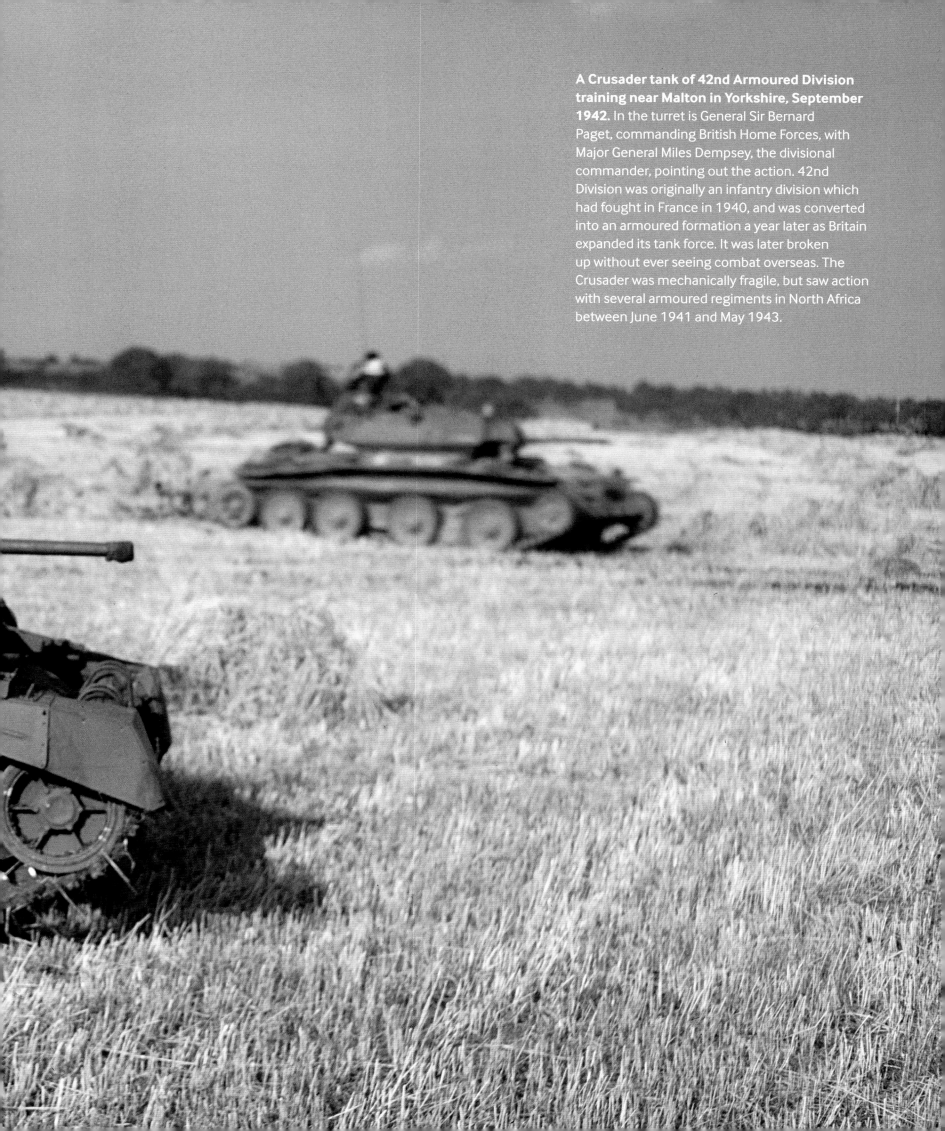

A Crusader tank of 42nd Armoured Division training near Malton in Yorkshire, September 1942. In the turret is General Sir Bernard Paget, commanding British Home Forces, with Major General Miles Dempsey, the divisional commander, pointing out the action. 42nd Division was originally an infantry division which had fought in France in 1940, and was converted into an armoured formation a year later as Britain expanded its tank force. It was later broken up without ever seeing combat overseas. The Crusader was mechanically fragile, but saw action with several armoured regiments in North Africa between June 1941 and May 1943.

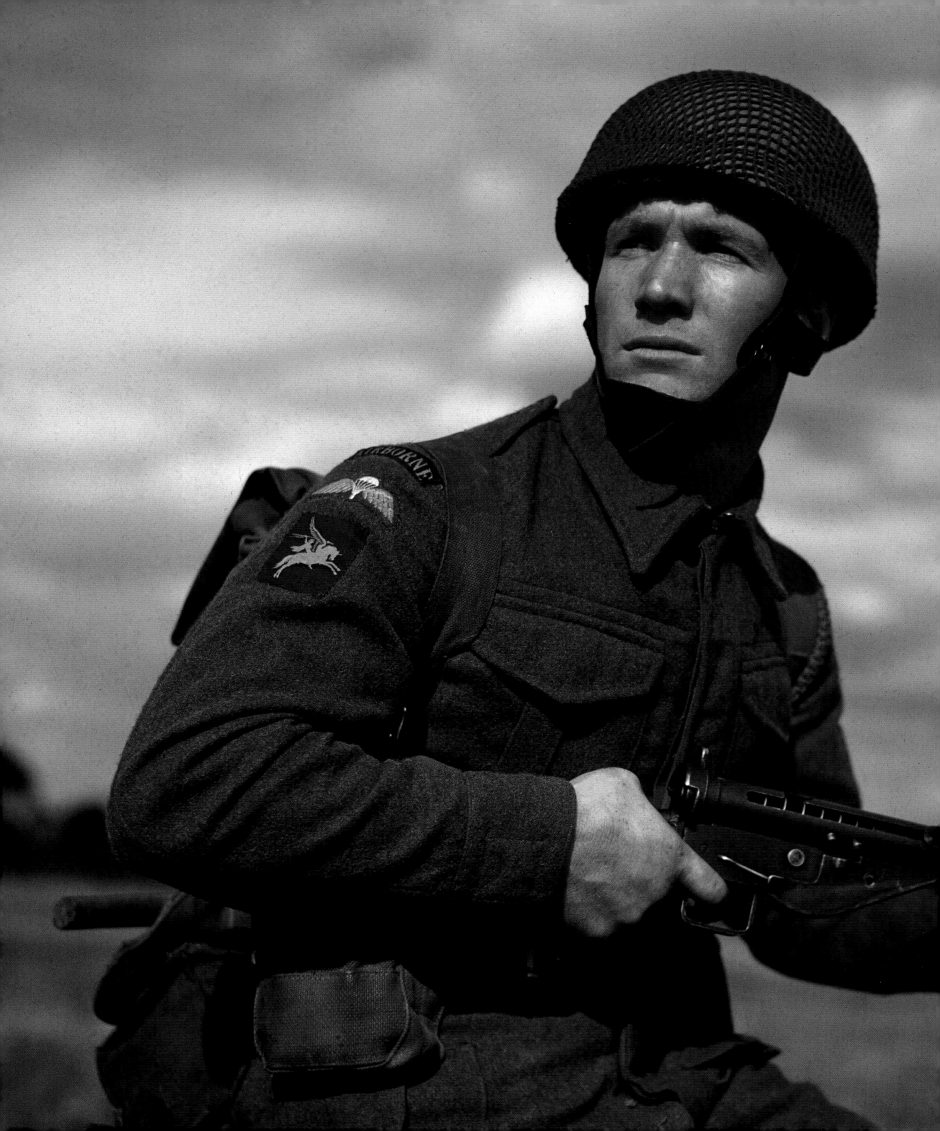

This paratrooper is armed with a Sten sub-machine gun. On his arm he wears the 'Airborne' shoulder title, his parachute wings (awarded after making seven jumps) and the newly created insignia for all airborne soldiers — the Greek mythological hero Bellerophon astride his winged horse 'Pegasus'. On his left shoulder is a red lanyard, denoting the 3rd Parachute Battalion.

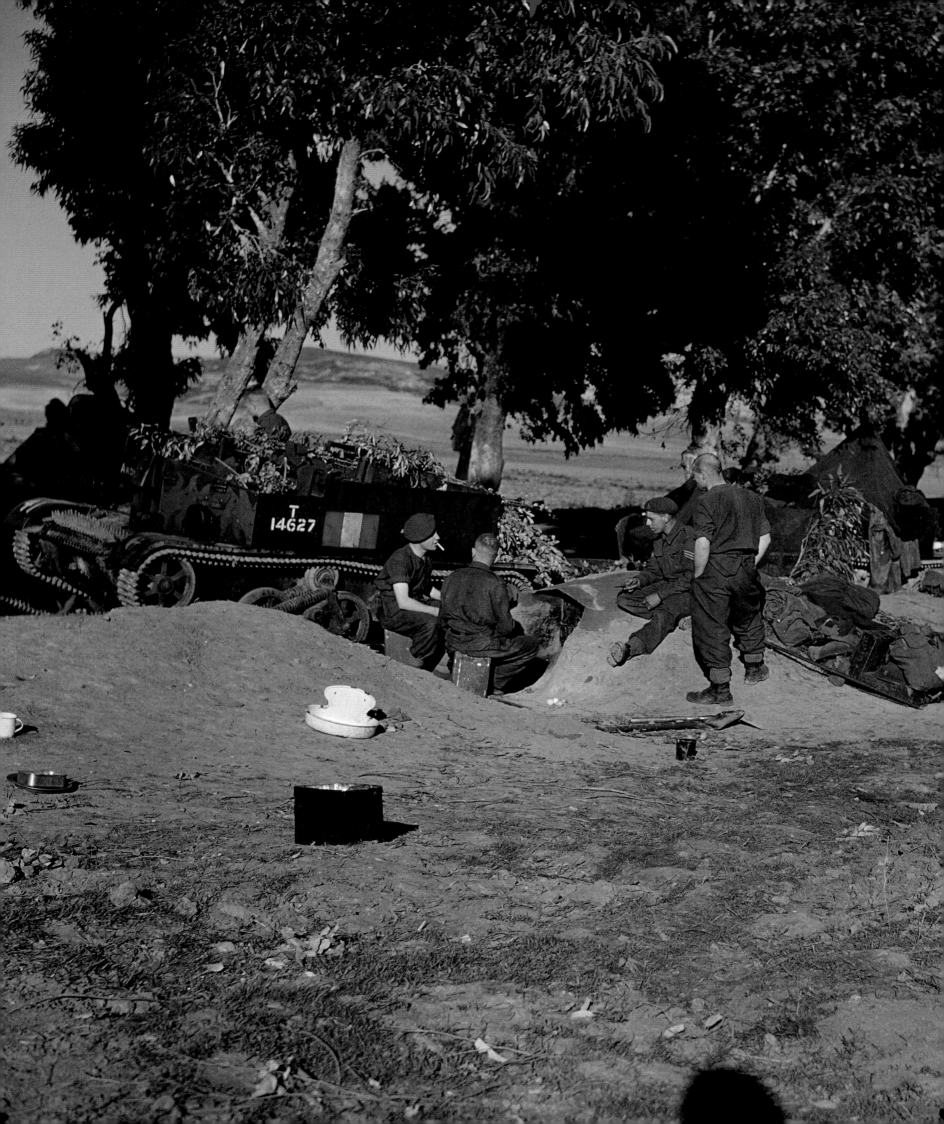

Men of 78th Infantry Division, nicknamed the 'Battleaxe Division' and regarded as one of the best formations in the British Army, at rest with their Universal Carriers in Tunisia, January 1943. After the landings in Vichy French Algeria and Morocco in November 1942, the Allied plan was for a quick advance by the British First Army along the coast towards Tunis, but Hitler sent in reinforcements and his forces in the north held their ground. In the south, the retreating Germans and Italians dug in behind the defences of the Mareth Line. It was not until March 1943 that the Eighth Army broke through, forcing an Axis retreat.

A Crusader Mk III crew of the 16th/5th Lancers, 6th Armoured Division, clean the barrel of their tank's 6-pdr gun at El Aroussa in Tunisia, May 1943. In February, the division helped block the German 10th Panzer Division advancing after defeating the Americans at the Kasserine Pass in the Atlas Mountains. It was then in the forefront of the final British assault on Tunis, which fell on 7 May. Though German resistance had been tenacious, the outcome of the Tunisian campaign was never in doubt. Some 238,000 Axis troops surrendered, a defeat comparable to the recent disaster at Stalingrad.

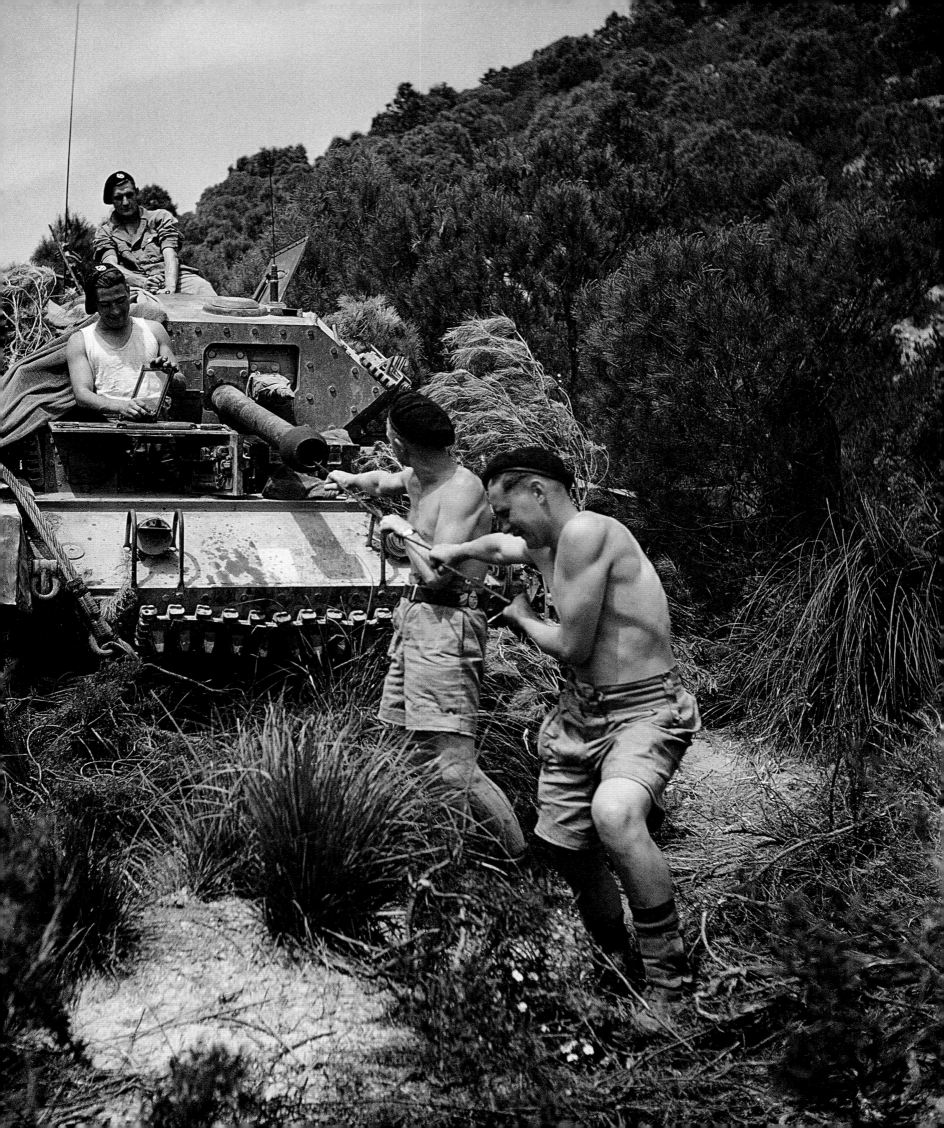

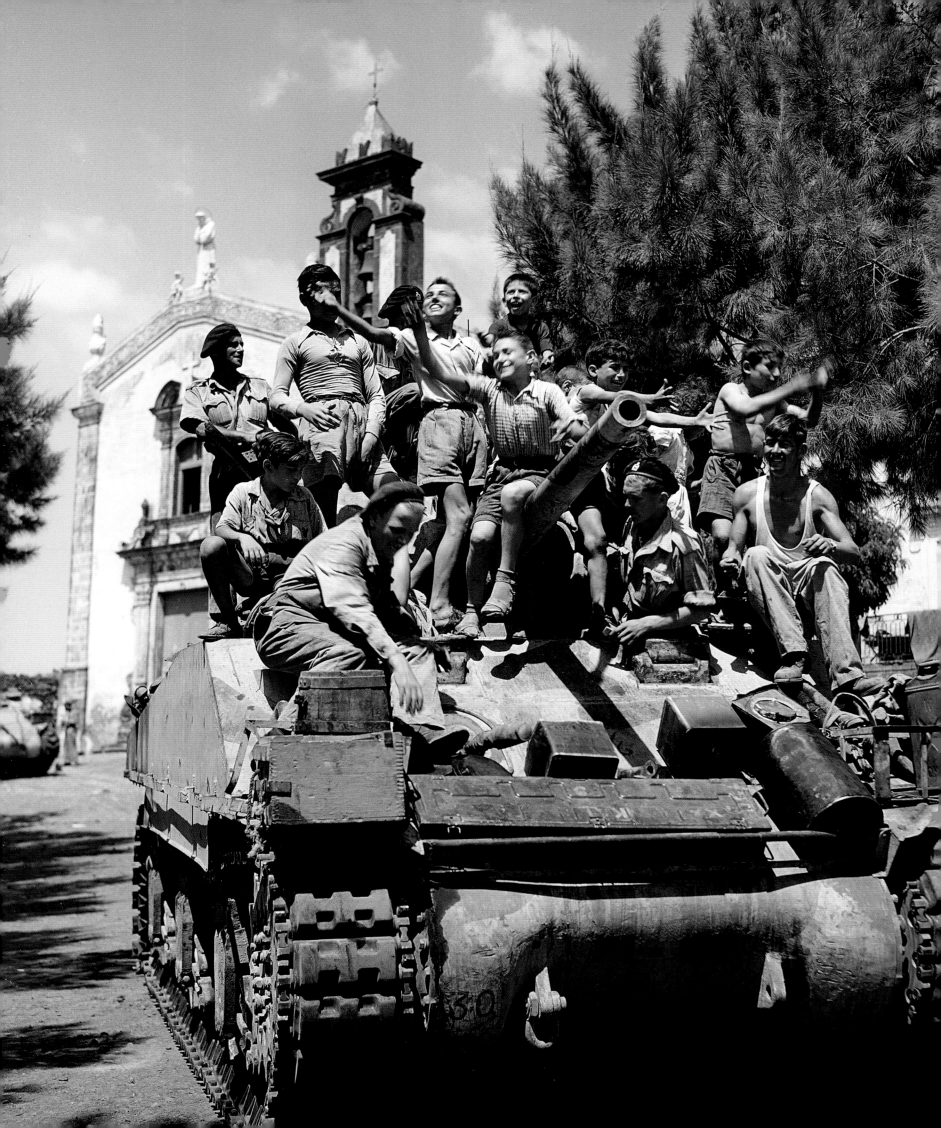

Sicilian boys enjoy a ride on a Sherman tank of the 3rd County of London Yeomanry (Sharpshooters) in the village of Belpasso, near Catania, August 1943. The invasion of Sicily, which began on 10 July 1943, was the next step in the Allies' Mediterranean strategy, but was flawed by poor Anglo-American cooperation. The Germans staged a masterful defence of the island, and managed to evacuate most of their troops to Italy before Allied units finally entered Messina on 16 August. By this date the reliable American-built Sherman had become the standard Allied tank, equipping most British and American armoured regiments.

(Next spread)
A 5.5-inch gun crew from 75th (Shropshire Yeomanry) Medium Regiment, Royal Artillery, in action in southern Italy, September 1943. Mussolini had been deposed, but Hitler refused to give up Italy, choosing instead to hold as much ground as possible. The advance northwards of the US Fifth and British Eighth Armies to Rome and beyond was hindered by the Apennine mountains, across which the Germans had created a succession of defence lines. Allied progress was eventually brought to a halt at the end of 1943 along the heavily fortified 'Gustav Line', which stretched from the mouth of the Garigliano River in the west to Ortona on the Adriatic coast.

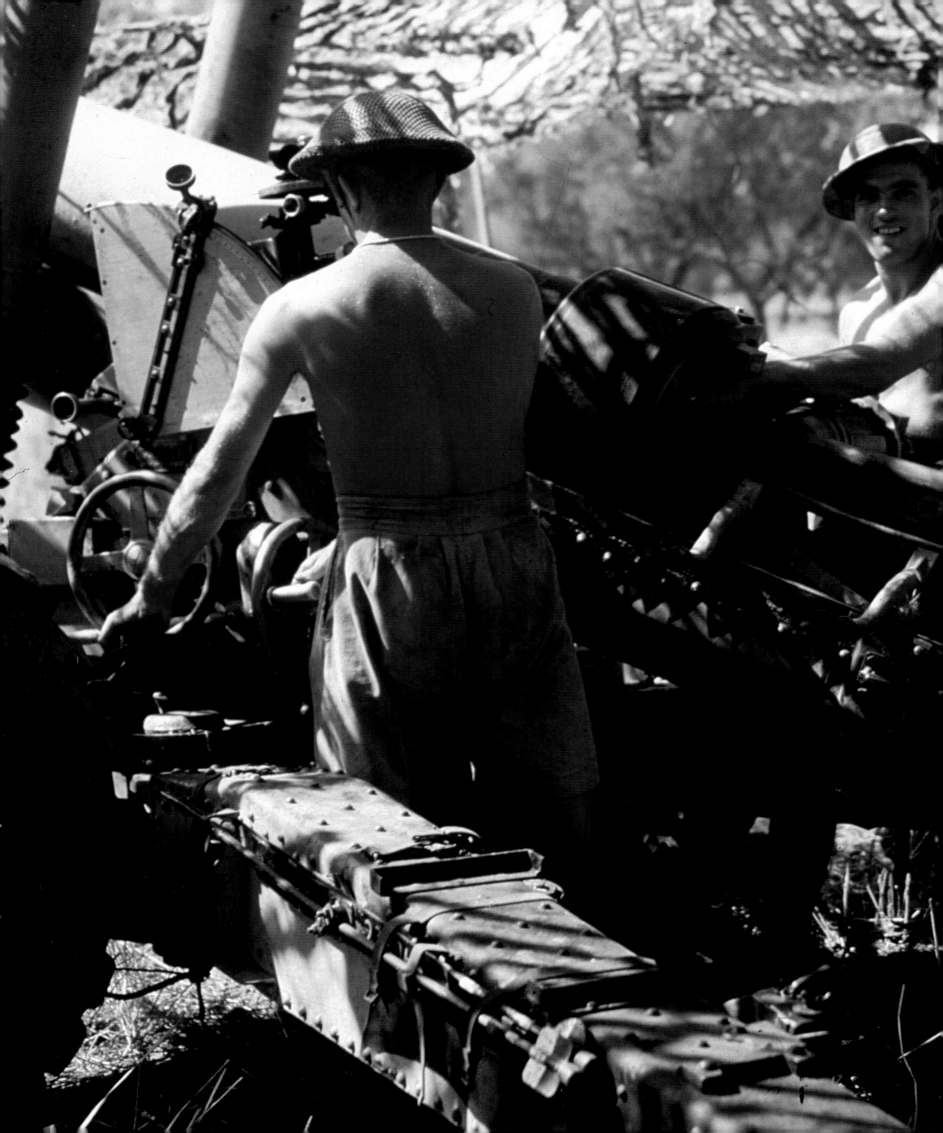

Lance Corporal A Durrant, an infantrymen in 56th (London) Division, snatches some sleep during a lull in the fighting in Italy, January 1944. He wears the Africa Star medal ribbon, denoting service in the Western Desert or Tunisia. The 'Black Cat' Division — named for its formation badge depicting Dick Whittington's famous cat — served briefly with the Eighth Army in Tunisia before being despatched to join British X Corps, attached to the US Fifth Army in Italy. When this photo was taken the troops had just taken part in the assault crossing of the deep and fast-flowing Garigliano river during the First Battle of Monte Cassino.

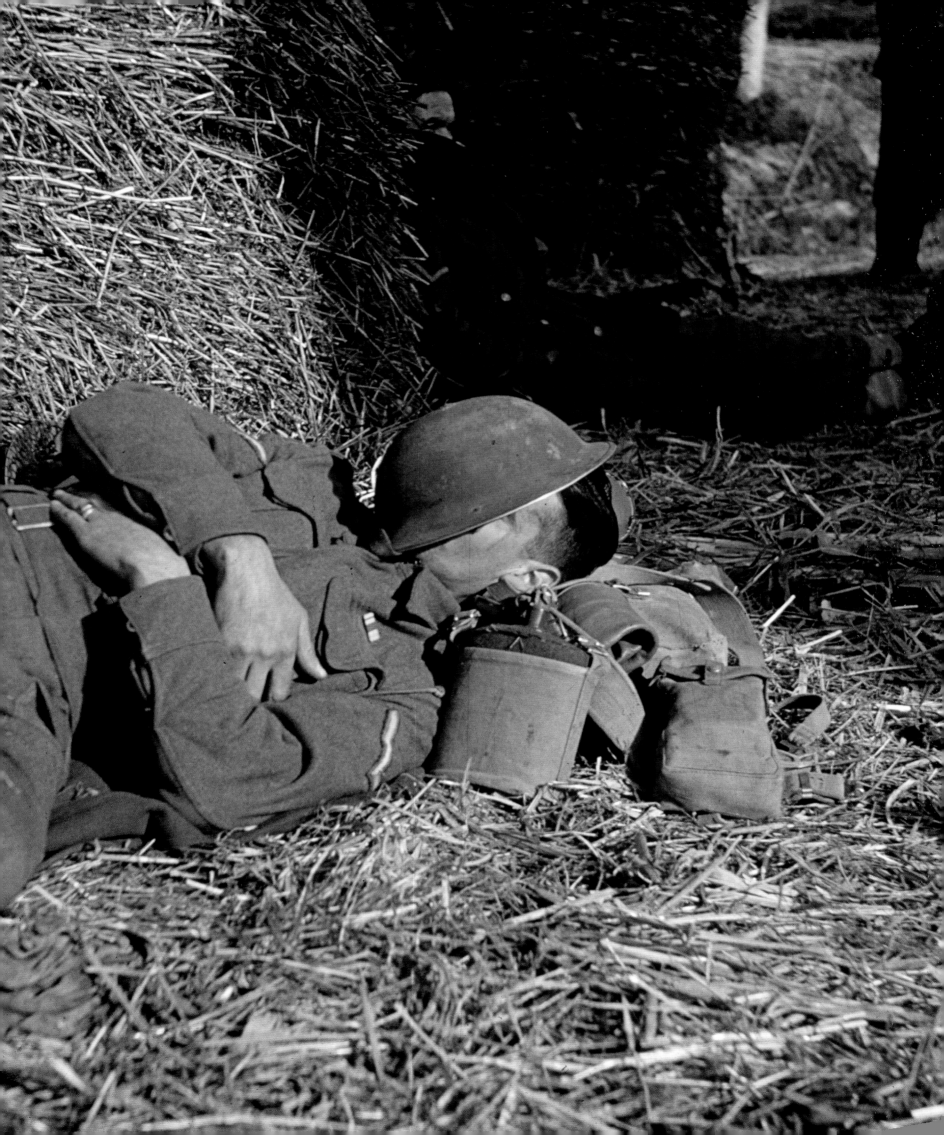

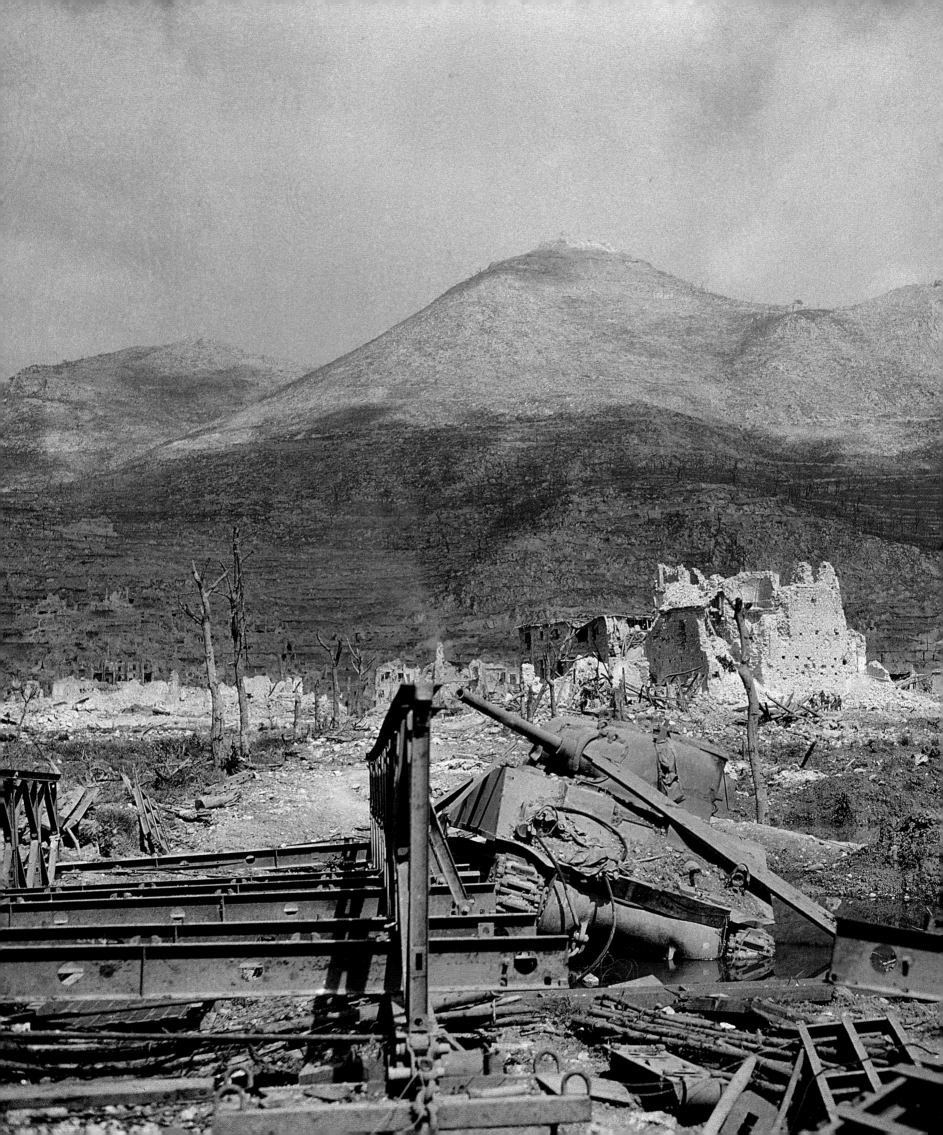

The Italian town of Cassino and the mountains around it were the key to the German defences of the 'Gustav Line'. From January to May 1944, British and American forces staged several major attacks here in an effort to dislodge the enemy. The towering Monte Cassino, with its ancient Benedictine monastery perched atop, was a principal objective. Allied bombing reduced both town and monastery to ruins, which were exploited by defending German troops. After ferocious fighting, Allied firepower eventually prevailed. In a final battle, Polish troops drove the Germans from the heights of Monte Cassino itself. Here, a Sherman tank lies abandoned on the battlefield, May 1944.

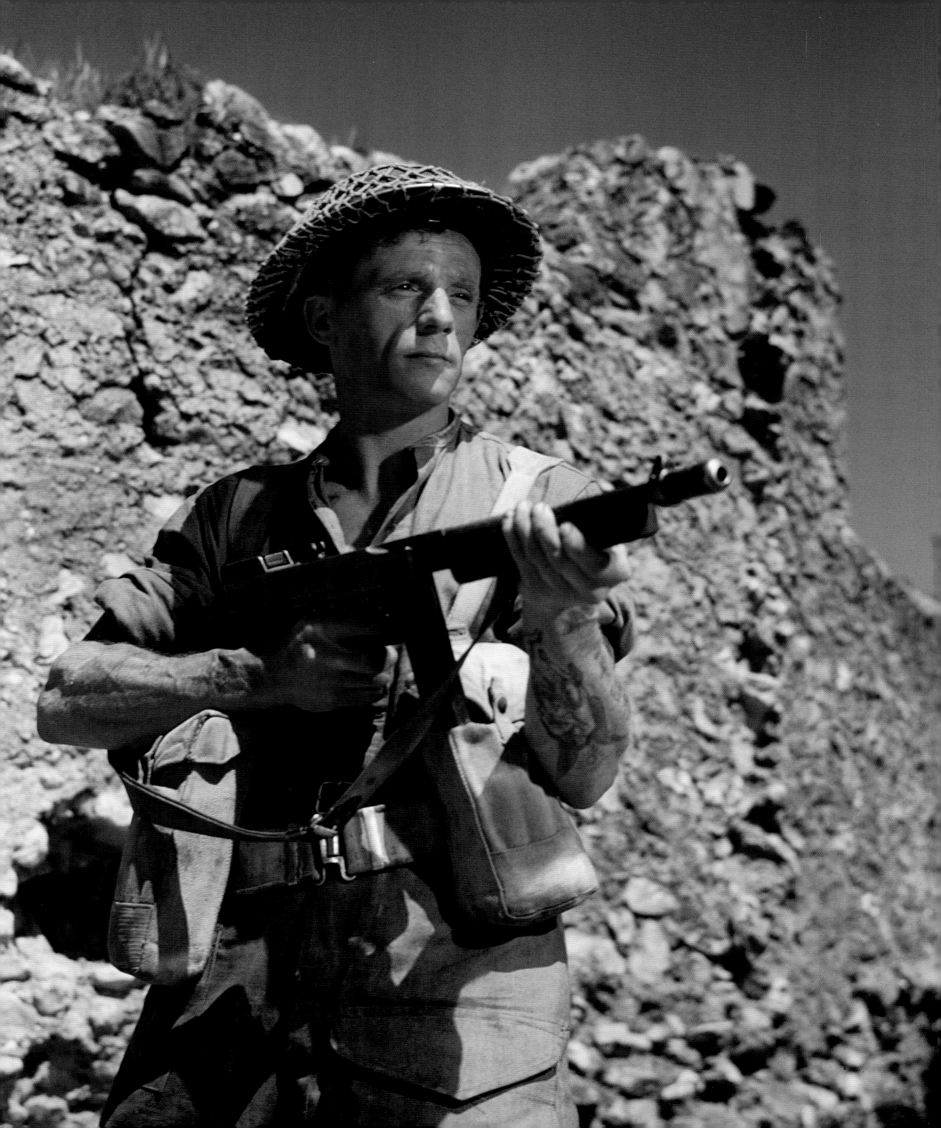

Corporal M Smith of the 2nd Battalion, Duke of Cornwall's Light Infantry, 4th Infantry Division, April 1944. He is armed with a Thompson sub-machine gun. In May, the battalion took part in Operation 'Diadem', the fourth and final major offensive to penetrate the German defences around Monte Cassino and open up the Liri Valley and the main road to Rome. The assault was costly but successful and German forces retired first to the 'Hitler Line' and then the 'Caesar Line' before giving up the capital entirely and establishing positions further north.

Members of the Army Film and Photographic Unit in the Piazza Venezia in Rome on 5 June 1944, the day after US troops entered the city. Behind is the Vittoriano, the monument to King Victor Emmanuel II. After the fall of Rome, Allied forces advanced northwards to the Germans' last defensive network — the 'Gothic Line' — which ran from Pisa to Rimini. This was breached, but the British and Americans failed to break out onto the Lombardy Plain. The final Allied offensive took place in April 1945 with the crossing of the River Po and capture of Bologna. The British Eighth Army had reached Venice and Trieste by the time the German forces formally surrendered on 2 May 1945.

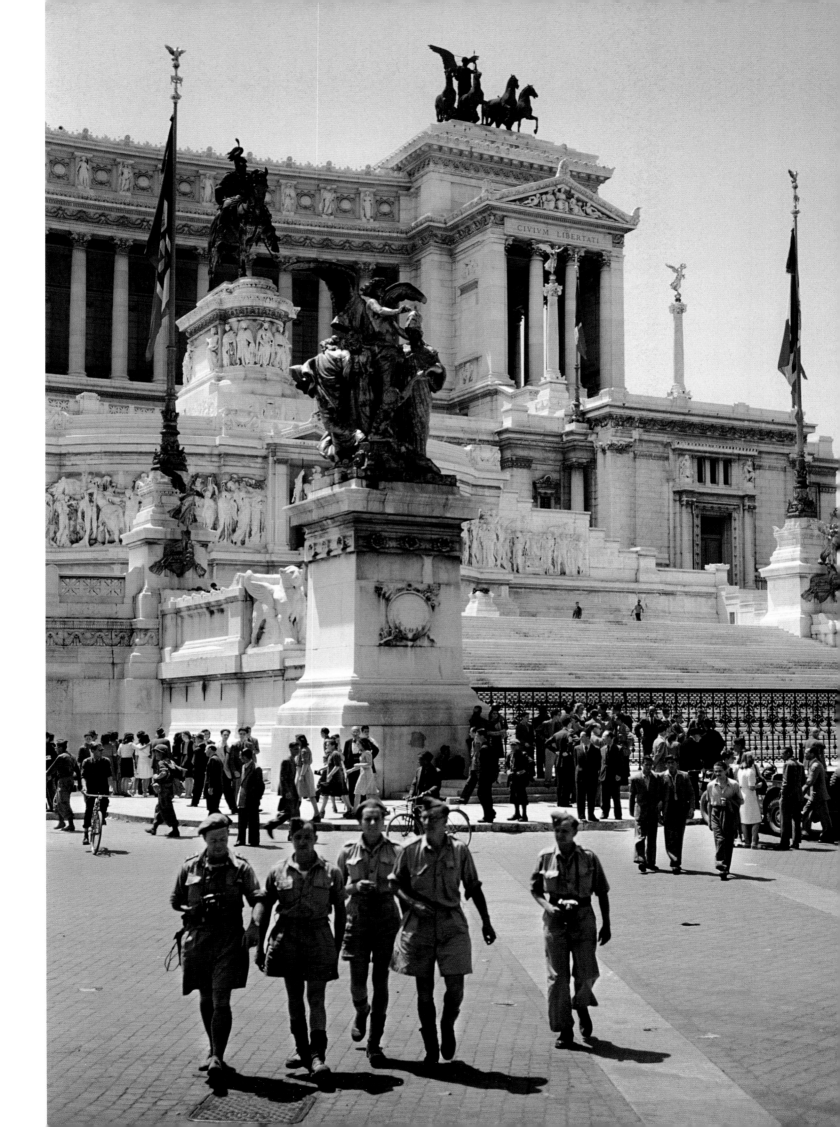

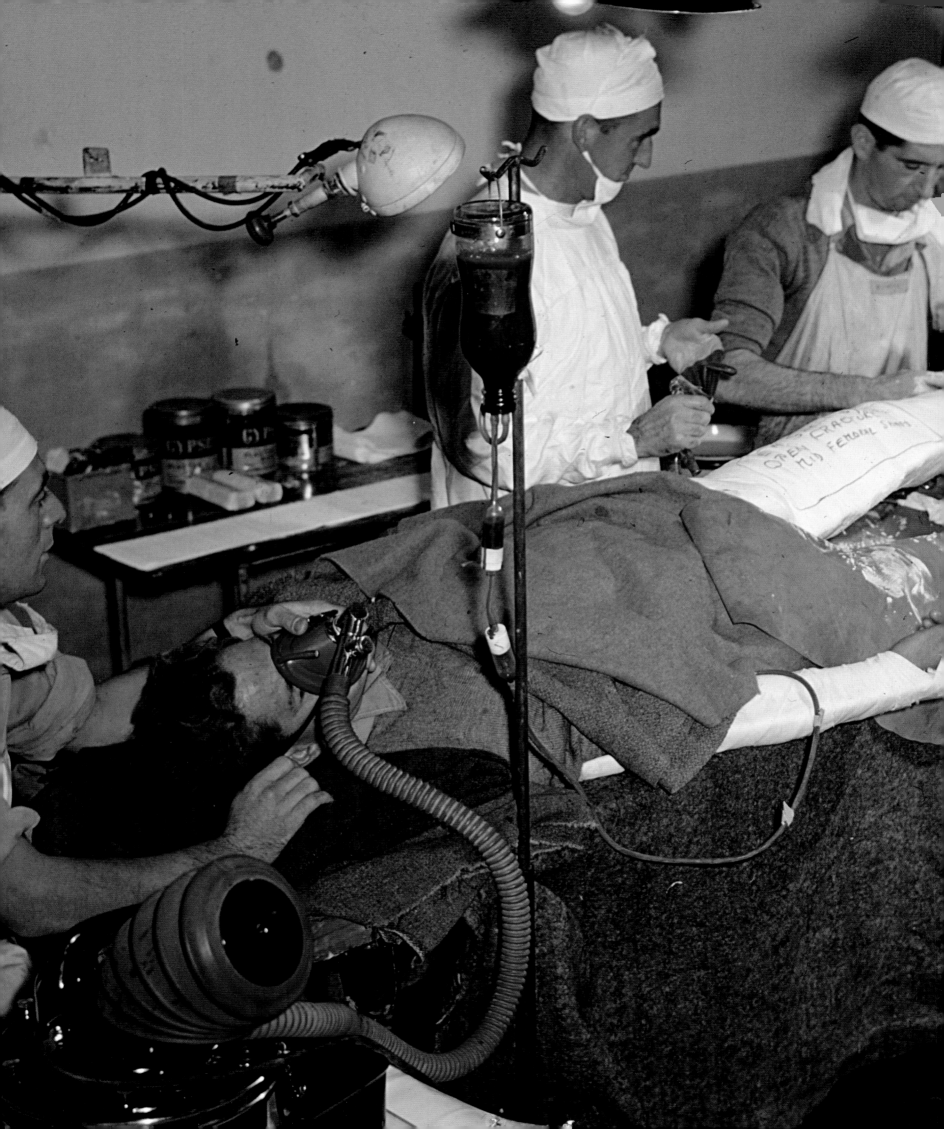

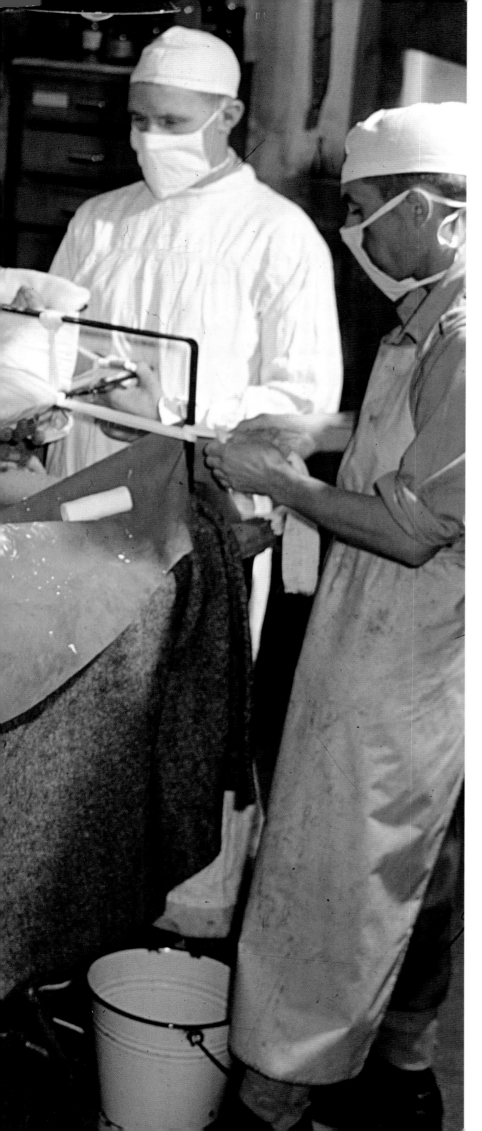

A British soldier is given a blood transfusion while his leg is set in plaster at an advanced dressing station in Italy, October 1944. Allied armies benefitted from excellent medical services, and a wounded soldier's chances of survival were greatly improved by prompt transport from a regimental aid post, where he was stabilised, to a dressing station close to the front line where surgical treatment and blood transfusions were available. Another vital weapon in the medical armoury was the new antibiotic drug Penicillin, used extensively in the last year of the war to control infection.

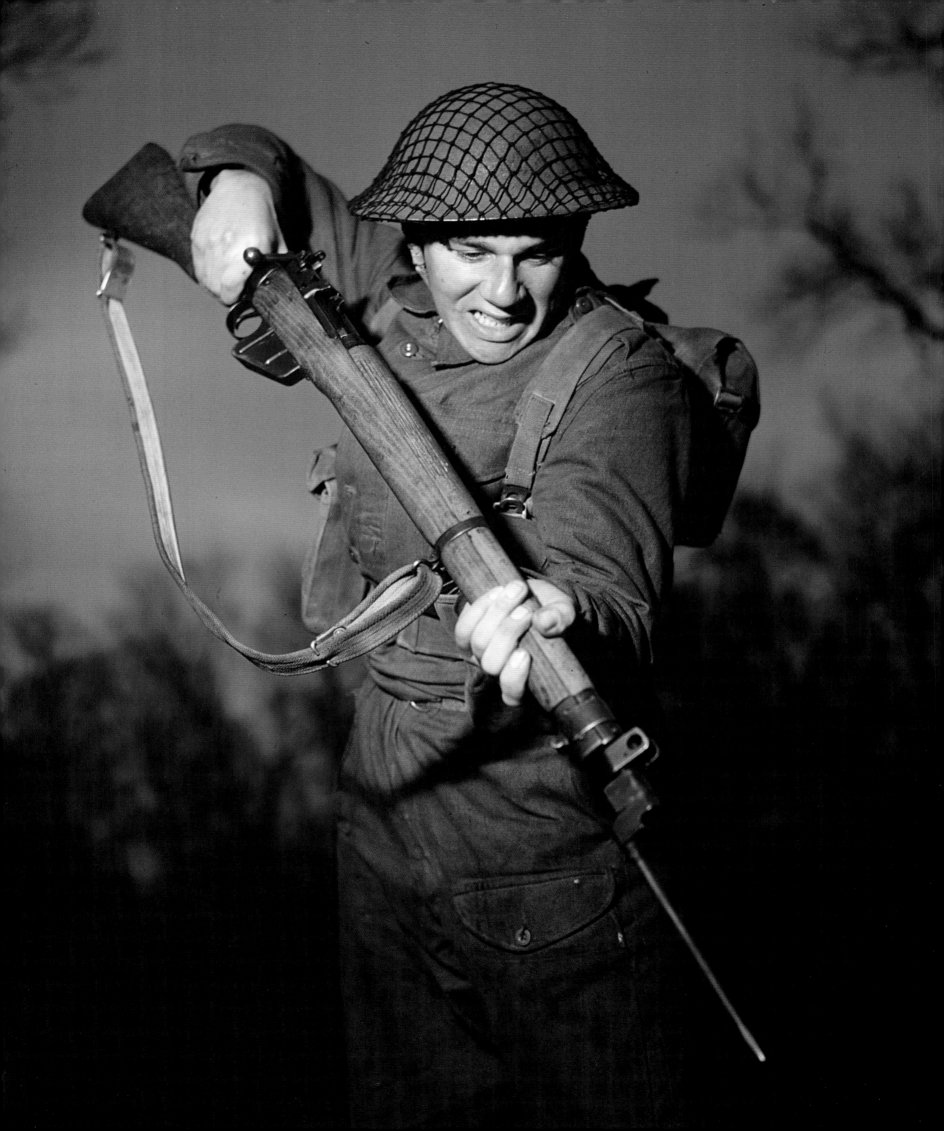

Private Alfred Campin of the 6th Battalion, Durham Light Infantry strikes an aggressive pose during battle training 'somewhere in Britain', March 1944. Campin, a 23 year-old former bricklayer from Northampton, was a veteran of the North African and Sicily campaigns. Three battalions of the Durham Light Infantry collectively formed 151st Brigade, part of 50th (Northumbrian) Division. The formation had been brought back from the Mediterranean in preparation for D-Day, and would land on Gold Beach. Sadly, Alfred Campin was killed in Normandy on 16 June 1944 and is buried at Bayeux War Cemetery.

(Next spread)
British paratroopers prepare for a practice jump from an RAF Dakota based at Down Ampney in Wiltshire, April 1944. Allied airborne forces played a key role on D-Day, dropping in darkness to secure the flanks of the seaborne assault. The British 6th Airborne Division seized vital river and canal crossings across the River Orne in the east of the lodgement area. Their most spectacular achievement came shortly after midnight on 5 June, when a small glider-borne party landed with pinpoint accuracy and captured 'Pegasus Bridge' over the Caen Canal.

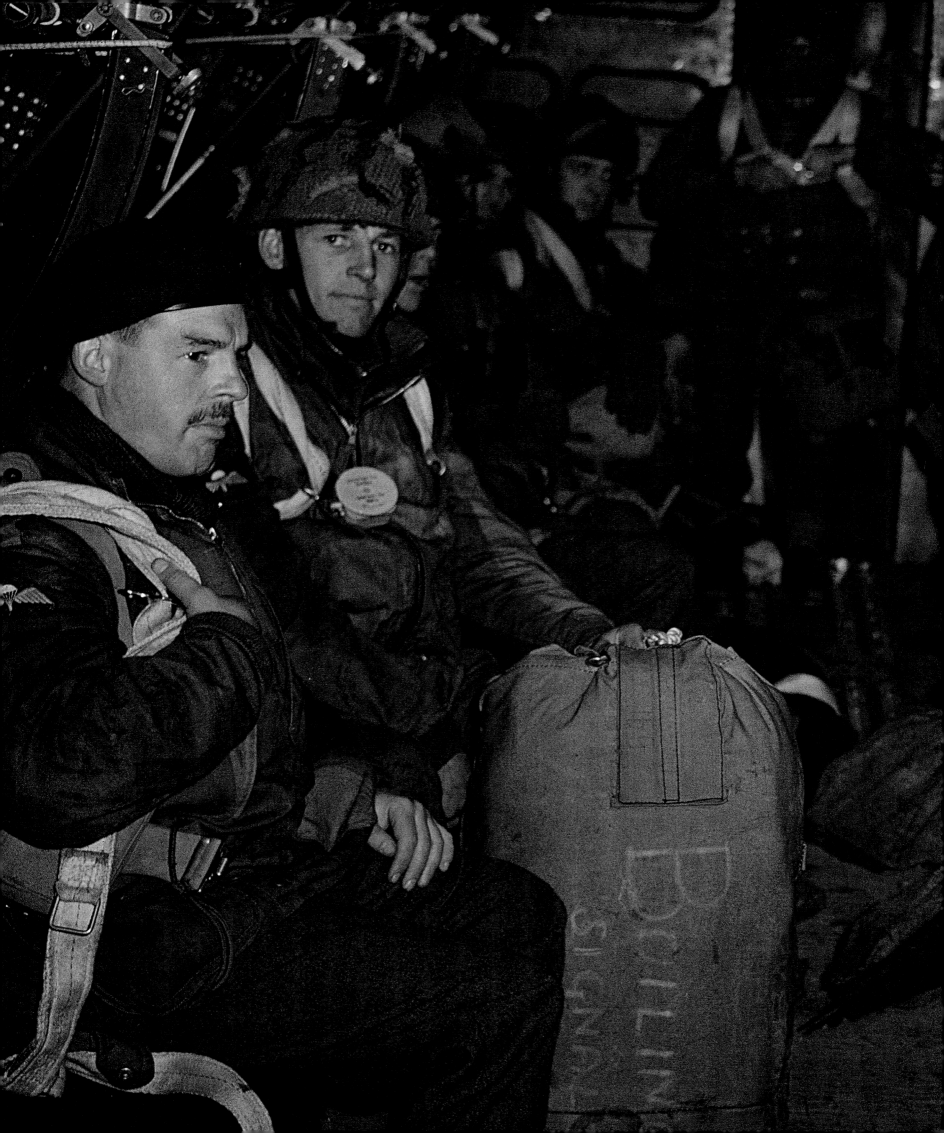

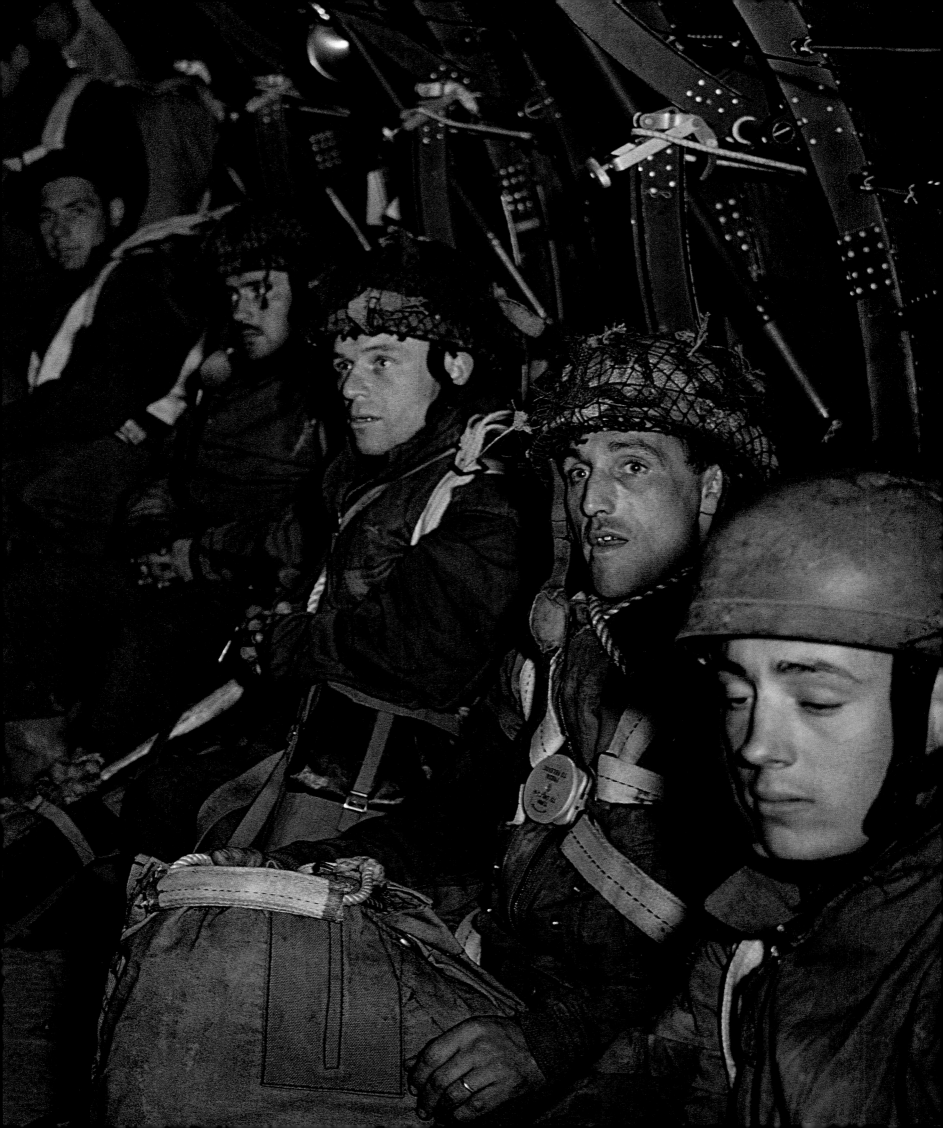

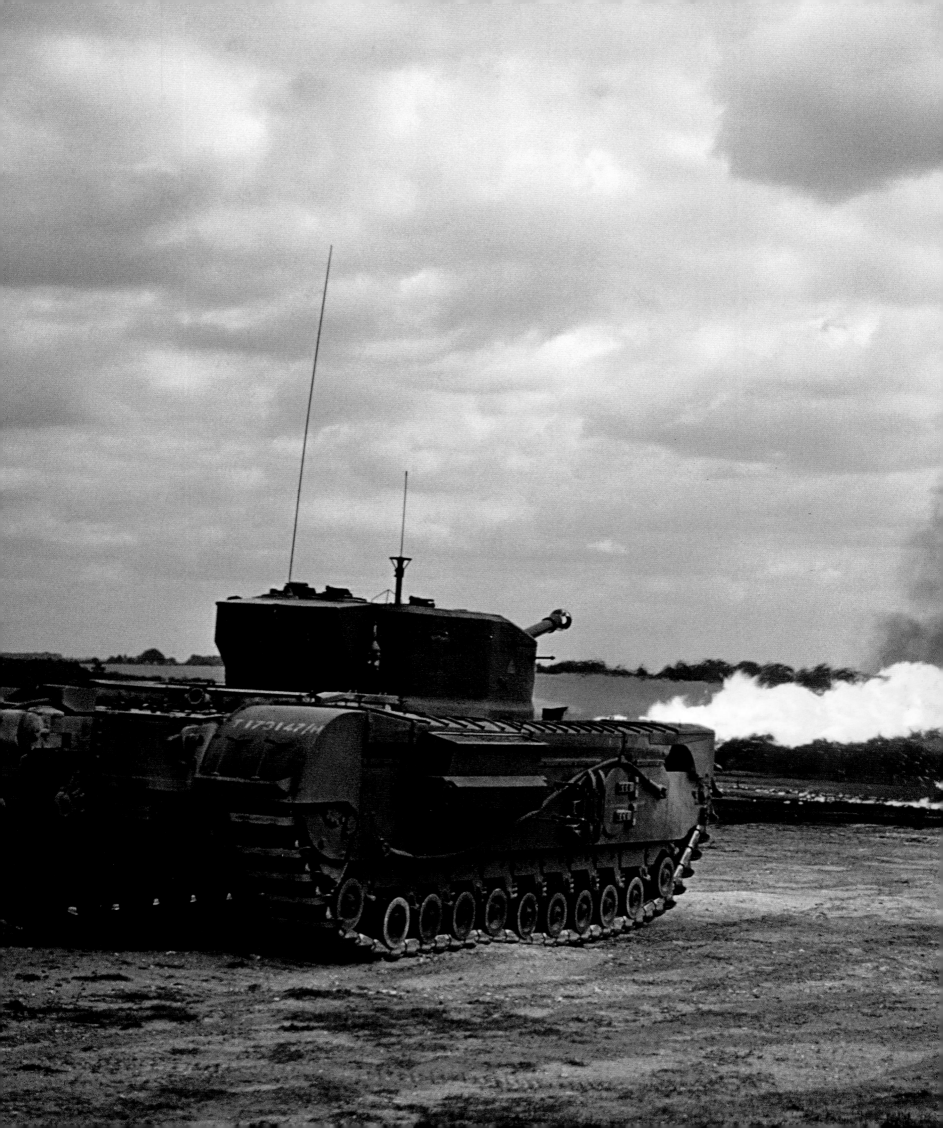

A Churchill Crocodile flamethrower tank in action during a demonstration, August 1944. Specialised armoured vehicles designed to clear mines, bridge gaps and demolish concrete bunkers played a key role on D-Day and in the subsequent north-west Europe campaign. These so-called 'Funnies' were operated by British 79th Armoured Division, and attached in small units to the various assault formations. The Crocodile was perhaps the most feared of these new weapons, and could blast a jet of flame up to 120 yards (110 metres) against pillboxes and bunkers.

Men from 53rd Heavy Regiment, Royal Artillery, ramming a shell into the breech of their gun during a bombardment of German positions around Caen, July 1944. This regiment was equipped with American-built 155mm guns, one of the largest weapons available to the British forces. The Allies in Normandy benefitted from prodigious fire support – from artillery, heavy bombers and even battleships anchored offshore. Throughout the war, the Royal Artillery was the most effective arm of the British Army, and the one most respected and feared by the Germans. Over 1.2 million men served as gunners, more than the number of sailors in the whole of the Royal Navy.

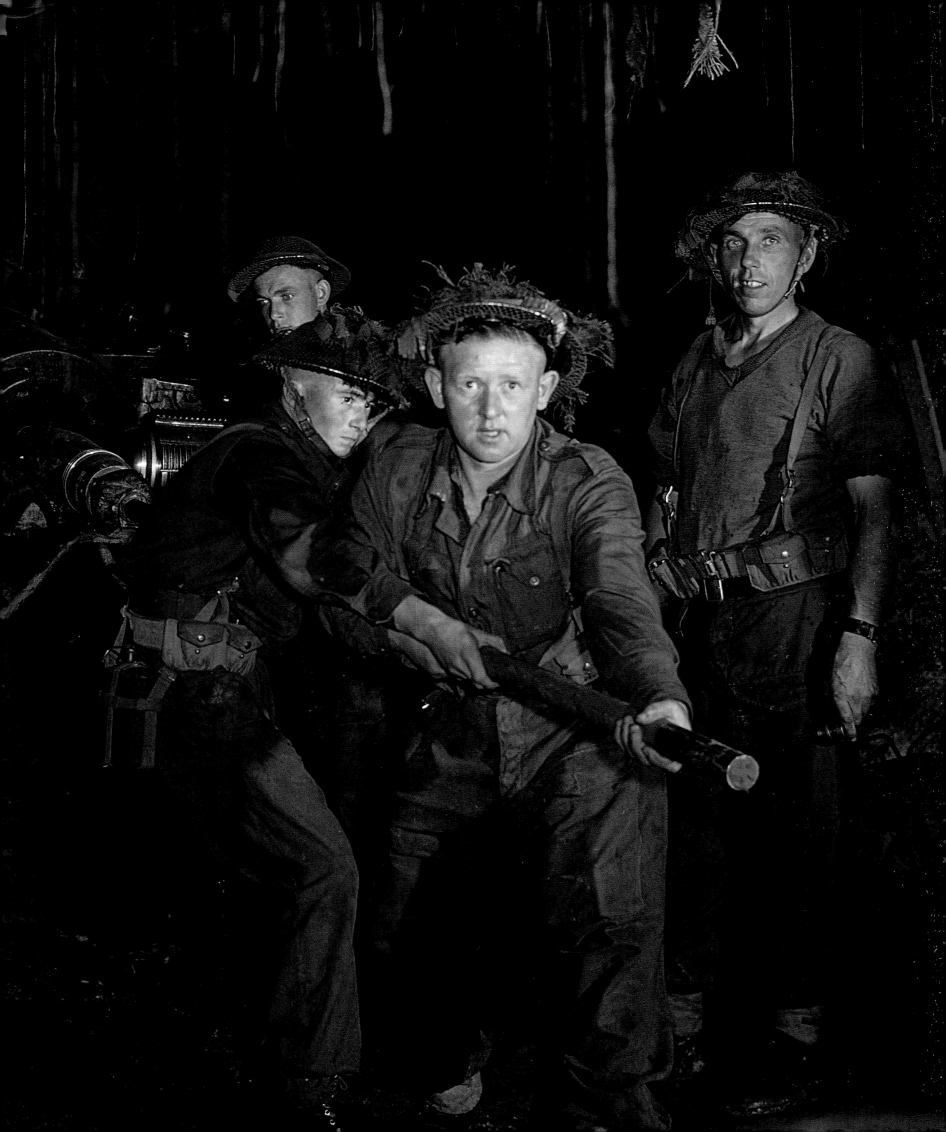

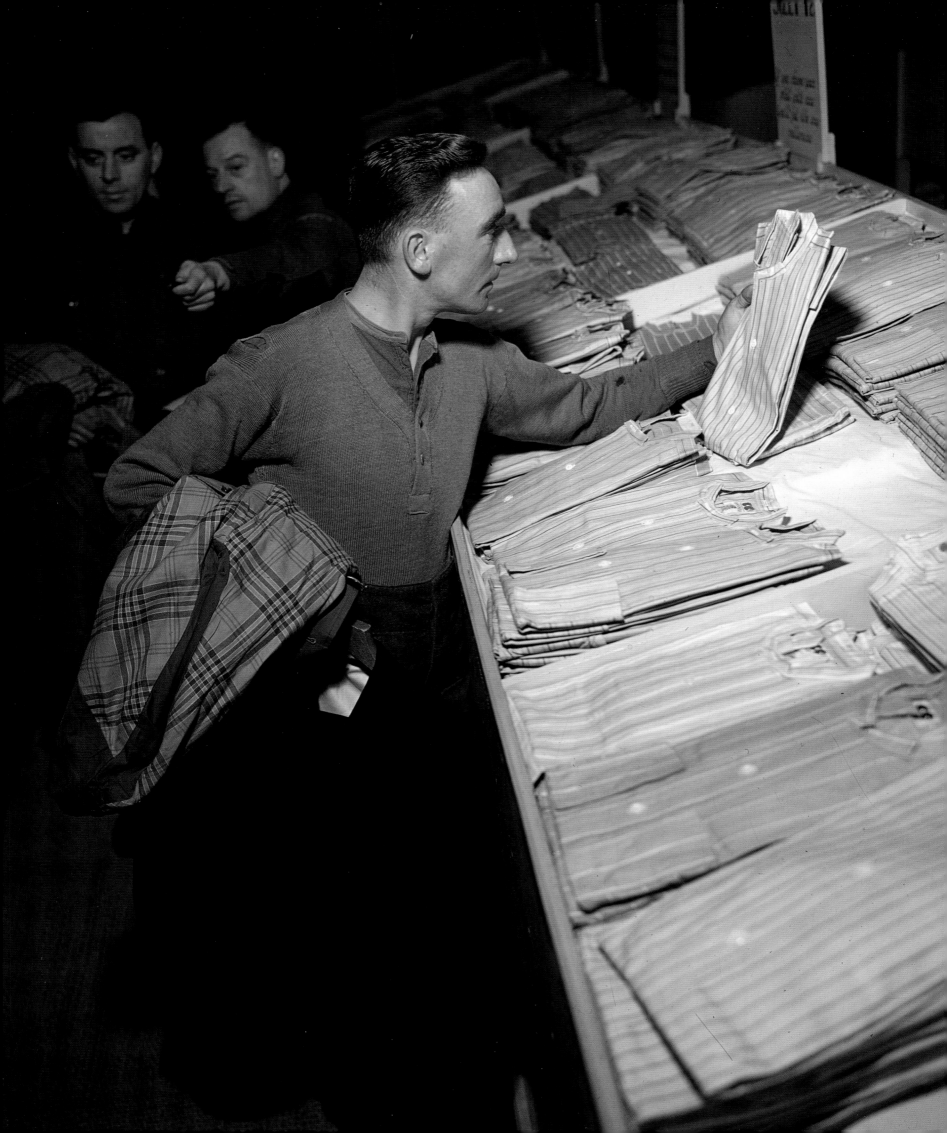

A soldier collects civilian clothing at a demobilisation centre, 1945. At the war's end servicemen were entitled to a pinstripe three-piece suit or jacket and trousers, two shirts, a tie, shoes, raincoat and hat or cap. These 'demob suits' were not universally popular, and in effect conferred a new uniformity on their wearers. Demobilisation of Britain's armed forces began on 18 June 1945, and by the end of 1946 over 4 million men and women had been released from service. The return to 'Civvy Street' could be a hard one, exacerbated by continuing shortages, rationing and the effects of the bombing.

Field Marshal Sir Bernard Montgomery explains Allied strategy to King George VI in his command caravan at 21st Army Group headquarters in the Netherlands, October 1944. 'Monty' was a controversial commander. To many of his peers, especially the Americans, he came across as arrogant and abrasive, convinced of his own abilities and scathing of others. But he was revered by the British public and the troops under his command. He made important changes to the original D-Day plan ensuring its success, but his reputation suffered after setbacks in Normandy and the failure of Operation 'Market Garden'.

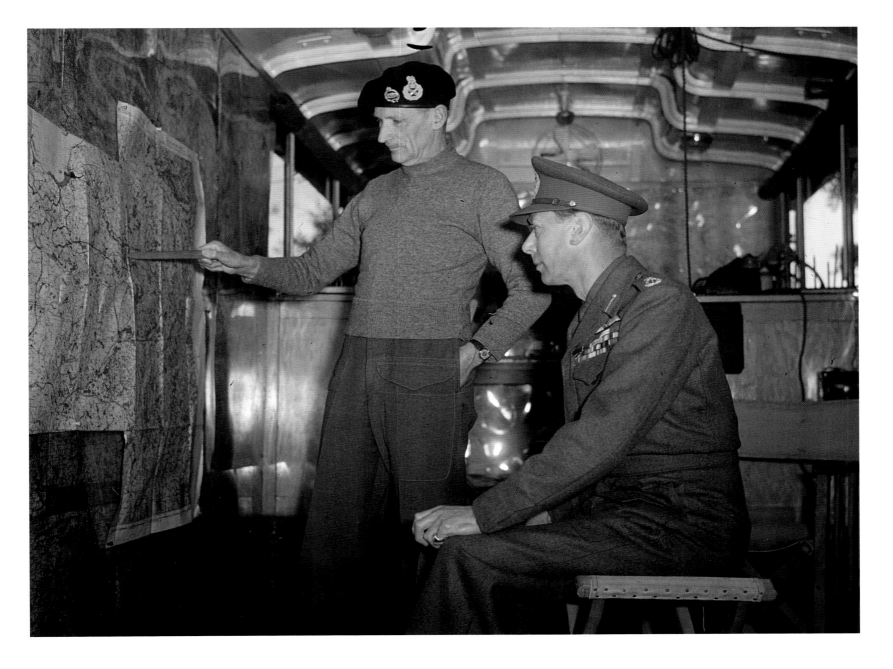

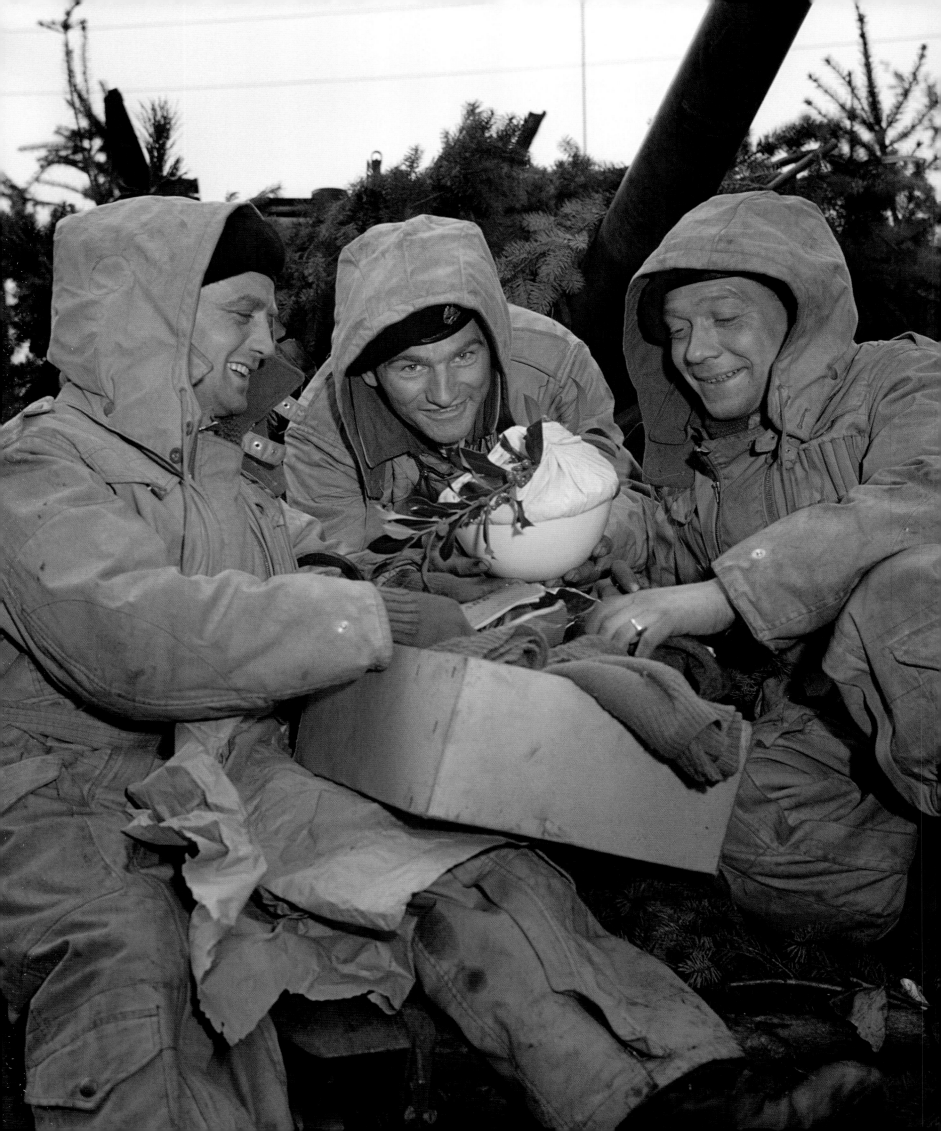

A Sherman tank crew of 44th Battalion, Royal Tank Regiment, 4th Armoured Brigade, unpack a Christmas food parcel near Weert in the Netherlands, November 1944. Troopers R Buckley (left), Joe Round and Sergeant H Kirk (right) were old hands, having seen action in North Africa and Italy with the Eighth Army. That winter there was little festive cheer for the Allied armies. The setback at Arnhem, and delays clearing the Scheldt estuary to open up the port of Antwerp, meant British, Canadian and American troops faced months of bitter fighting in harsh weather conditions as they closed up to the Rhine in preparation for the final push into Germany.

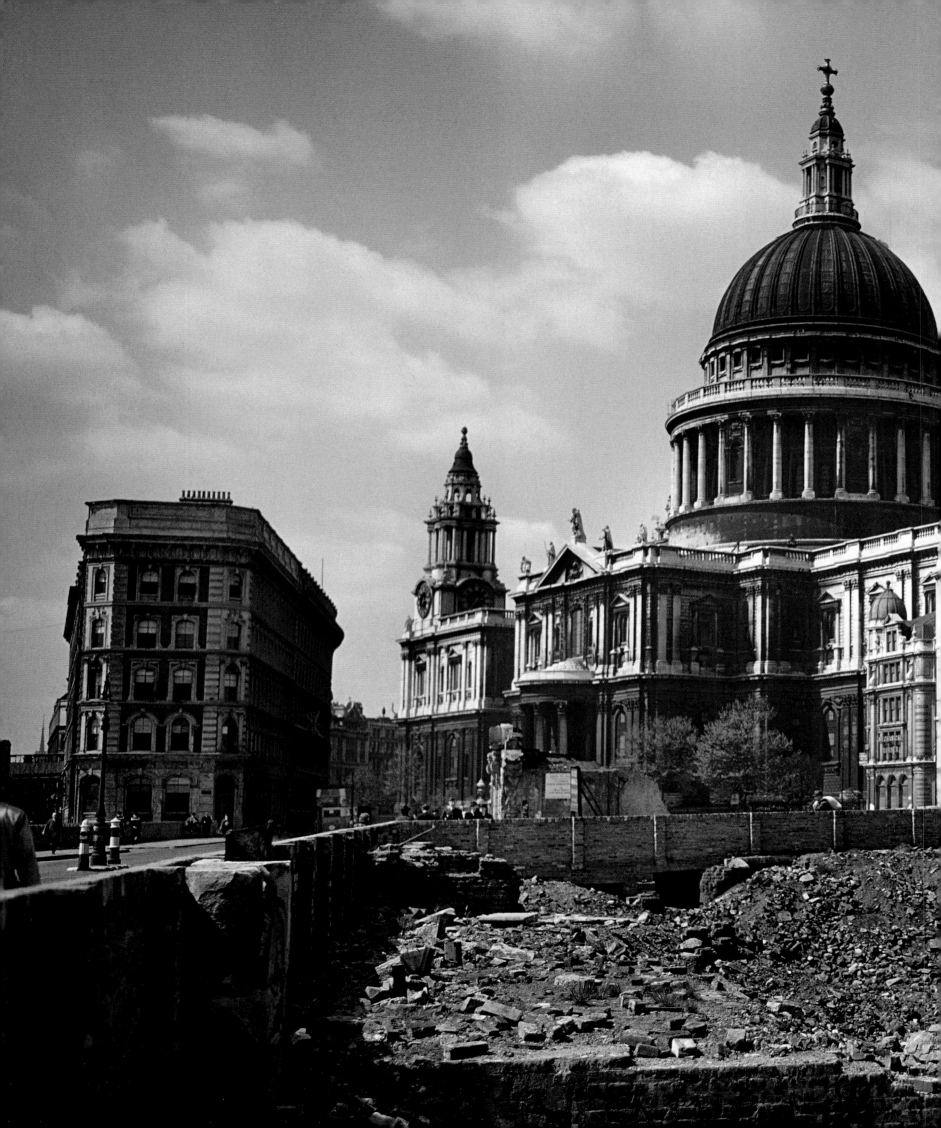

CHAPTER TWO

PEOPLE'S WAR

At the outbreak of war many people in Britain expected an immediate rain of death from the skies. Public shelters were prepared, children were evacuated and gas masks issued. Hospitals readied themselves for up to two million casualties. However, the projected mass Luftwaffe bombing raids did not occur. The country was spared the conflagration predicted during the interwar years. Instead, accidents and crime in the blackout posed the greatest threat to a population trying to resume their normal routines. This so-called 'Phoney War' lasted until the spring of 1940 when Hitler's conquest of Norway and France suddenly brought the war to a crisis point.

The British Army was evacuated from Dunkirk, and invasion seemed imminent. Over a million men not eligible for military service came forward to join the Local Defence Volunteers, later known as the Home Guard. Some in government contemplated making peace with Germany. The key opponent of this position was Winston Churchill, who was summoned to be Prime Minister after the fall of Neville Chamberlain. Churchill, now head of a coalition government, could offer only 'blood, toil, tears and sweat'. But his resolute will to resist Hitler and fight on inspired the nation. That summer the RAF won the Battle of Britain in the skies over southern England and Hitler shelved his plans to invade. The German plan was now to inflict decisive economic damage and undermine British morale with a bombing campaign against major ports and cities.

Britain was to suffer years of aerial bombing but its impact, though locally devastating on occasions, would be less catastrophic than previously feared. The Home Front became a battlefield, where men and women fought in civil defence – as air raid wardens, ambulance drivers, firefighters and rescue workers. In all 2,379 of them were killed. The most sustained period of aerial attacks was known as the 'Blitz', the period between September 1940 and May 1941 when the Luftwaffe concentrated on London, but also mounted major raids on other cities throughout Britain. The centre of Coventry was destroyed in one night in November 1940 and 568 people were killed. There were further periods of bombing later in the war as Hitler demanded retaliation for RAF bombing raids, but these attacks were smaller in scale, and prohibitively costly for the Luftwaffe. In 1944,

the V-weapon campaign saw pilotless V-1 flying bombs and V-2 rockets launched at London. The morale of a war-weary population was affected by the random nature of these so-called 'vengeance weapons', but the attacks ultimately proved futile. In 5 of years of bombing, a total of 60,595 civilians were killed.

Britain's pivotal battle for survival was fought in the Atlantic. Germany's U-boat campaign against merchant shipping, which began at the very start of the war, aimed to cut the country's imports of food, fuel and raw materials. The impact on the civilian population was profound. Food rationing was introduced at the start of 1940, and became more draconian as the war continued. While few would starve, the monotony of a restricted diet, shortages of popular items and the inevitable queues outside shops were trials to be endured. Agriculture was put on a war footing, and large areas of hitherto unproductive land brought into cultivation. Allotments and gardens great and small were turned over to vegetables as the government urged the nation to 'Dig for Victory'. Non-food items became scarce as well. The production of kitchen utensils and crockery, books, toys, cosmetics and a host of other household items was scaled back or halted altogether. Clothes were rationed too — 'Make Do and Mend' became another national slogan.

From the outset, British industry was mobilized for Total War and the Emergency Powers Act brought all aspects of the nation's economy under tight government control. The most critical issue was a shortage of skilled manpower. From 1941 workers were required to register for war work, and those engaged in the most vital industries were forbidden to leave their jobs. However, strikes and other industrial disputes resulted in the loss of millions of days of vital productivity. By 1944, a third of the population was employed in munitions, ship-building, aircraft production, transport and agriculture. This workforce included millions of women, who were encouraged to 'do their bit' for the war effort. Many of them struggled to balance work with running a home, others were discriminated against by employers or trades unions keen to preserve men's jobs. But as the war dragged on, the role of women became increasingly important. Only the coal mines remained an entirely male preserve, where labour shortages forced the conscription of miners in 1943 — the so-called 'Bevin Boys'.

In December 1941, Britain became the first country in the world to introduce female conscription. Single women aged between 20 and 30 could be called up and offered a choice between the armed forces, civil defence or war work — usually munitions. The military represented an exciting opportunity, and those conscripted were joined by a far greater number of women who volunteered. Most went into the Army's Auxiliary Territorial Service (ATS). Others chose the Women's Auxiliary Air Force (WAAF) or Women's Royal Naval Service (WRNS). By 1943, almost half a million women were in uniform. Some were posted overseas but the majority were based in the UK where they took on many of the technical roles previously filled by men. Many members of the ATS served at the sharp end, manning searchlight batteries and anti-aircraft gun sites.

The Allied invasion of Normandy in June 1944 brought hopes for victory that year, but fanatical German resistance meant the war would drag on into 1945. The privations of wartime Britain continued, but plans for post-war reconstruction and social reform were already at an advanced stage. In May 1945 the population of Britain celebrated victory in Europe, and a general election saw the Labour Party sweep into power. Churchill, the great war leader, was not the man to lead the peace. The election result reflected a mood among many that nothing should be the same again. Britain's war effort had seen vast sacrifices, upheavals and social changes. The people now looked towards their new government to use its wide-ranging powers of intervention to create what many hoped would be a fairer society for all.

(Page 60)
St Paul's Cathedral photographed from the remains of Cannon Street in 1944.
Sir Christopher Wren's masterpiece became a symbol of resistance for Londoners during the war. The building's almost miraculous survival was down to the heroic efforts of army bomb disposal teams and a well-organised group of fire-watchers — incendiaries lodging themselves in the roof timbers of the dome were a particular threat. In September 1940 a large delayed-action bomb was successfully defused and removed. The Cathedral was hit by bombs on two further occasions, causing significant damage.

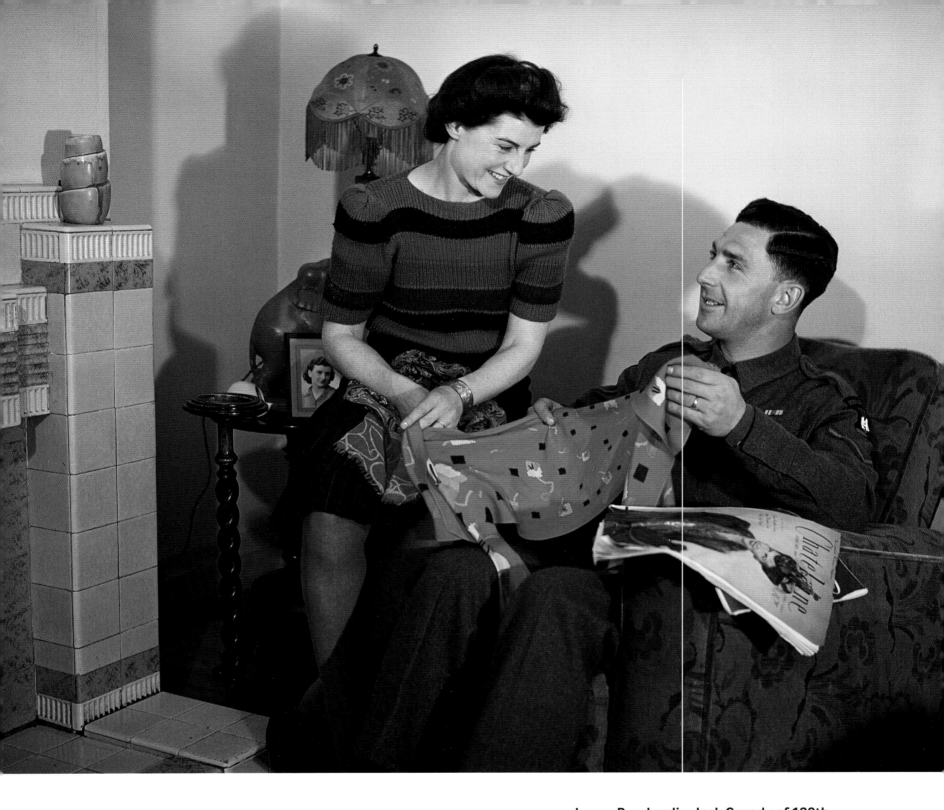

Lance Bombardier Jack Grundy of 128th Field Regiment, Royal Artillery, with his wife Dorothy while on leave at the family home in Irby, Cheshire, April 1944. The couple, and their children Randall and Gilda, featured in a Ministry of Information photo story, which followed Jack's period of seven days leave. Jack, aged 37, had been in the army for two and a half years, and had already seen service in North Africa and Sicily. His unit was part of 50th Division, which would go ashore on 'Gold' Beach on D-Day, 6 June 1944.

An Air Raid Precautions (ARP) warden in Holborn, London, 1944. He wears the blue serge uniform first issued in April 1941. The ARP, later renamed the Civil Defence Service, was set up before the war in response to the threat of aerial bombing. The wardens' job of enforcing the blackout and checking on the living arrangements of people on their patch sometimes made them unpopular – but if a house was reduced to rubble it was vital to know who might be trapped inside. Most wardens were volunteers, with regular daytime jobs. One in six were women. During raids the wardens ensured people took shelter, reported on the severity of bombing 'incidents' and co-ordinated the work of stretcher parties and rescue teams.

(Next spread)

An Army exhibition on the site of the John Lewis department store in Oxford Street, London, 1943. The building had been reduced to a blackened shell during a heavy Luftwaffe raid on London on the night of 17–18 September 1940. Several other prestigious shops and department stores in London's West End were also destroyed or badly damaged that night. The area was cleared and used throughout the war for popular public exhibitions, including this one which showed off weapons and military equipment used by the British Army. The store was rebuilt in the late 1950s.

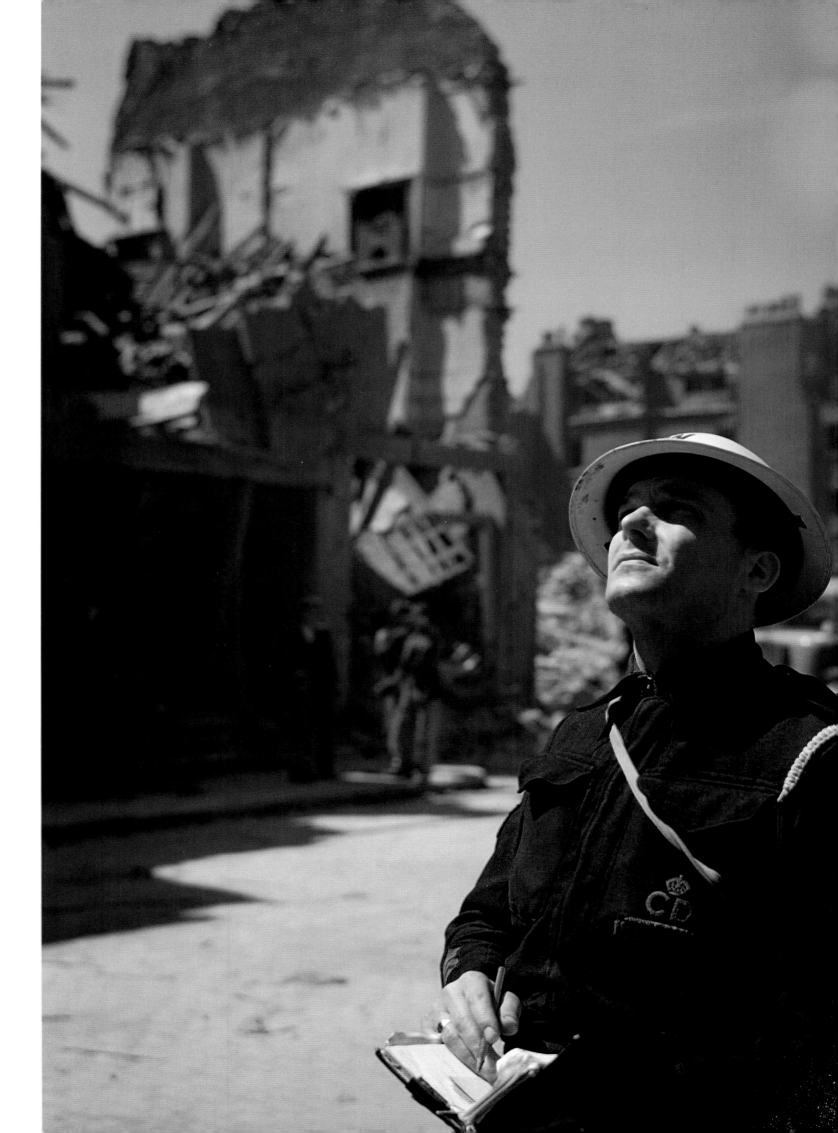

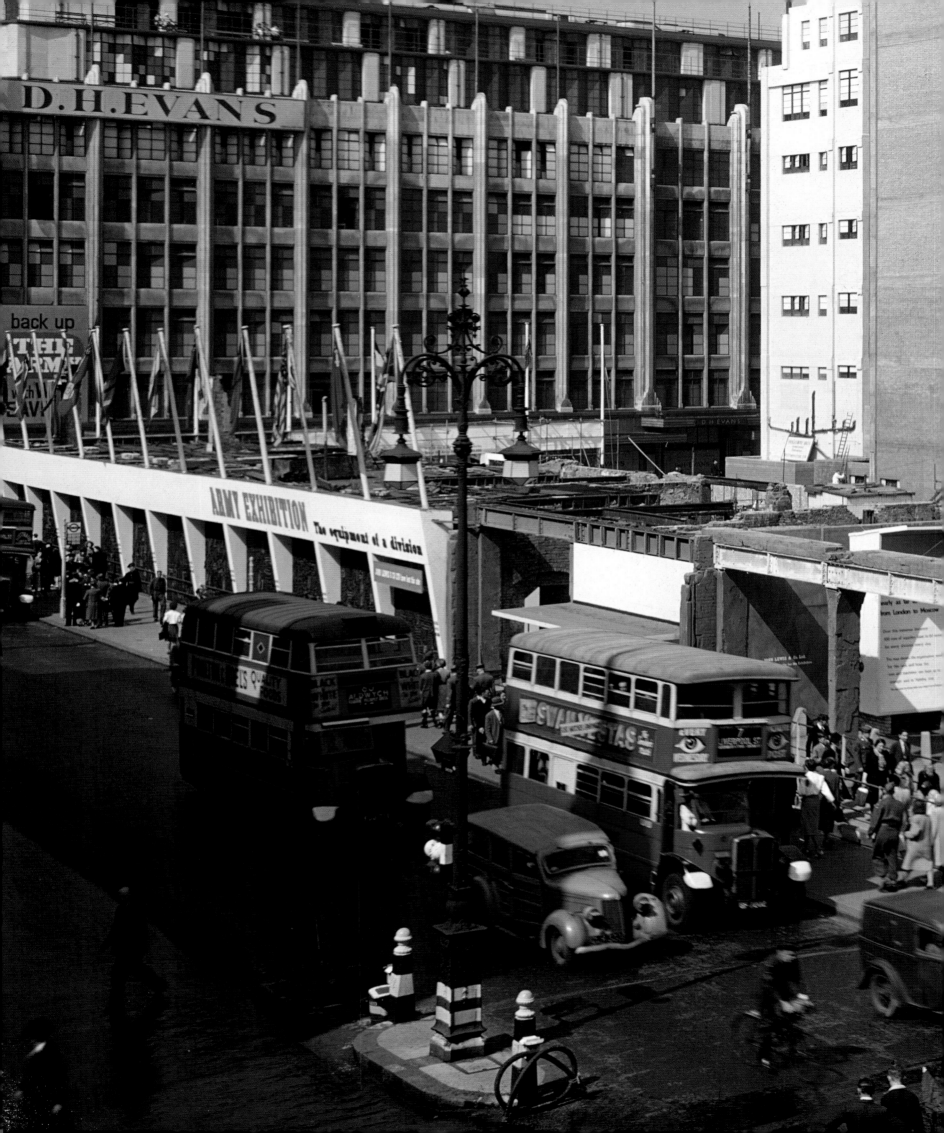

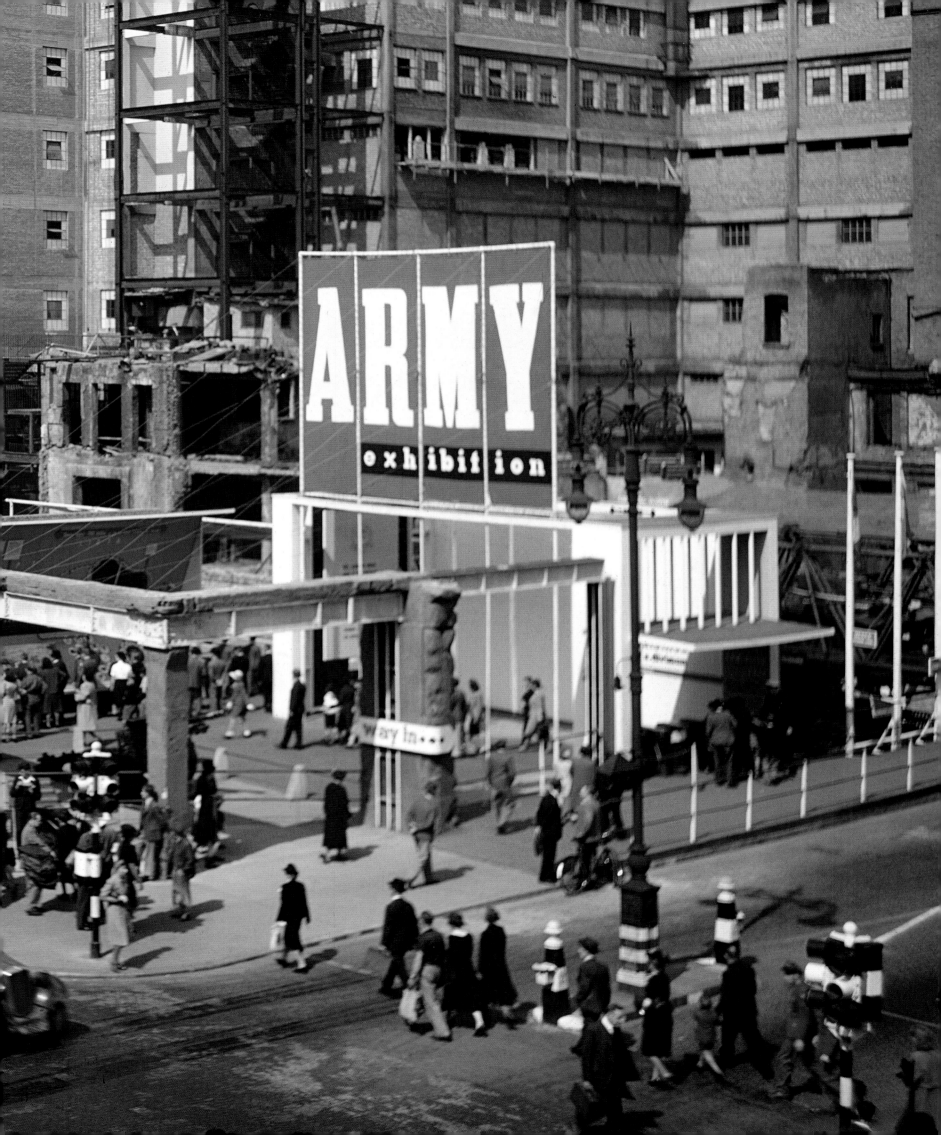

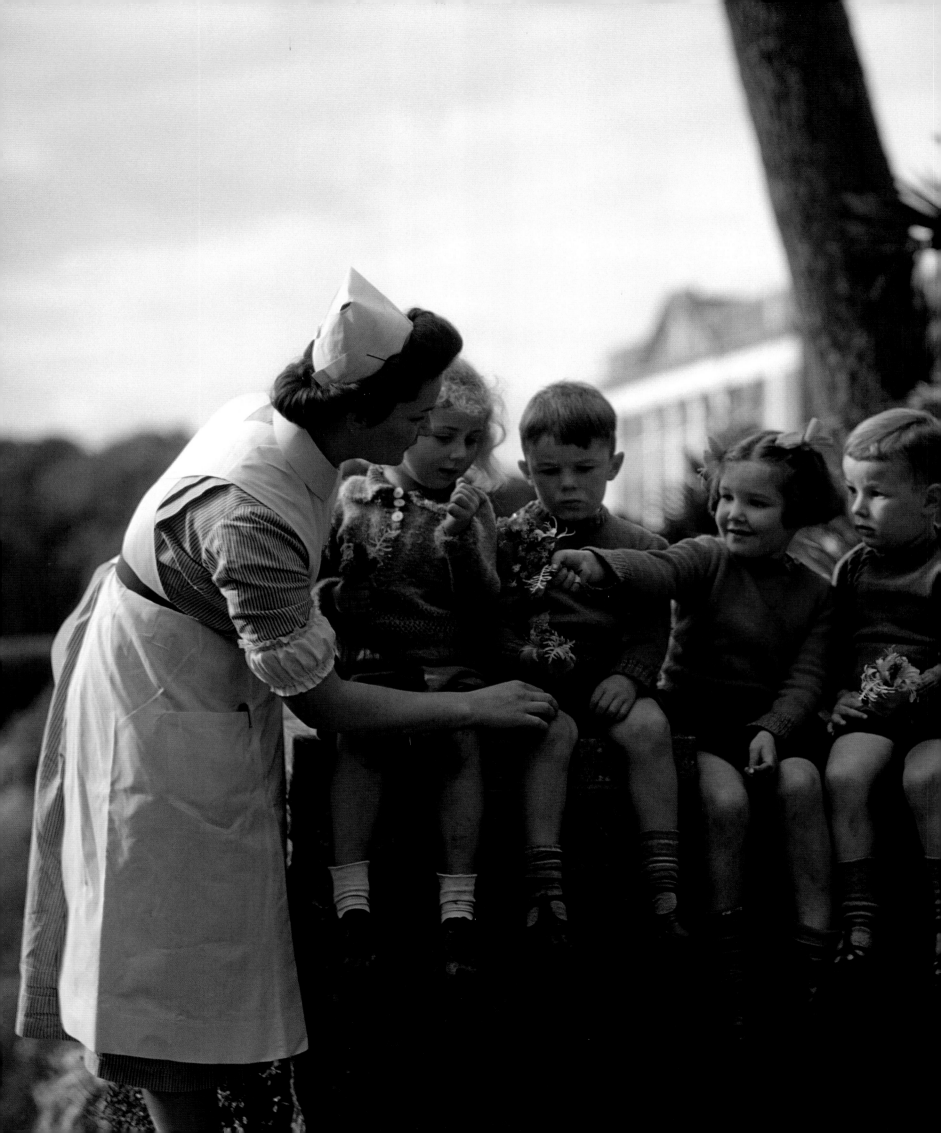

A nurse with young child evacuees in the gardens of Tapeley Park, at Instow in North Devon, October 1942. The country house was used to accommodate 50 children evacuated from Plymouth after a series of Luftwaffe bombing attacks in March and April 1941. The port and naval docks at Devonport were the principal target, and were heavily damaged, but the city itself was devastated in one of the worst episodes of the Blitz. There were 932 people killed, and some 40,000 made homeless. In all, Plymouth suffered 59 separate bombing raids between 1940 and 1944, and a total of 1,172 civilians died.

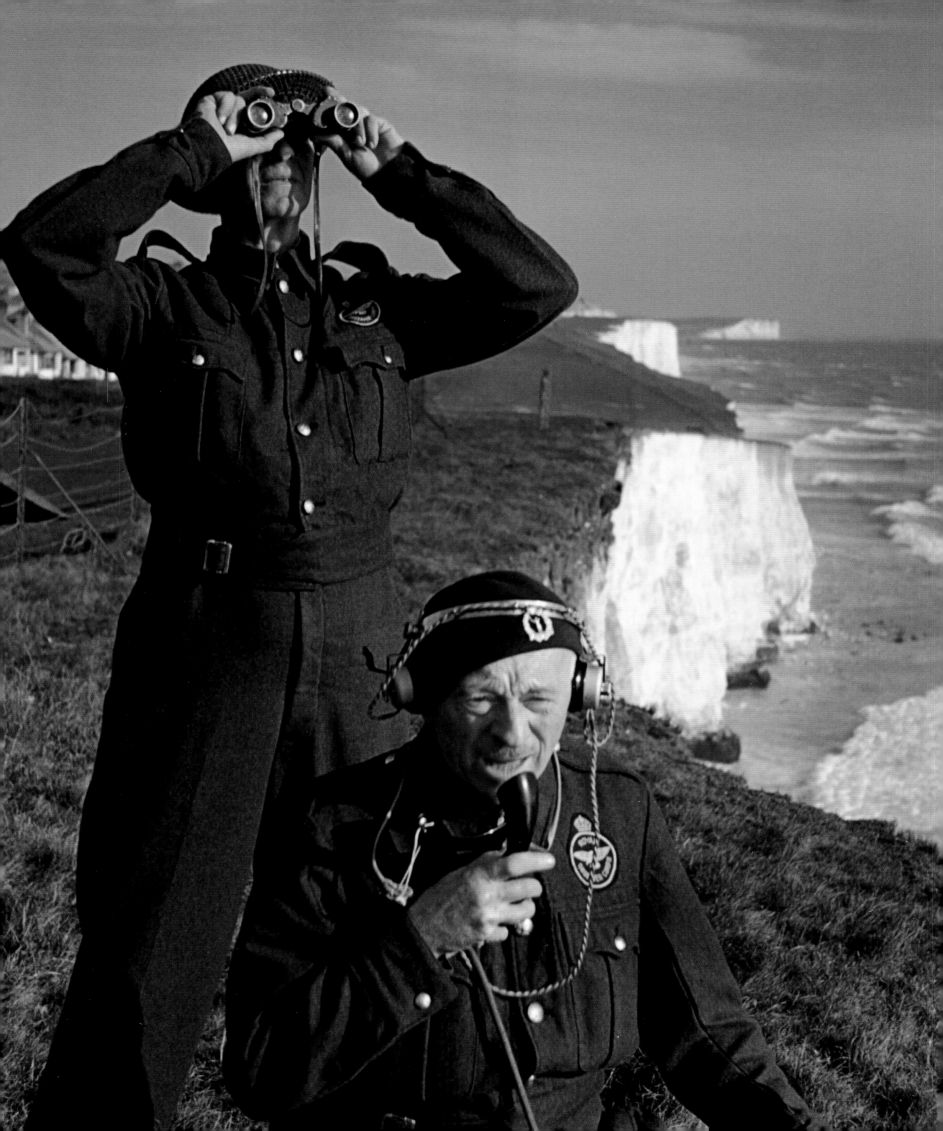

Men of the Royal Observer Corps at a cliff top post on the south coast, 1943. Founded before the war, the Observer Corps was staffed by civilian volunteers whose task was to report the height, direction and number of enemy aircraft after they'd crossed the coast and were beyond RAF radar. The 'Royal' title was conferred in April 1941 in recognition of the valuable role the organisation played during the Battle of Britain, and its members were also issued new uniforms and insignia. By 1944 there were 1,500 two-man observer posts scattered around the country, each linked to a local control centre which relayed information to RAF and civil defence headquarters.

(Next spread)
Eighteen year old Eileen Oats, in the red head scarf, fires a 3-inch mortar at an army test range in Cornwall, 1943. She and the other women present were all workers from J & F Pool Ltd, a small engineering company in Hayle, now making munitions. As a reward for producing their one millionth mortar bomb, the Ministry of Supply treated the women to a day out to see the weapons in action. By 1943, 7.5 million women between the ages of 19 and 50 were engaged in factory work, representing over 40 per cent of the work force.

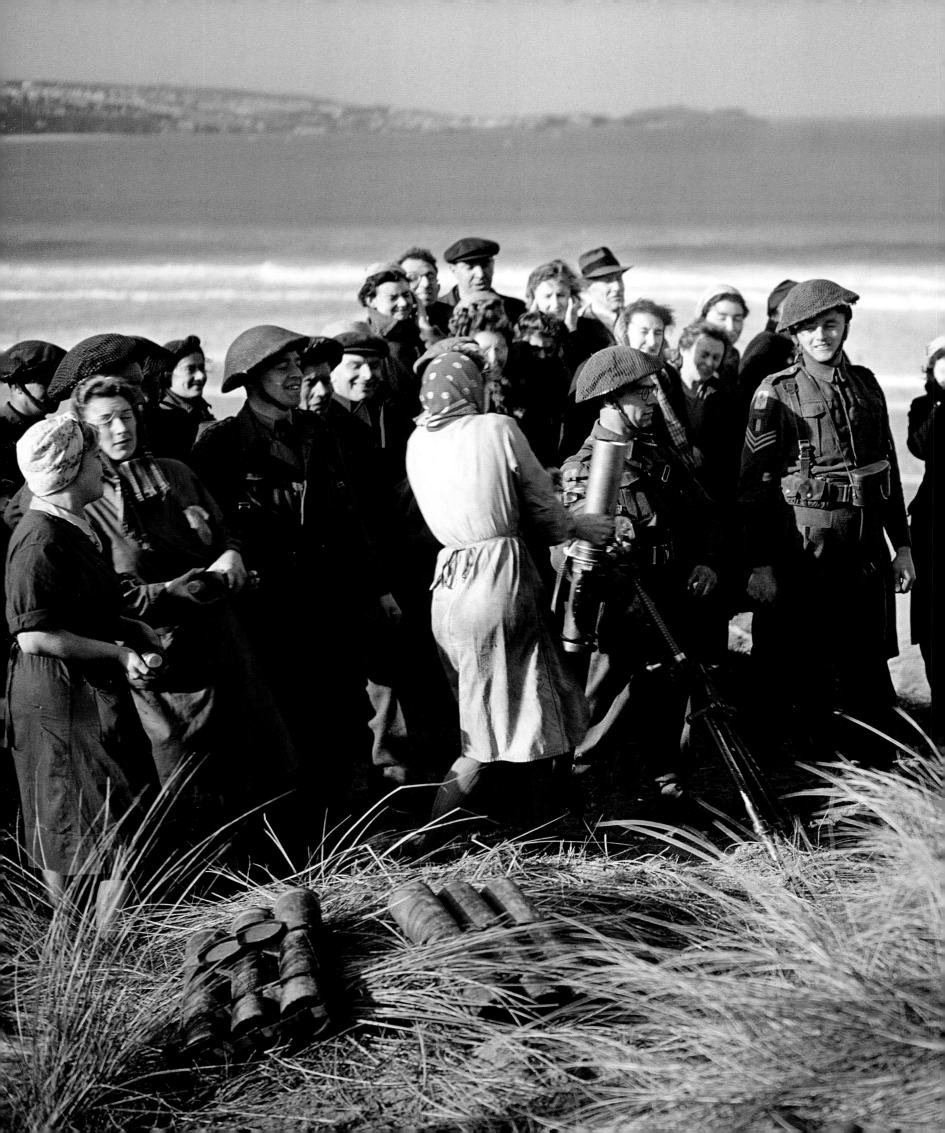

An ATS 'spotter' at a 3.7-inch anti-aircraft gun site, December 1942. On her shoulder can be seen the badge of the 1st Anti-Aircraft Division, which controlled the searchlight and gun batteries defending London. The ATS was established in September 1938, to allow women volunteers to serve in non-combatant roles in the Territorial Army (and initially, the RAF too). As the war progressed conscription was introduced, and duties expanded to include more than 80 trades, some highly specialised and technical. The ATS reached a peak strength of 210,308 officers and other ranks in June 1943.

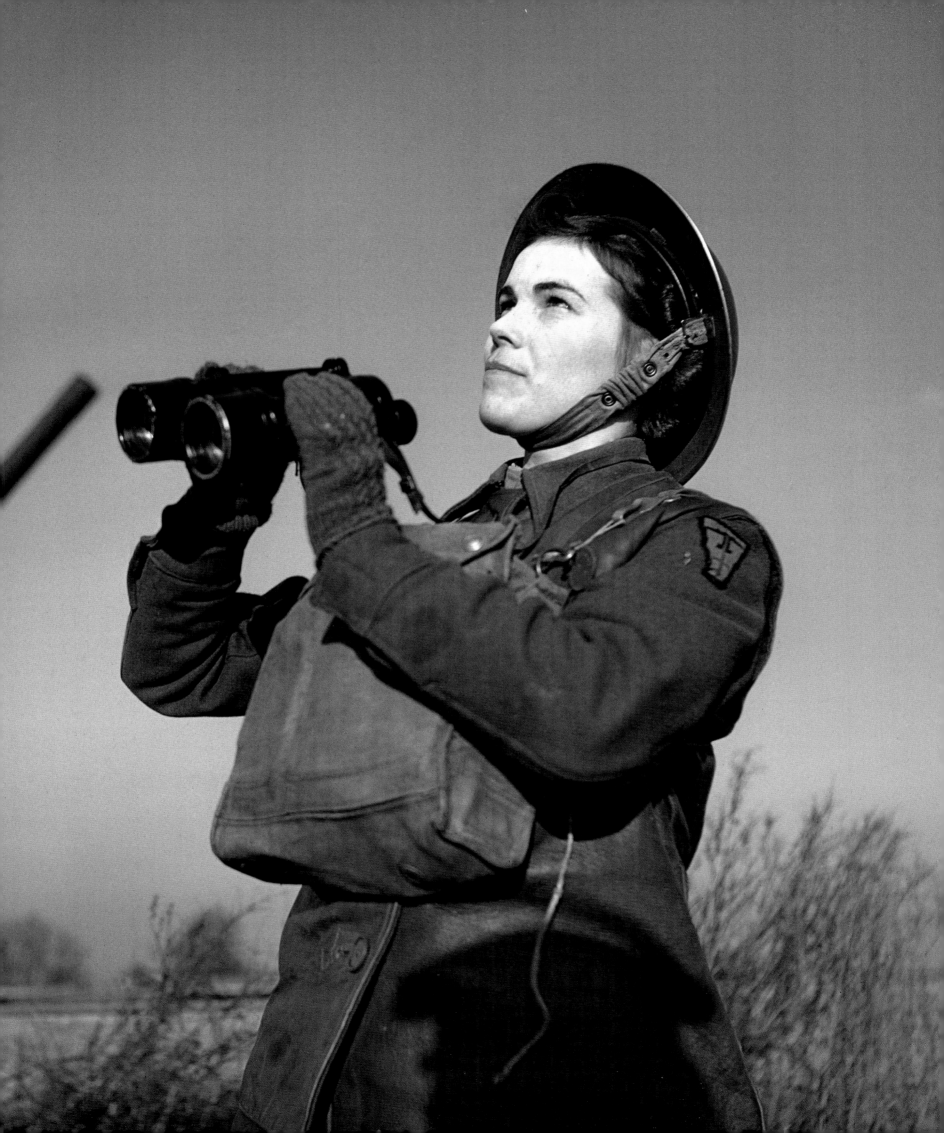

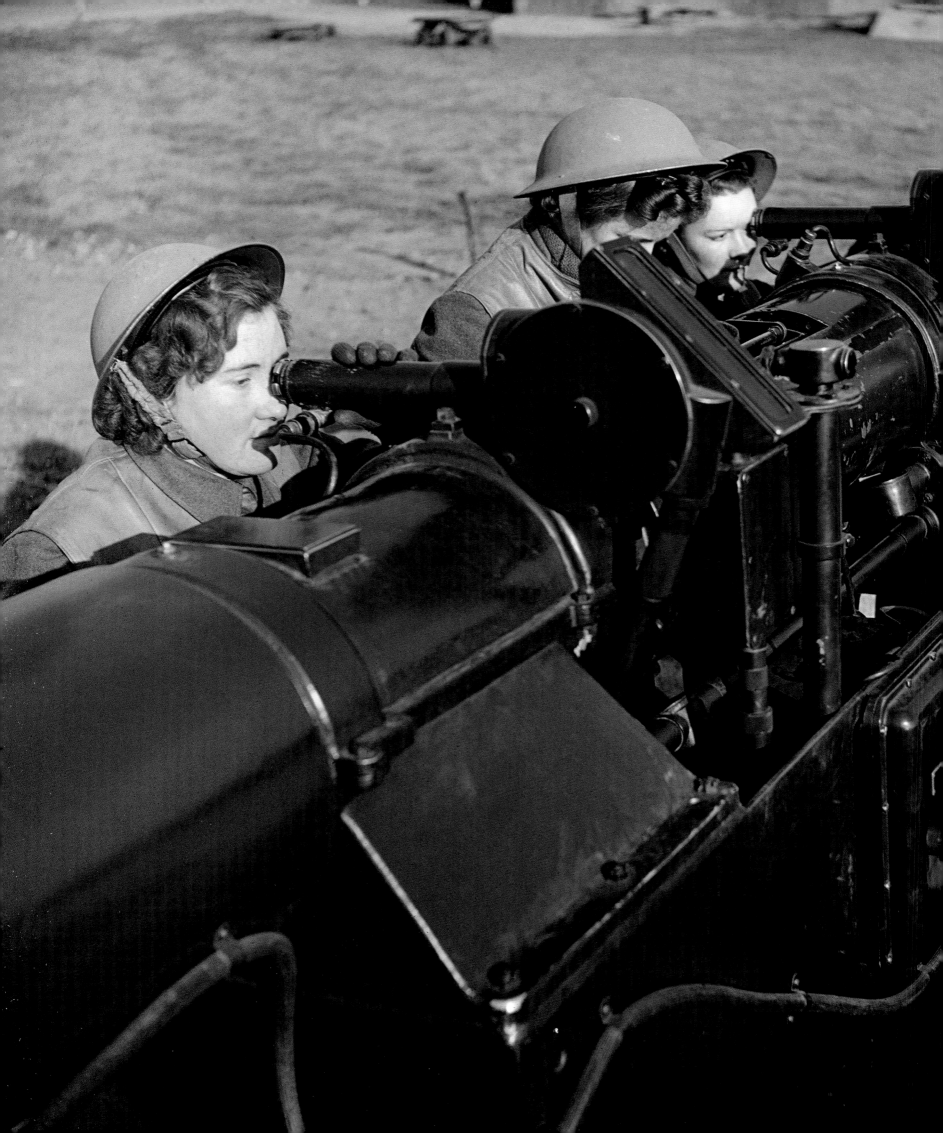

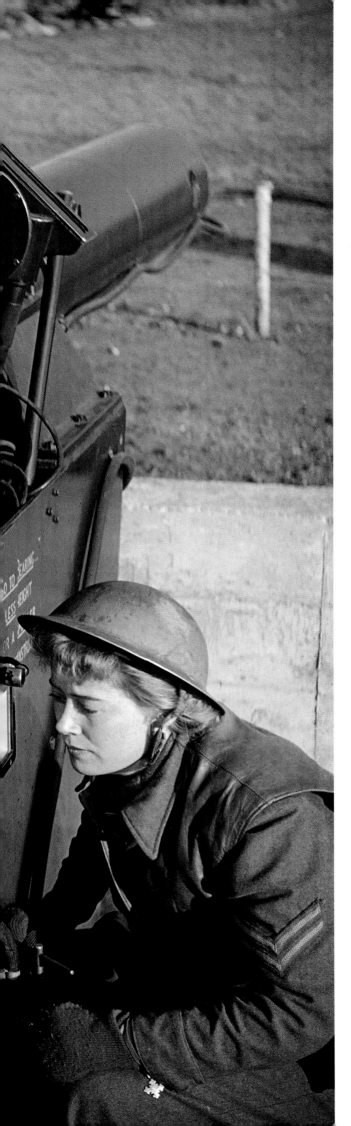

ATS women operating a height and range finder. Mixed-sex gun batteries were introduced throughout Anti-Aircraft Command in 1941 to help resolve a major shortage of manpower, although technically the women were not actually allowed to fire the guns. By September 1943 over 50,000 women were serving in this role, and proving far more effective than the doubters had predicted. Some searchlight batteries were staffed entirely by ATS personnel. Mixed heavy anti-aircraft regiments also served in north-west Europe after D-Day to bolster the defences against German V-1 flying bombs.

ATS plotters working at the headquarters of a Royal Artillery coastal battery, Dover, December 1942. The onset of war brought a massive increase in the number of coastal defence batteries, some using stocks of old naval guns of various calibres brought out of storage. Once the threat of invasion had passed, the main task of coastal artillery was to engage enemy shipping. Several new batteries of heavy guns with sophisticated radar fire control systems were installed around Dover for this purpose. Plotting the range and bearing for these guns was just one of the specialised roles now being carried out by the ATS.

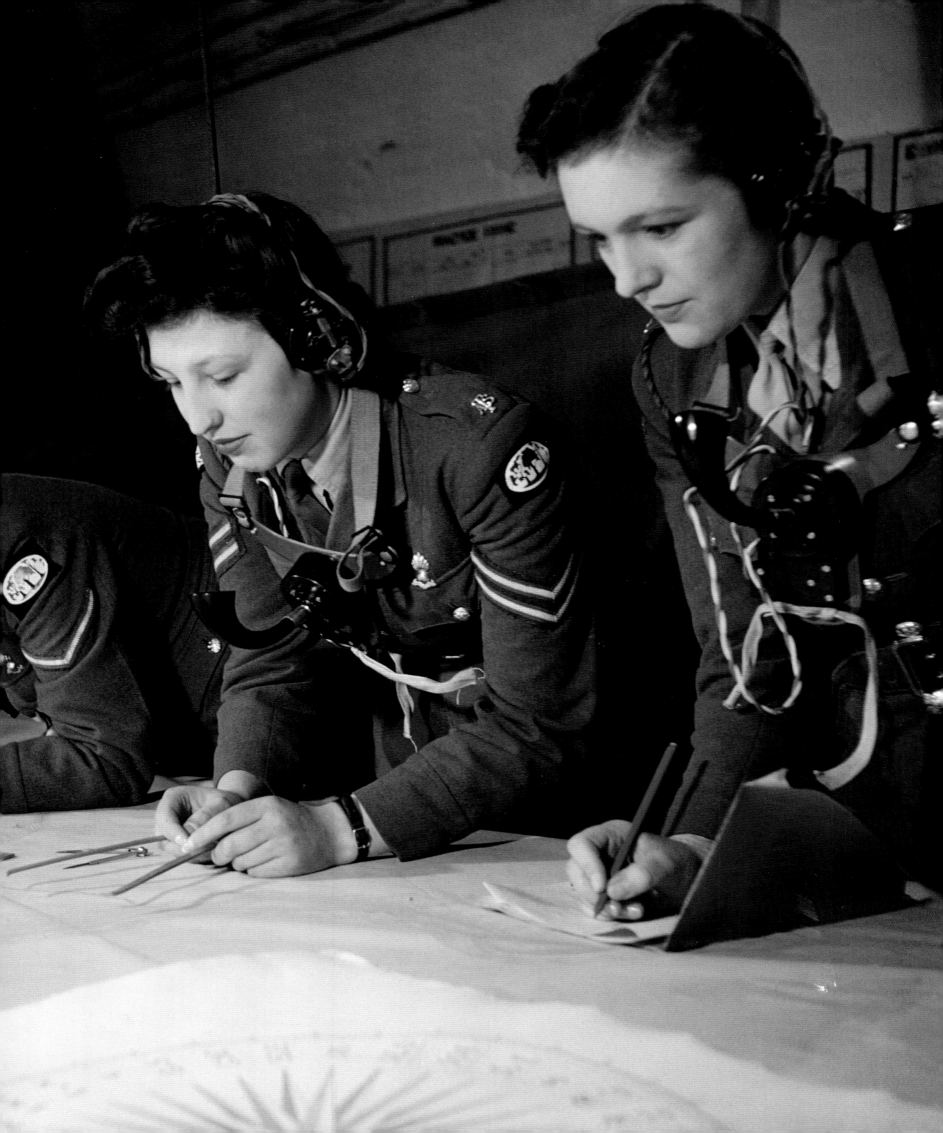

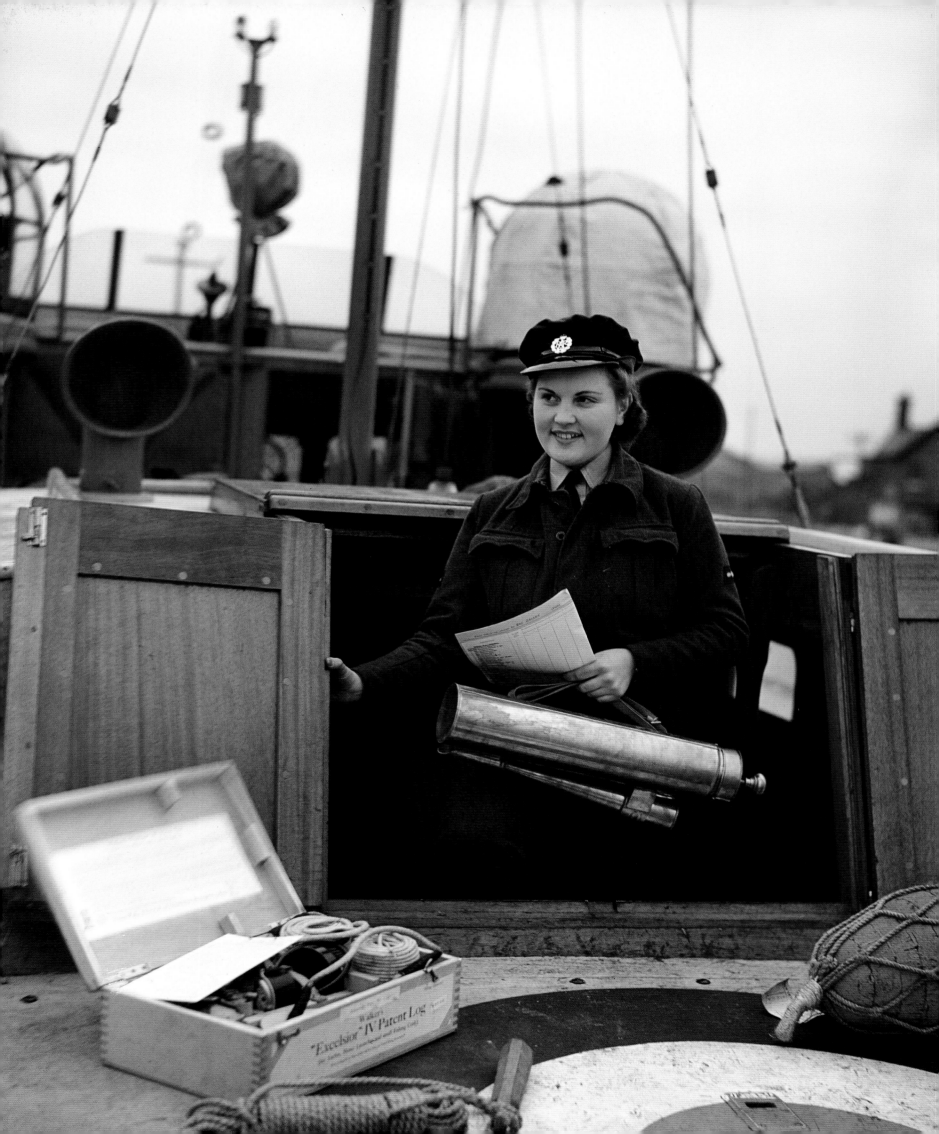

A member of the WAAF checks equipment aboard an RAF Air Sea Rescue launch, in November 1942. In her hand is a brass fire extinguisher, while in front is a 'Walker's Excelsior IV Patent Log', a nautical instrument used to measure speed and distance travelled, and a plumb line. The WAAF was created in June 1939, and initially comprised women transferred from the RAF companies of the ATS. The first conscripts were called up in April 1942. By the end of the war there were 182,000 WAAFs — a fifth of the RAF's strength in Britain.

WAAFs sewing parachute canopies which will be used by British airborne forces during the Allied invasion of Europe, May 1944. As the war progressed, the role of women in the Royal Air Force expanded far beyond the more traditional clerical and catering duties. They served as radar plotters, barrage balloon operators and meteorological officers. They examined aerial reconnaissance photographs for enemy activity and interrogated aircrews on their return from bombing operations. Operational flying was prohibited, but some WAAF nurses served on ambulance transport aircraft.

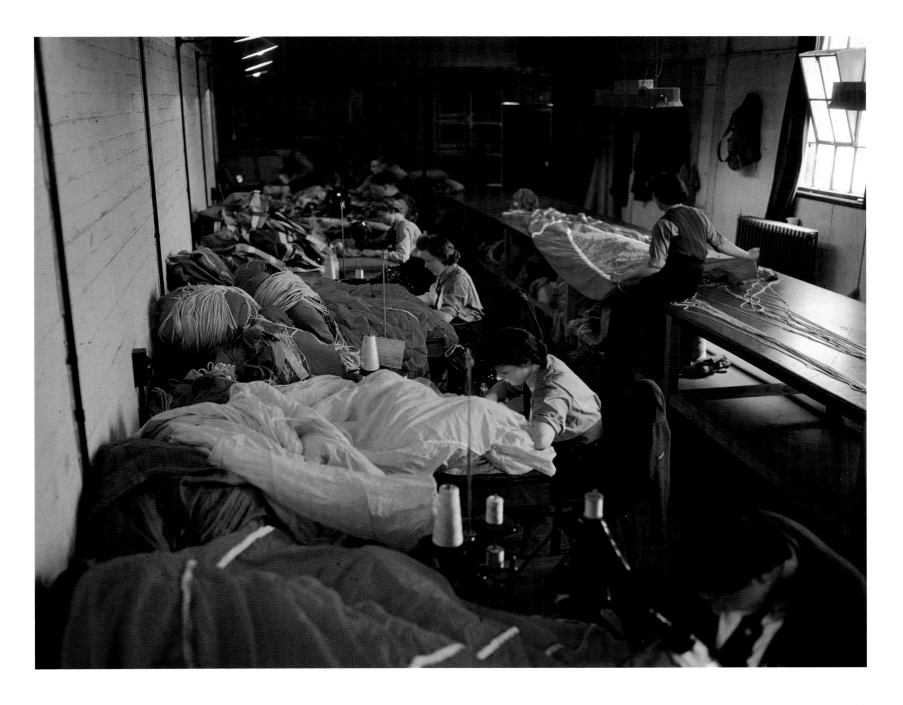

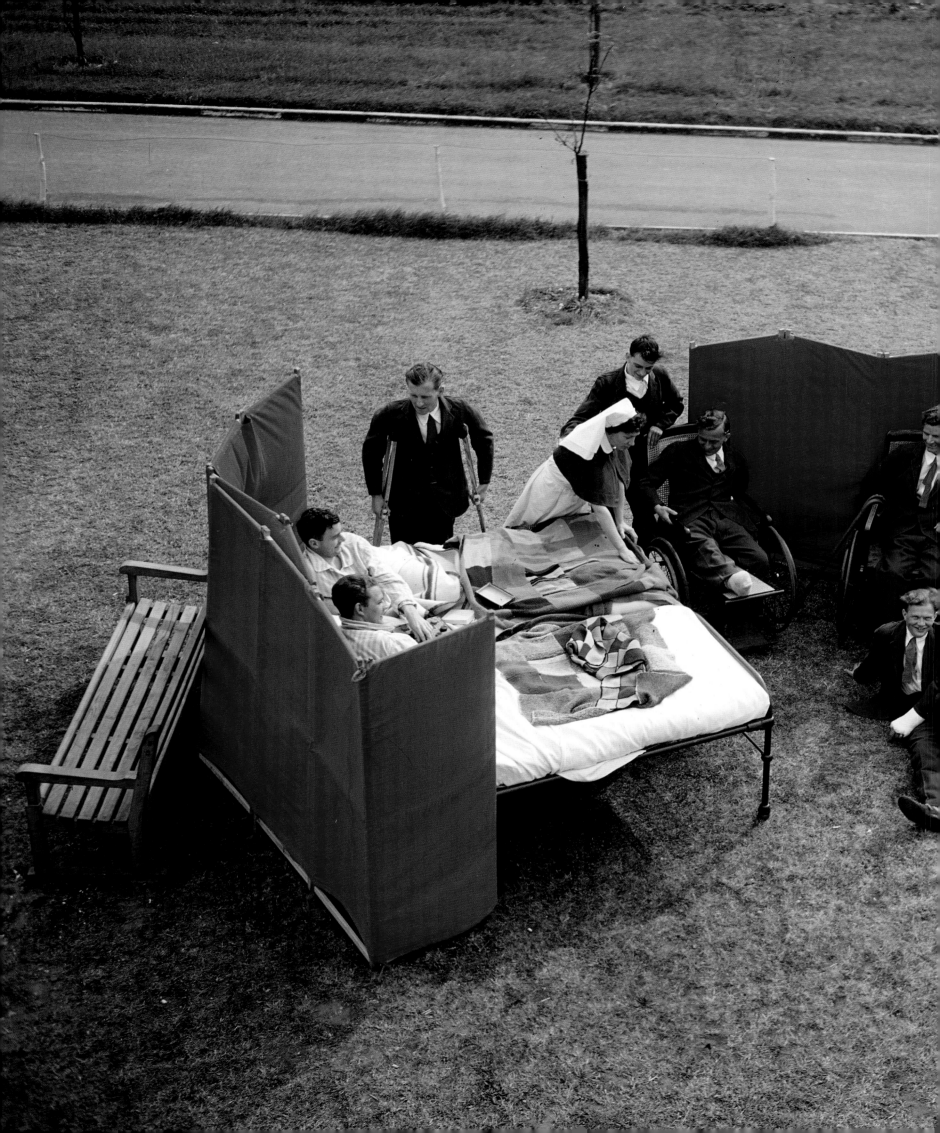

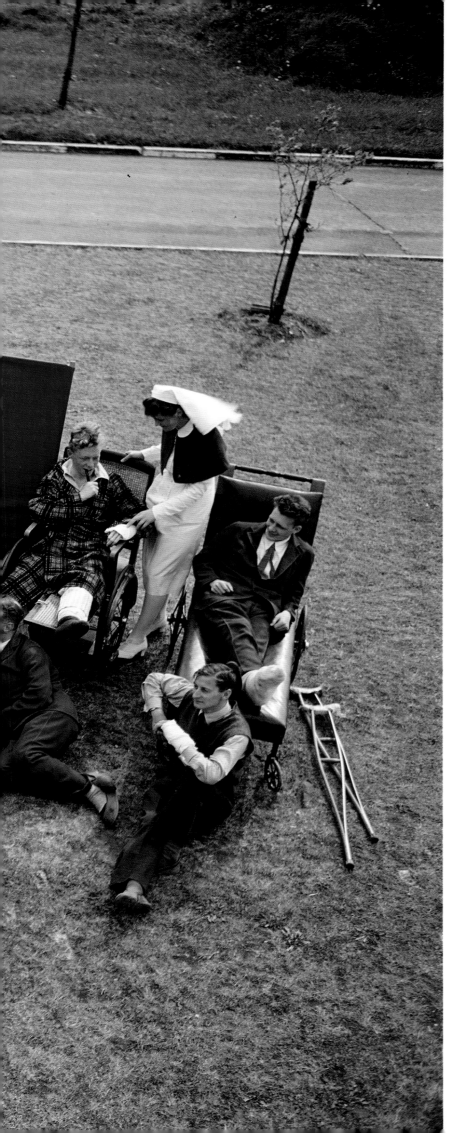

Members of the Princess Mary's Royal Air Force Nursing Service with convalescent aircrew at RAF Hospital Halton, Buckinghamshire, August 1943. Most of the men are wearing their 'hospital blues' — the uniform worn by wounded servicemen from the Crimean War to the 1960s. Halton opened in 1927, and treated some 20,000 RAF casualties during the Second World War. The RAF's nursing service was established in 1918, and received official patronage — and the royal prefix — from Princess Mary, daughter of King George V, in 1923. It was a women-only organisation at the time, with nurses serving in RAF hospitals and station sick quarters in Britain and overseas.

'Wrens' (members of the Women's Royal Naval Service) loading the Browning .303-inch machine guns of a Hawker Sea Hurricane Mk IB at RNAS (Royal Naval Air Station) Yeovilton, Somerset, September 1943. By 1944, 75,000 women were serving in the Royal Navy at bases in the UK and overseas, freeing up men for active service. Although a few served as boat crews on tugs and harbour launches, they were not allowed to go to sea. Instead, they performed a range of shore-based roles, many of them of a technical nature such as ship repair, aircraft maintenance and radio communications.

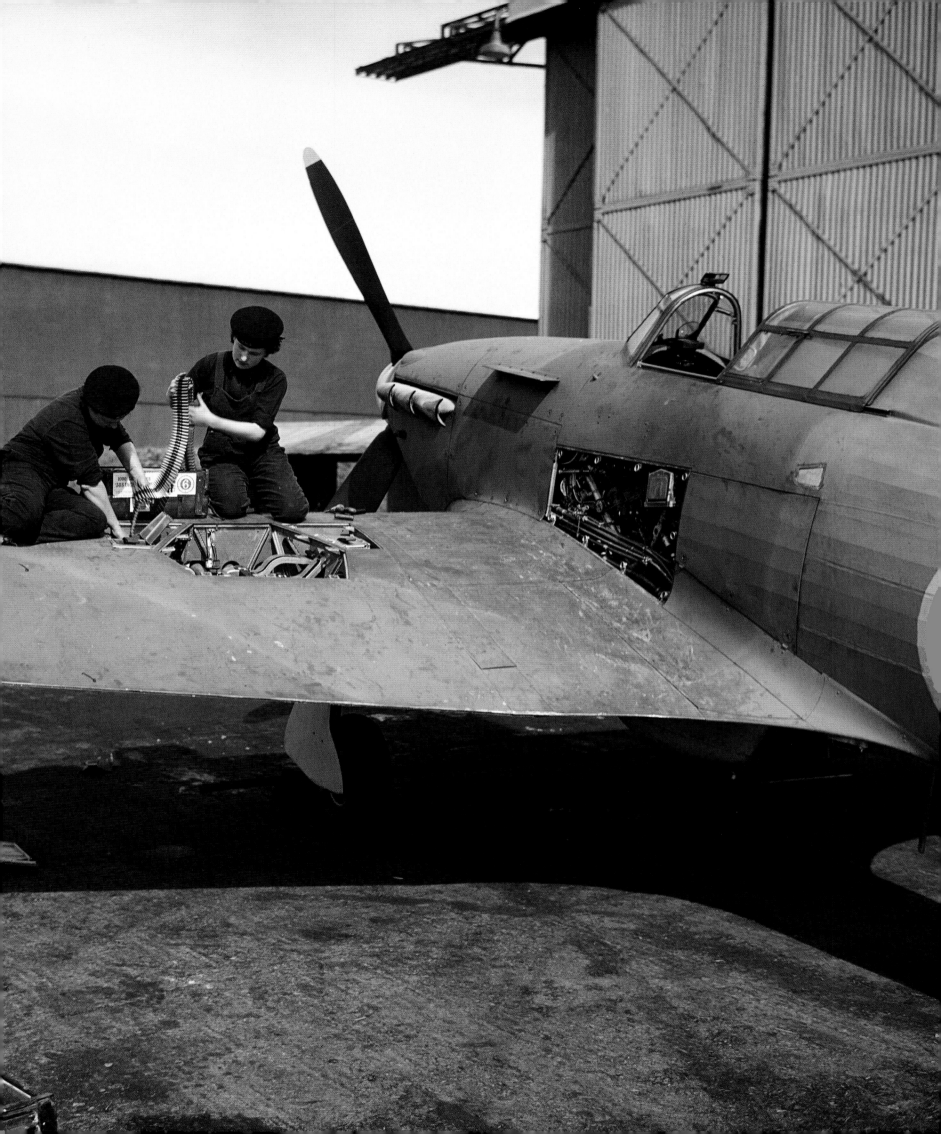

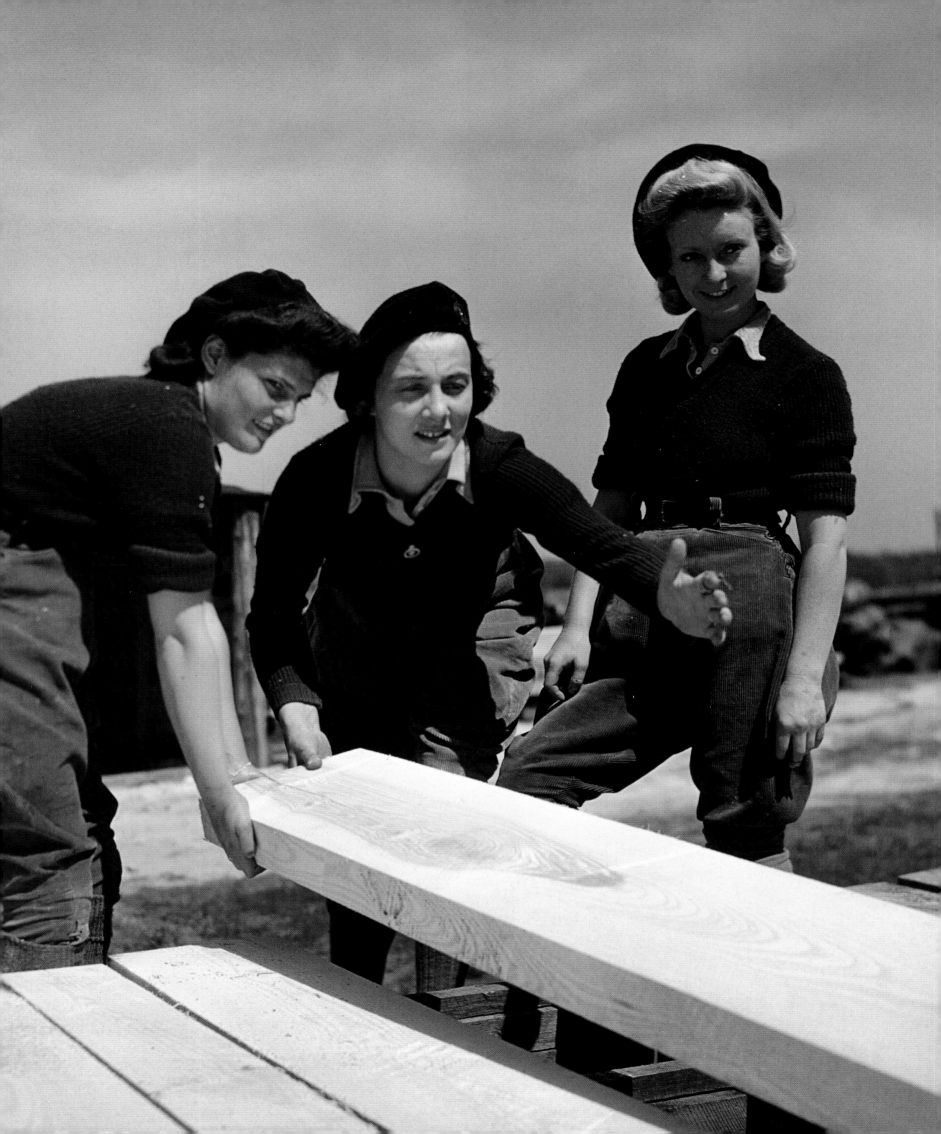

'Lumber Jills' working at the Women's Timber Corps training camp at Culford, near Bury St Edmunds in Suffolk, 1943. Here, instructor Peggy Barnett guides two of her trainees. The Women's Timber Corps was part of the larger Women's Land Army, and was set up in April 1942 in response to a shortage of imported timber for items such as pit props and telegraph poles. Duties included felling, crosscutting and sawmill work. The Women's Land Army itself was reestablished in 1939 to help replace those farm labourers called up for military service.

(Next spread)
Two steam paddle tugs at work among the hulls of newly launched cargo ships on the River Wear in Sunderland, 1943. Despite labour problems, British yards produced seven million tons of merchant shipping during the war, helping to replace the savage losses inflicted by the U-boats. In November 1942 alone, the worst month of the war for sinkings, 117 merchant ships (700,000 tonnes) were lost. Ships could not be built fast enough, however, and Britain was compelled to order vessels from the United States, where President Roosevelt, anticipating the threat to Britain's survival and his own country's future needs, had launched a massive emergency shipbuilding program.

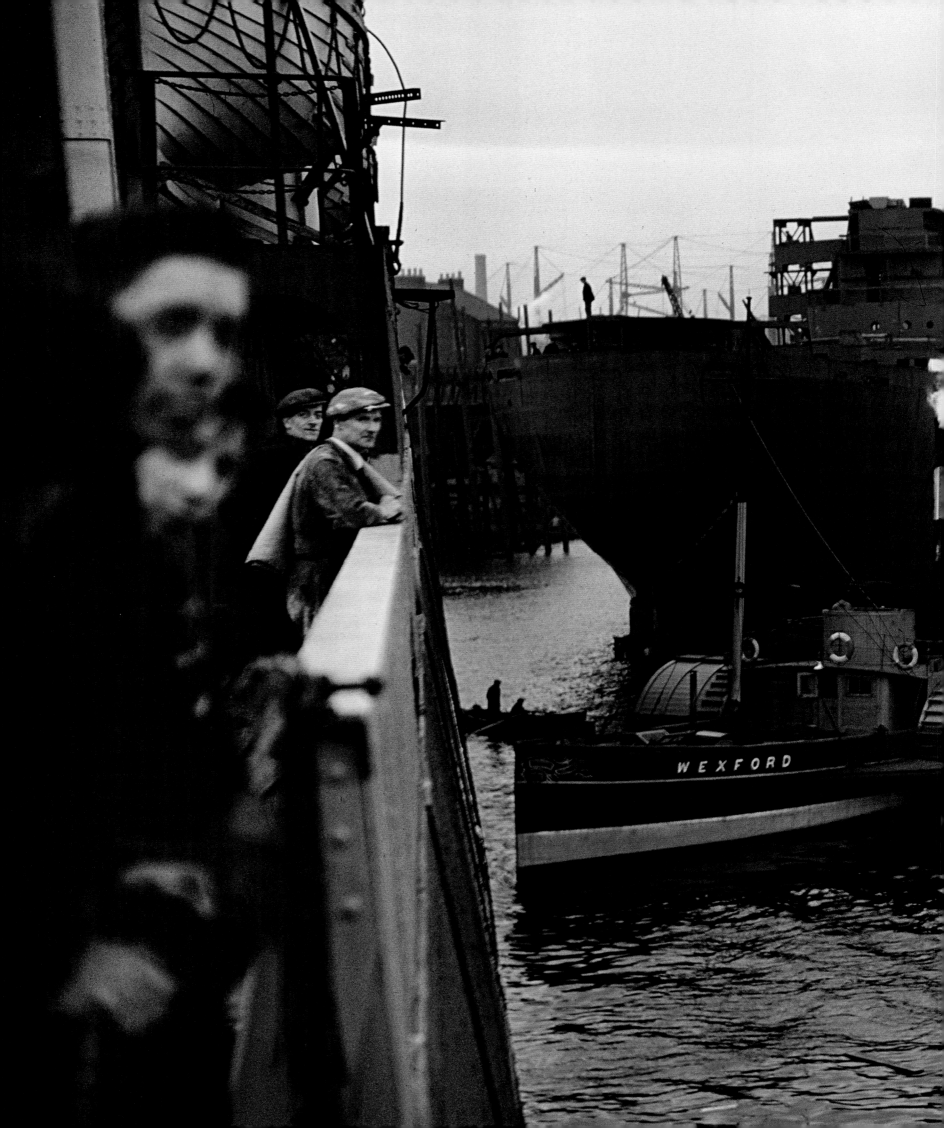

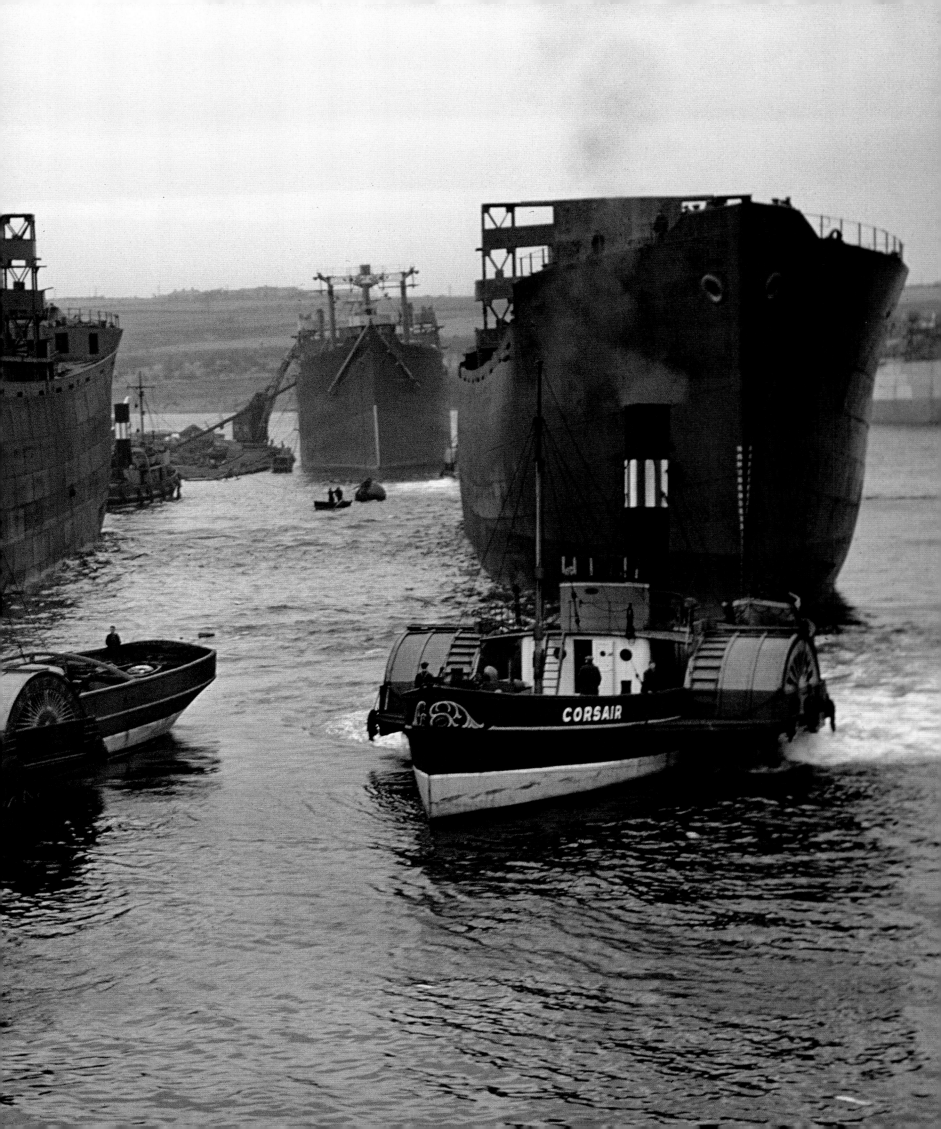

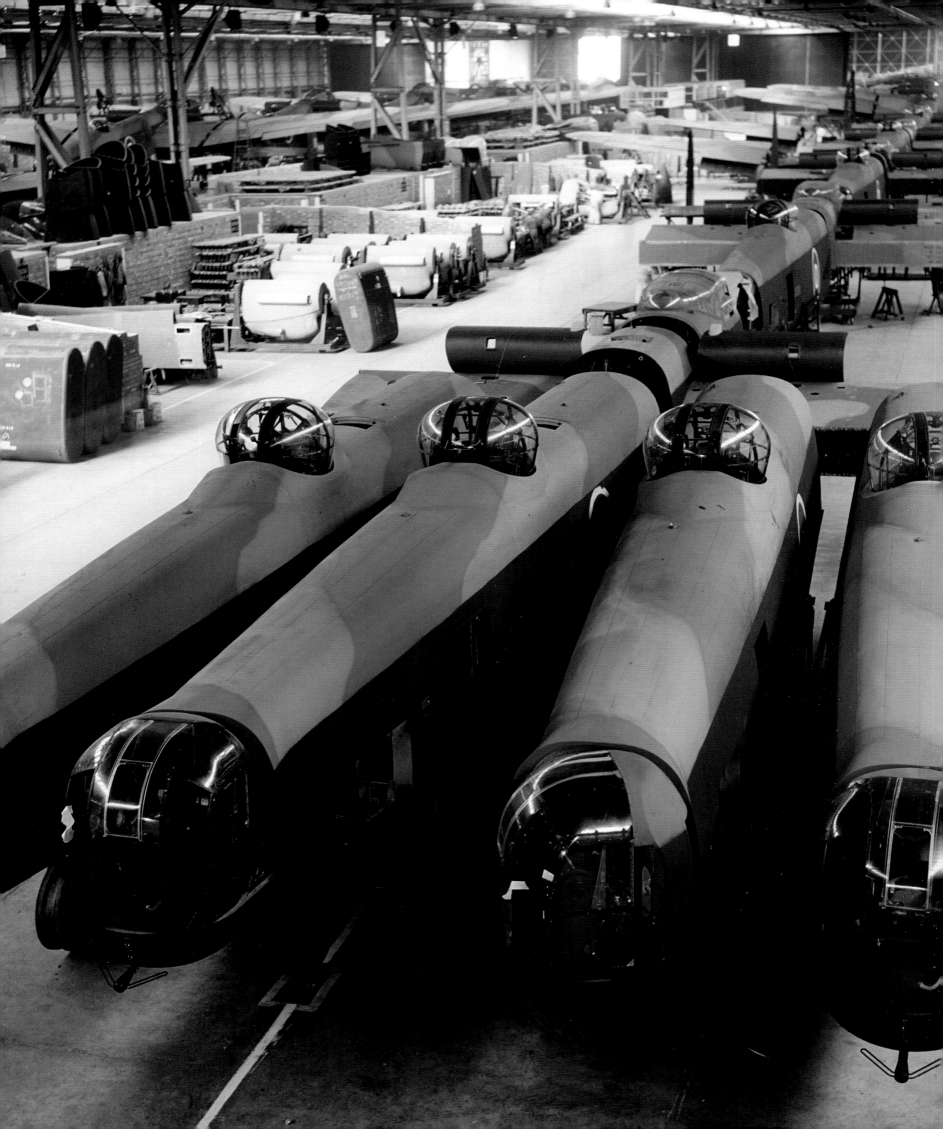

Avro Lancasters during final assembly at Woodford near Manchester, 1943. This most famous of British bombers was built by six companies at various locations in the Midlands and northern England, and one in Canada. Lancaster production accelerated from a modest 23 in January 1942 to a wartime peak monthly output of 281 aircraft in September 1944. Half of all the 7,377 Lancasters built were manufactured at Avro's own plant at Chadderton near Oldham, then assembled and test flown at Woodford. The aircraft industry was critical to Britain's war effort, and consumed vast resources. By the war's end, 125,000 aircraft of all types had been built, with women forming over half the workforce.

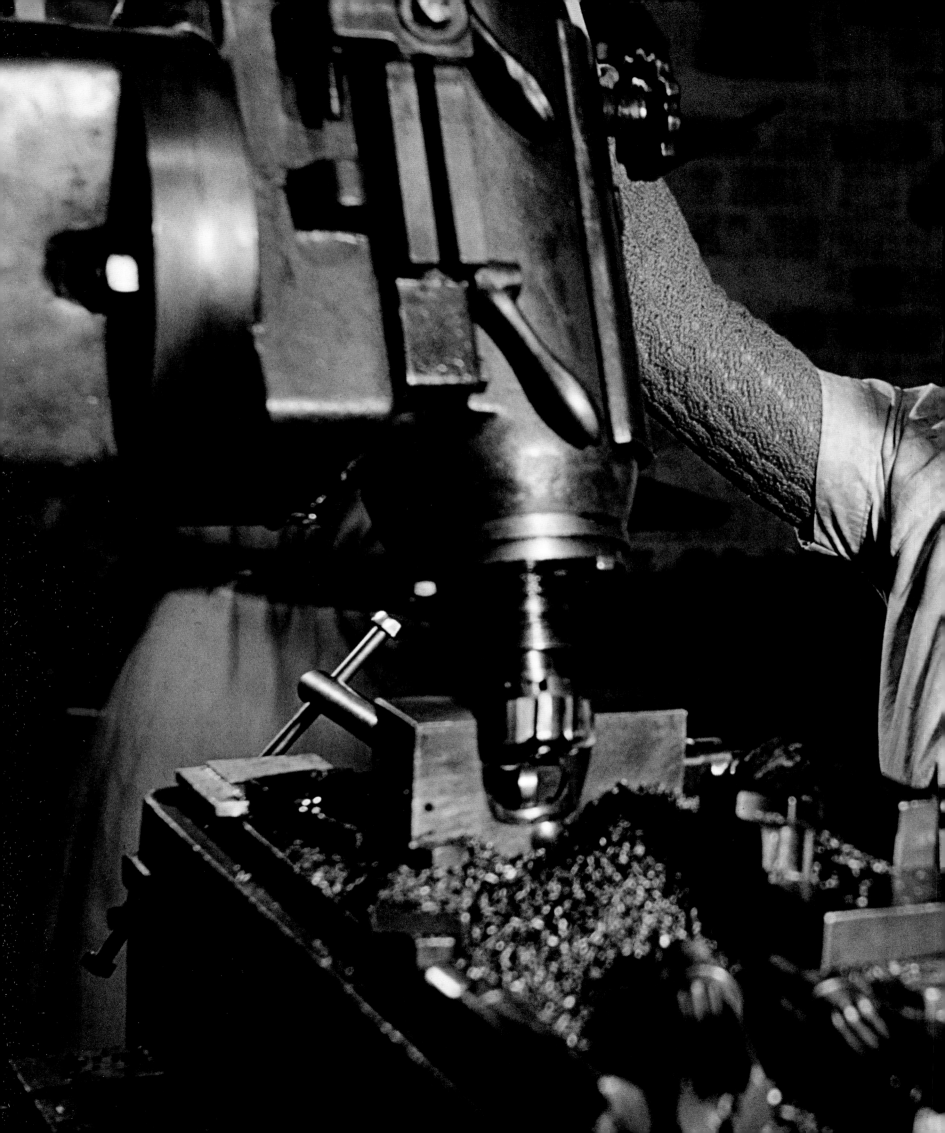

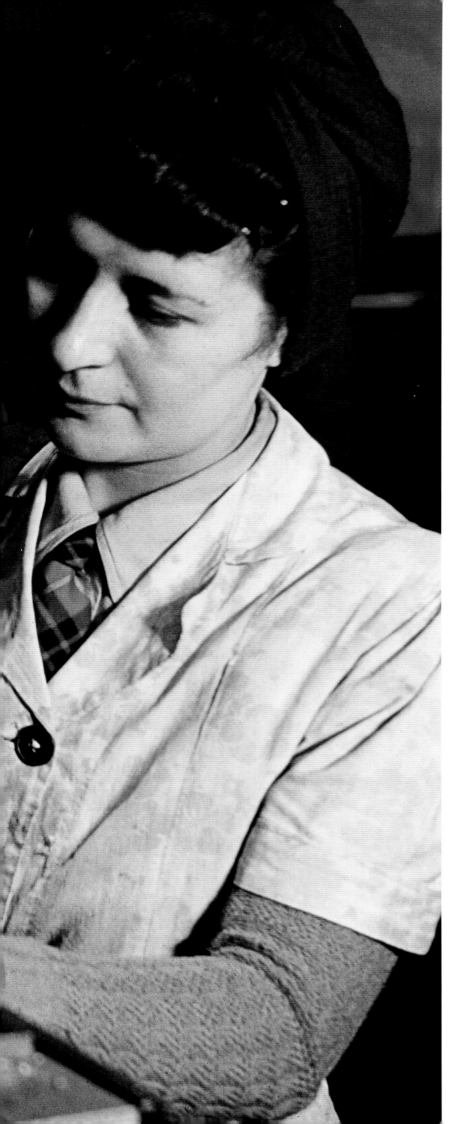

A worker milling breech blocks for Sten sub-machine guns at a small engineering works 'somewhere in the south of England', 1943. The components were then sent on to a glass factory for polishing before shipment to the Royal Ordnance Factory at Fazakerley, near Liverpool, for final assembly. The Sten gun was designed to be cheap and quick to make from simple stamped metal components, with the minimum of machining. Each one cost about 15 shillings (£30 in today's money) and required an average of 5 man (or woman) hours to produce. Around 4 million of the weapons were produced during the war.

Women at work in an underground munitions factory at New Brighton on the Wirral, Merseyside, 1945. The factory was located in underground tunnels and caverns originally used by smugglers and then re-discovered during the construction of the New Brighton Palace amusement arcade in the 1930s. At that time, New Brighton was a popular seaside resort for the people of Liverpool. During the war, the tunnels were initially used as air raid shelters before housing the factory which employed more than 200 people, making 20mm cannon shells and .303-inch rifle ammunition.

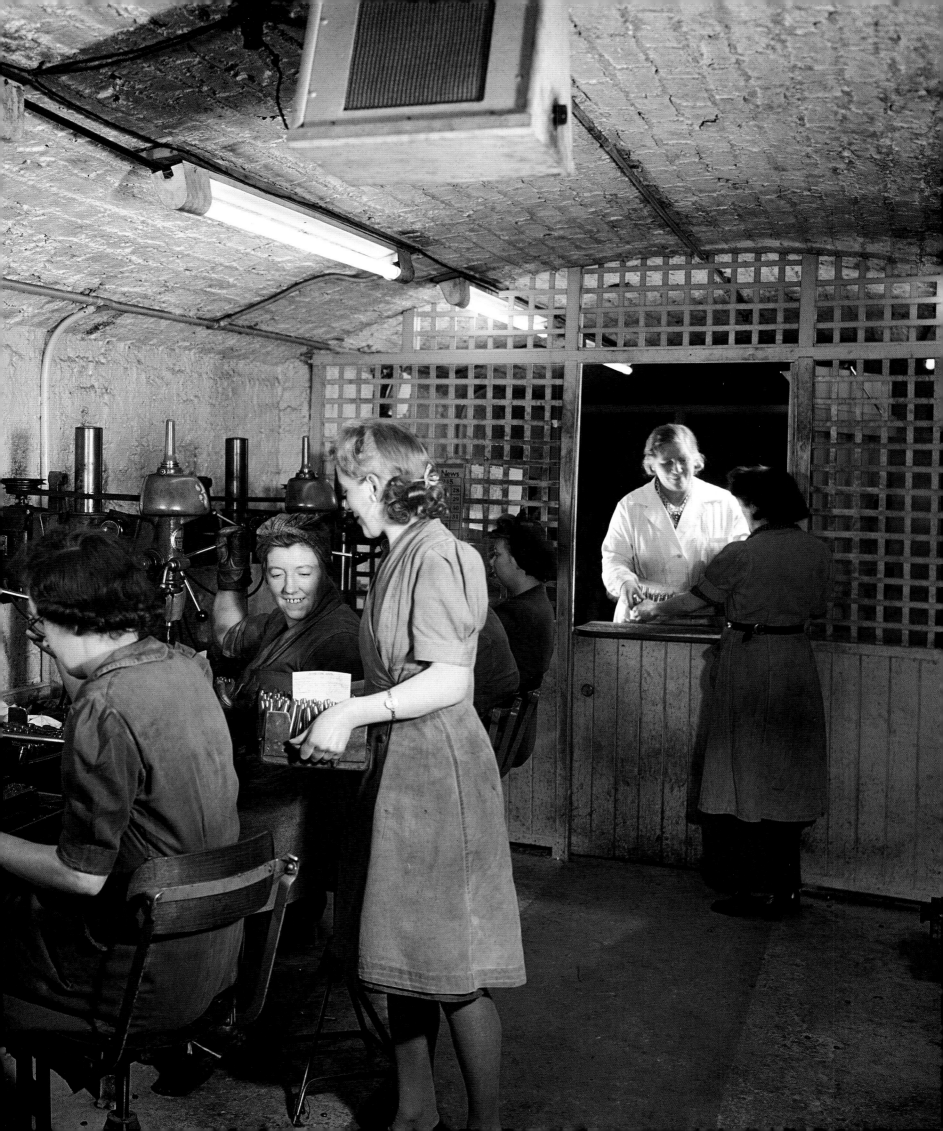

Sacks of flour being offloaded at a British port. At the start of the war Britain imported most of its food – 20 million tons a year – much of it from Canada and the United States. German U-boats threatened to disrupt these supplies and so, in January 1940, the government introduced food rationing, starting with basic items such as meat, sugar and butter. Only foods of which supply could be guaranteed were rationed, but the availability of many other items such as fruit, poultry and fish was erratic. Later, a 'points' system was introduced to cover a variety of foods. The measures were vital – by 1944, food imports had fallen to less than 12 million tons.

(Next spread)
Activity on William Alexander's dairy farm at Eynsford in Kent, 1943. Grass is being cut to make silage for winter fodder. In 1939, most farms in Britain were given over to pasture and dependent on cheap imported livestock feed. The war forced a change to edible crops – wheat, oats, barley and potatoes. Animal herds were reduced, which lessened the need for fodder, but also reduced the amount of meat available. Milk production was still vital though, and the yield from dairy farms remained fairly constant during the war. There was also an increased use of mechanisation, including the Caterpillar tractor seen here.

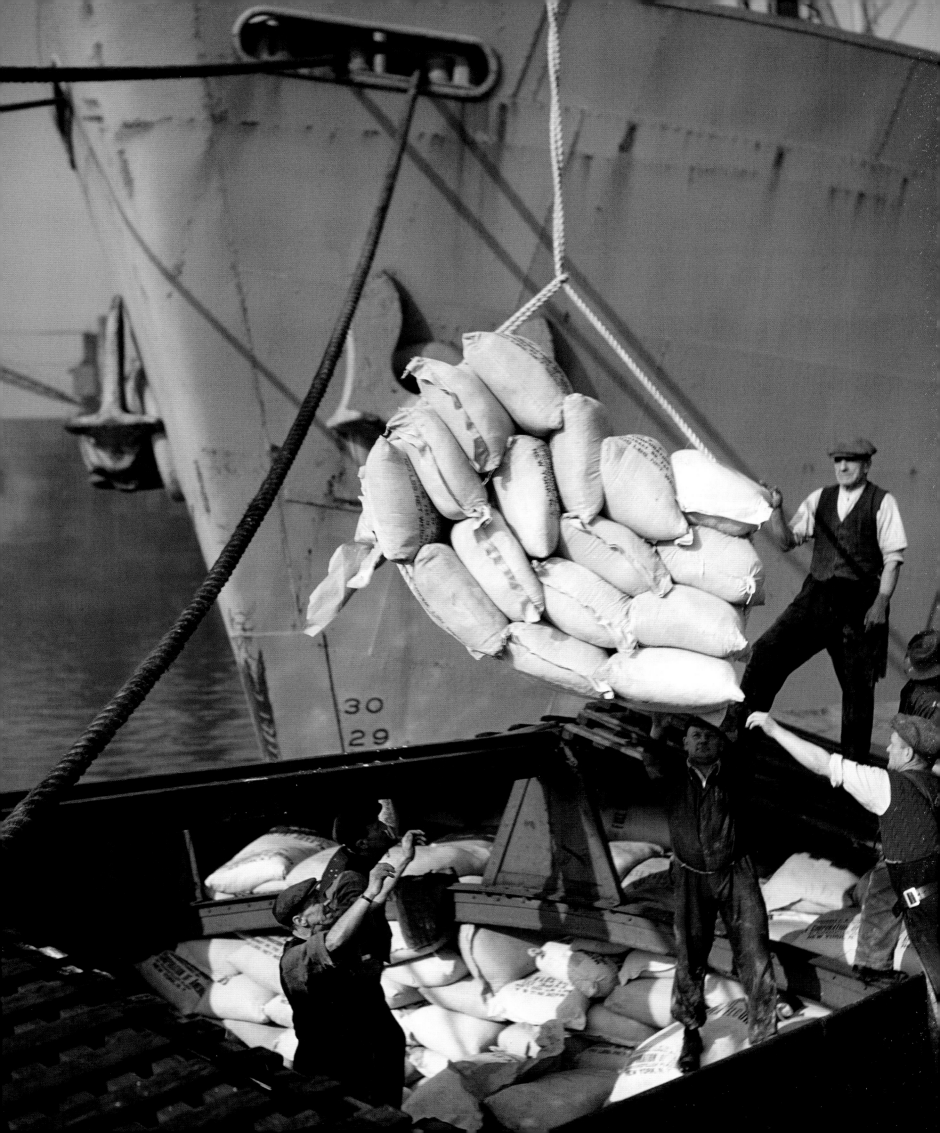

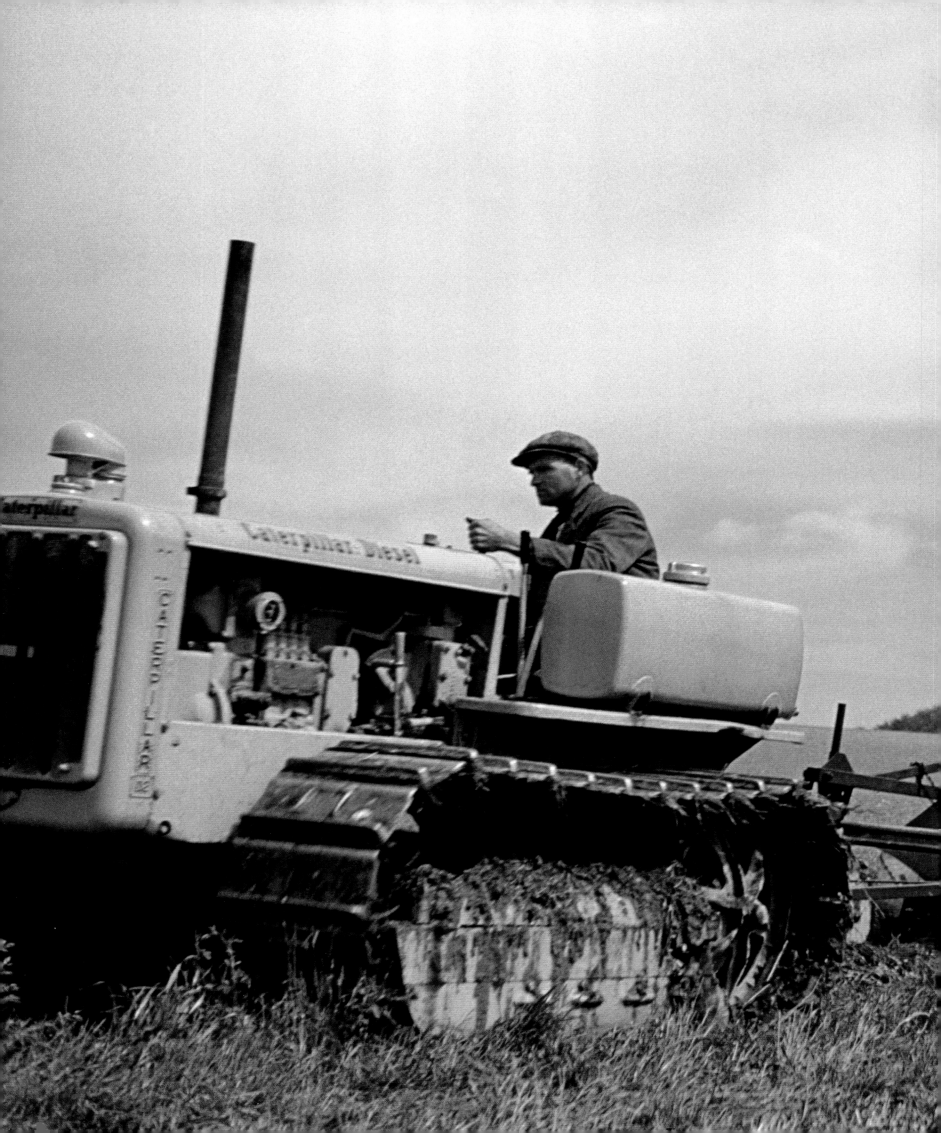

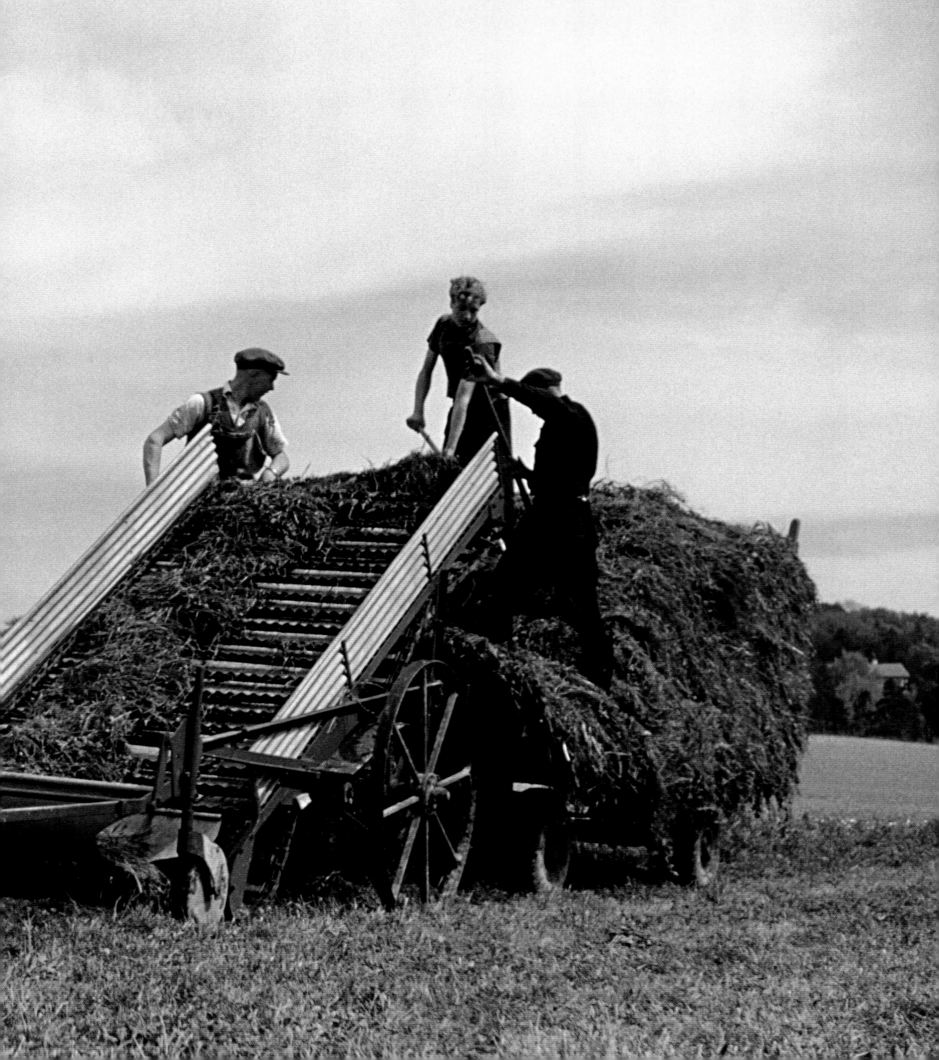

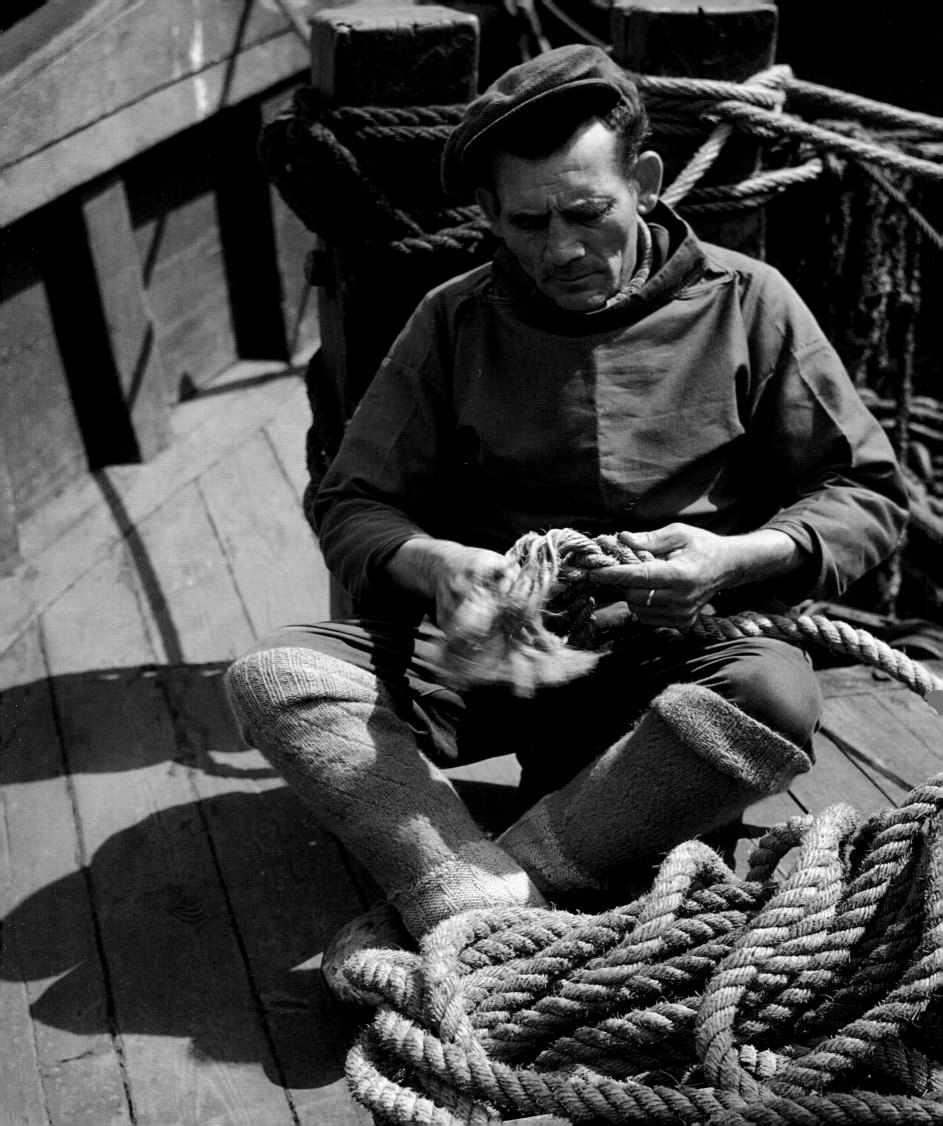

A Belgian fisherman, a refugee now plying his trade in Britain, splicing rope on a fishing boat at Brixham in Devon, 1944. Britain's fishing industry was deeply affected by the war. Fish was never rationed, but supplies fell dramatically. Many trawlers, drifters and whalers were requisitioned by the Admiralty for minesweeping tasks. The North Sea, heavily mined, was mostly out of bounds so the fishing fleets moved west — to the Irish Sea and the waters off Scotland and Iceland. It was dangerous work as the enemy saw fishing boats as legitimate targets. At least 1,243 fishermen were killed, while another 2,385 died serving with the Royal Navy.

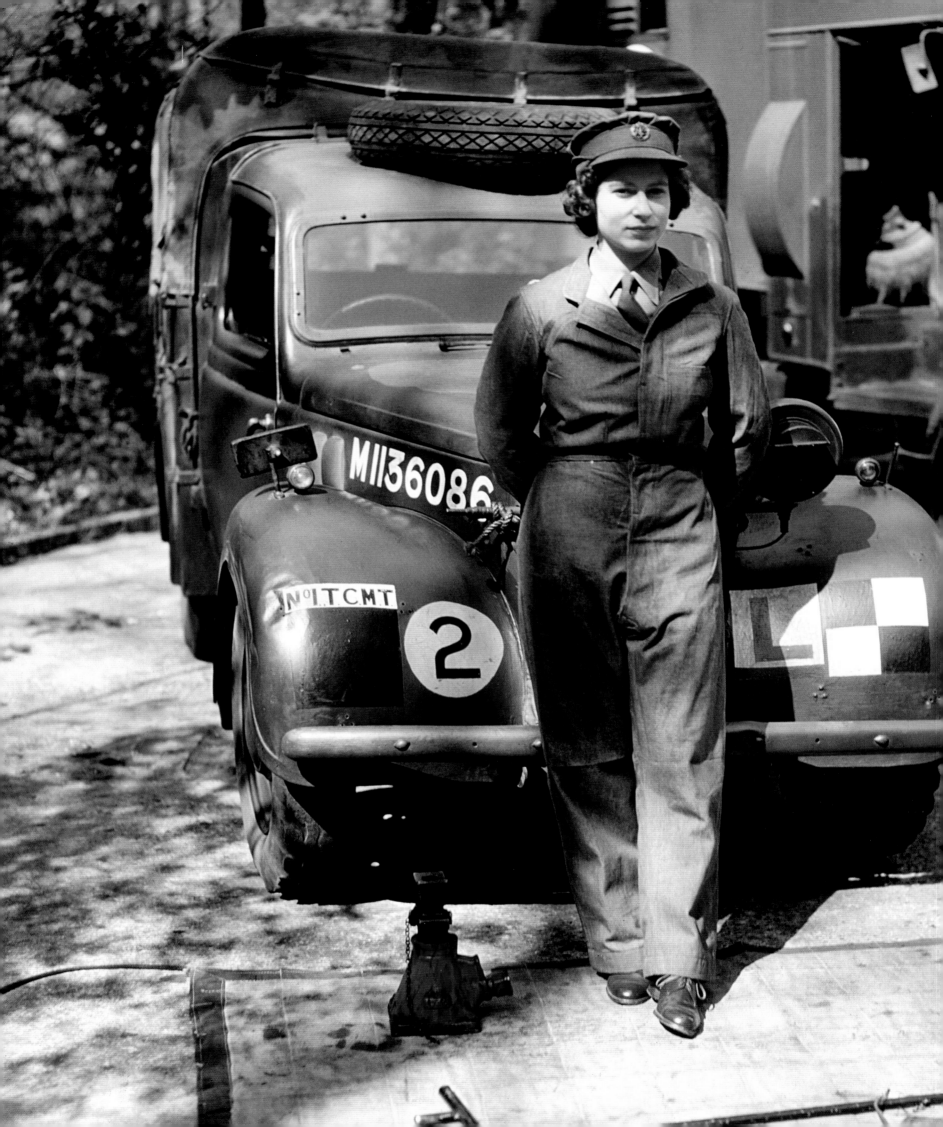

Princess Elizabeth (the future Queen Elizabeth II) photographed during her service in the ATS at Camberley in Surrey, April 1945. Neither King George VI nor Queen Elizabeth wanted their daughters to be evacuated abroad, and so Princess Elizabeth spent most of the war at Windsor Castle with her younger sister, Margaret Rose. Elizabeth was keen to do her bit for the war effort, and was allowed to join the ATS in February 1945. As honorary Second Subaltern Elizabeth Alexandra Mary Windsor, she learnt to drive and maintain vehicles such as the Austin 10 'Tilly' and Austin K2 ambulance seen in this photograph.

Jubilant crowds gather in Whitehall in London on VE Day, 8 May 1945. The German High Command had surrendered unconditionally to the Western Allies on 7 May, and the day after was declared 'Victory in Europe Day' and a national holiday. No official ceremonies for the occasion had been planned – instead people took to the streets in spontaneous celebration. That afternoon Winston Churchill addressed the nation and the world in a radio broadcast, declaring that the war in Europe was over and that people might allow themselves 'a brief moment of rejoicing'. However, the fighting in the Far East and Pacific dragged on, and victory over Japan would not be celebrated until 15 August 1945.

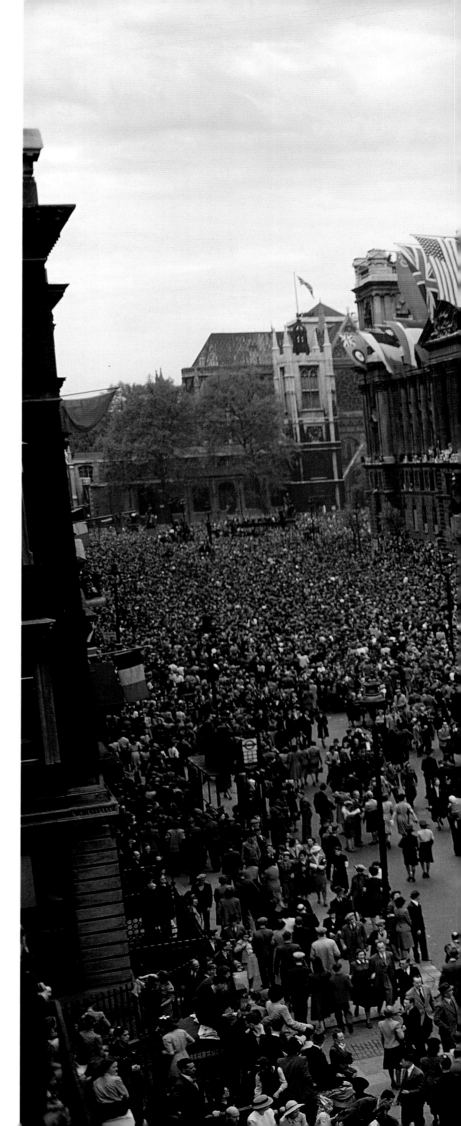

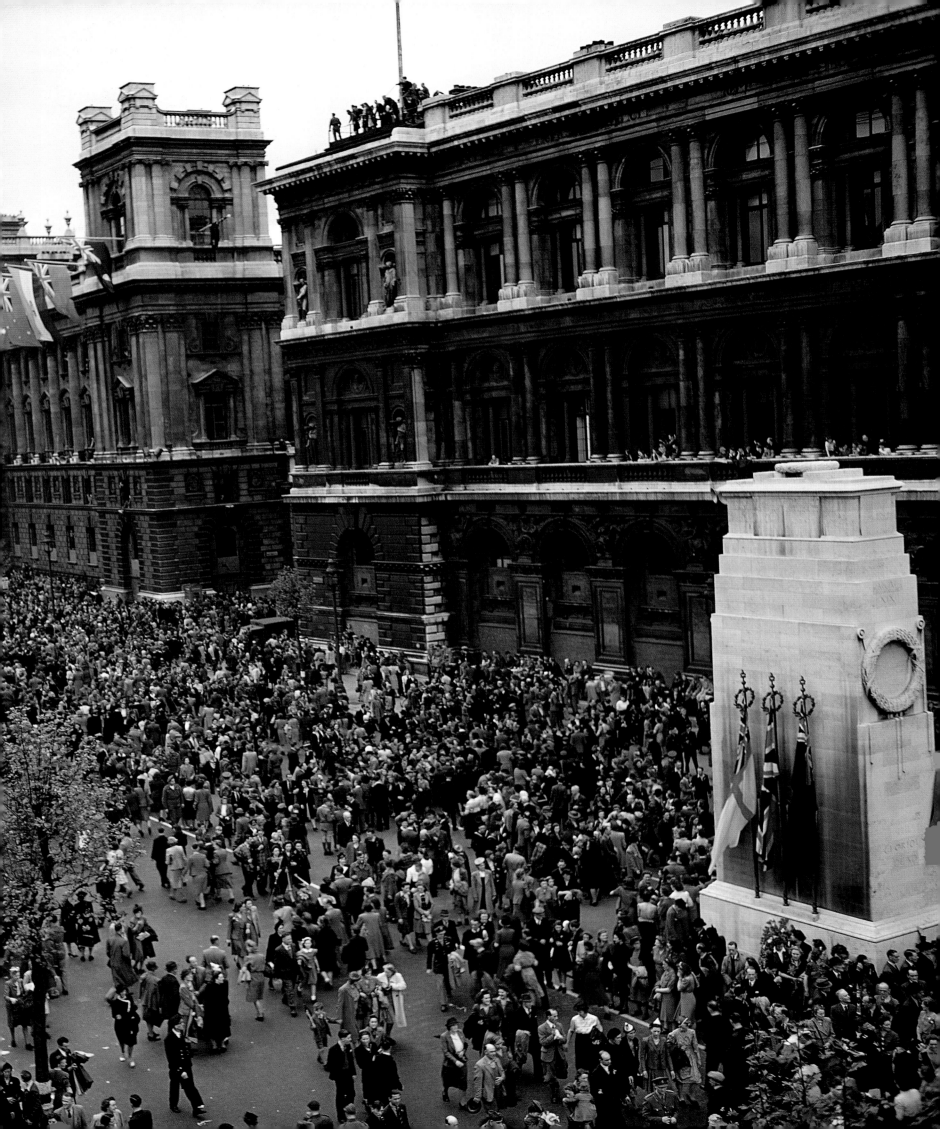

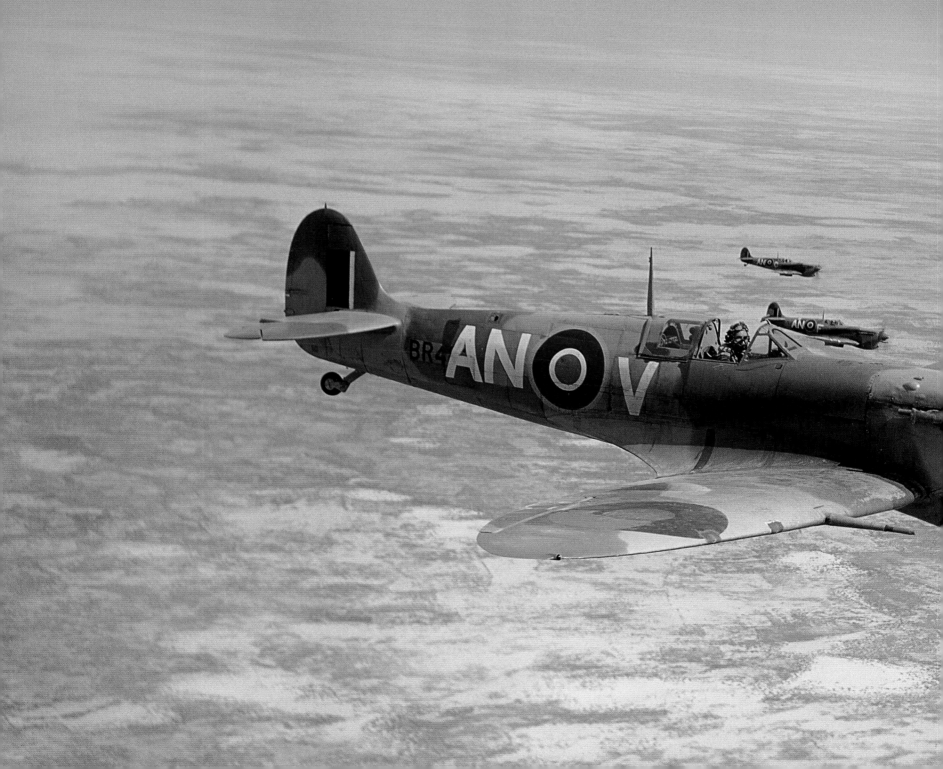

CHAPTER THREE
TWO AIR FORCES

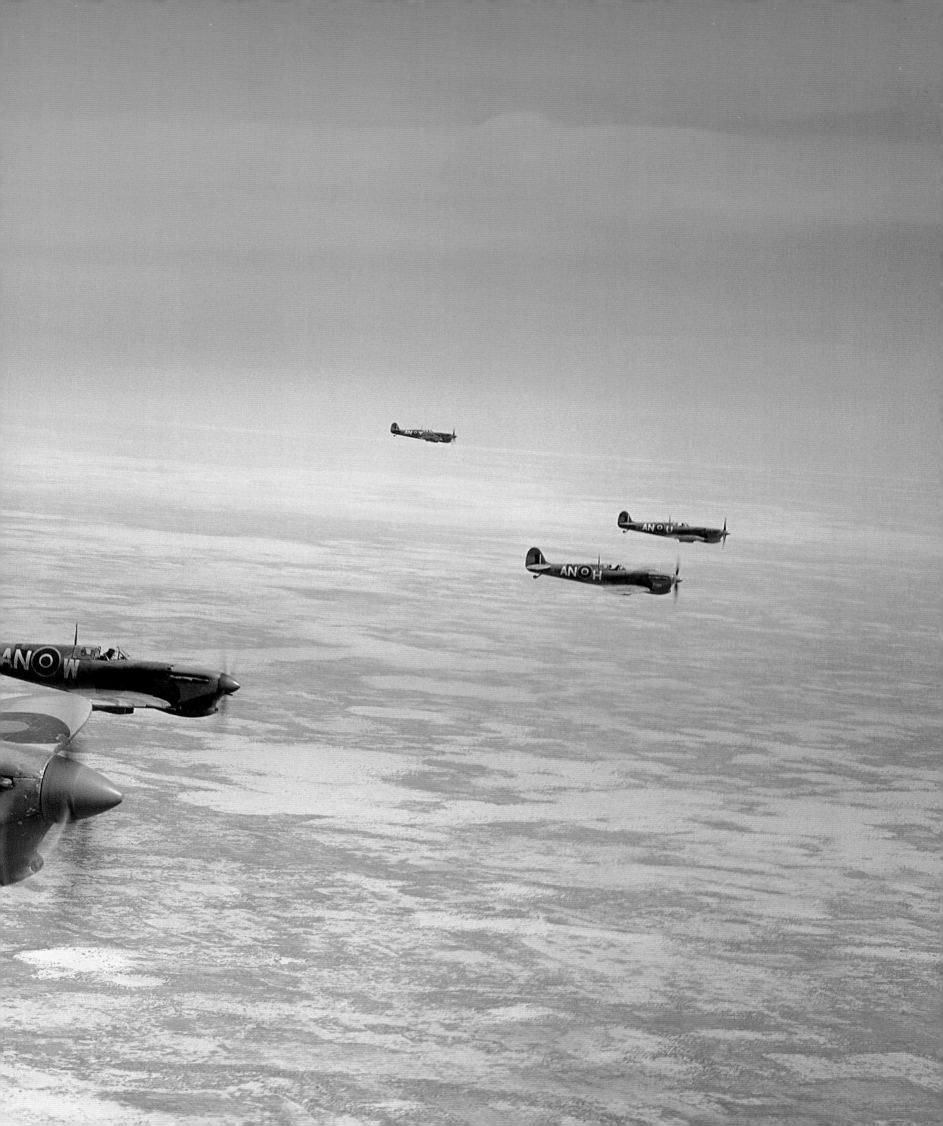

In the summer of 1940 the Royal Air Force won a decisive and famous victory over the Luftwaffe. The Battle of Britain was crucial to the country's survival, but the RAF always considered that its principal role was to take the war to the enemy. This translated into a lengthy bombing campaign against German industry, which some believed might achieve victory on its own. The RAF was later joined in this endeavour by the United States Army Air Forces, keen to prove their own war-winning potential. As well as the strategic bombing campaign flown from Britain, the two air forces co-operated in a supporting role over the battlefronts. This combined air effort became central to the strategic direction of the war, as it soon became apparent that Allied success on land or at sea was impossible without control of the air.

RAF Fighter Command expanded rapidly after the Battle of Britain. Many new squadrons were formed, with the Spitfire the most numerous type. German aerial attacks on the United Kingdom, which peaked during the 'Blitz' in the winter of 1940–1941, continued sporadically for much of the war, but on a decreasing scale as the Luftwaffe was diverted elsewhere. 1944 saw the last major attacks on Britain by conventional aircraft. After that, Hitler resorted to pilotless V-1 flying bombs. These proved tricky to intercept, but the RAF managed to shoot down over 1,700 of them. The other so-called 'vengeance weapon', the V-2 rocket, was impossible to intercept.

Many UK-based fighter squadrons were switched to offensive operations, flying ground attack missions and sweeps over enemy territory. Initially, losses were high and the Spitfire's limited endurance was a major problem. The twin-engine Mosquito was better suited to the task, possessing the necessary speed and range, as well as a formidable armament, for long-distance missions over Europe. In June 1944, after the invasion of Normandy, fighter squadrons were able to relocate to airfields in Europe, where as part of the new 2nd Tactical Air Force they provided vital support for Allied ground forces.

The RAF played a key role on fighting fronts further afield. In 1942, the strategically vital island of Malta held out against sustained Axis air attacks, thanks in part to Spitfires flown in from aircraft carriers. In North Africa, the Desert Air Force provided

close support for the Army as it advanced westwards. By the time of the final battles in Tunisia, its aircraft were firmly in control of the air. It was a similar story when Allied forces invaded Italy in 1943. RAF squadrons took part in a sustained and effective campaign of interdiction against enemy troop positions and transport.

Bomber Command, based in Britain, was the RAF's main strike force, although at first it lacked the strength to make an impact. Plans for precision attacks on individual factories and oil plants were abandoned once it became clear that crews could rarely find or hit them in the darkness. Bombing policy had to be changed, and from now on whole cities – and their working populations – became the targets. The aim of the new 'area bombing' campaign was to destroy enemy morale and bring German industry to its knees. Air Chief Marshal Sir Arthur Harris, who led Bomber Command from 1942 till the end of the war was its keenest advocate, and the new Lancaster heavy bomber gave him a suitable tool for the job.

In 1943 Bomber Command embarked on a major assault on the Ruhr industrial region, including Essen with its vast Krupp armaments works. This time, new technology enabled specialist Mosquito 'pathfinders' to accurately mark targets through smog and cloud. The raids caused extensive damage, but 900 bombers were lost. In the summer, Hamburg was consumed in a huge firestorm which left the Nazi hierarchy genuinely shaken. But despite such destructive attacks, the morale of German citizens held out, just as that of Londoners in the Blitz had done. That winter, Bomber Command carried out a sustained offensive against Berlin. Harris claimed it would decide the war, but the RAF lost over 1,100 aircraft and still failed to inflict a decisive blow.

Meanwhile, the Americans had joined the aerial assault on Germany. The US Eighth Air Force was trained to operate in daylight, and regarded precision attacks on key German industries as its prime mission. Unlike RAF Bomber Command, the Eighth flew in daylight, relying on its heavily armed Flying Fortresses and Liberators fighting their way through to the target. The British were sceptical, but it provided an opportunity for 'round the clock' bombing. The German aircraft industry was

picked out for particular attention, as reducing the Luftwaffe's strength was seen as an essential prerequisite for the invasion of Europe.

The American bombers flew missions deep into Germany during 1943, but suffered horrendous losses. Allied escort fighters could only go part of the way, and once on their own the bombers were easy meat for the Luftwaffe. In two big attacks on the Messerschmitt plant at Regensburg and ball-bearing factories at Schweinfurt, 120 bombers were shot down. Such losses were unsupportable, and operations were curtailed. In the spring of 1944, the situation was transformed by the appearance of the new P-51 Mustang fighter, which could escort the bombers to the furthest targets. The Mustangs soon gained the upper hand over a depleted Luftwaffe, and were instrumental in winning control of the skies over Germany.

Bomber Command and the Eighth Air Force were now placed under Supreme Allied Commander General Eisenhower's control for the invasion of Europe. The French railway system was the priority target, to prevent the Germans reinforcing the Normandy battlefield. The bombers also hit coastal defences and troop positions. Significantly, the USAAF carried out a number of effective attacks on German synthetic oil plants, now identified by the Allied High Command as the weak spot in the enemy war machine.

In the autumn of 1944, the bombers were again unleashed to concentrate on German targets. Harris got back to pulverizing industrial cities, but it was soon apparent that targeting Germany's synthetic oil plants and transport system was more effective. Despite herculean attempts to repair and disperse production, German industry was progressively disrupted. In 1945, Allied attacks reached a crescendo. Among the raids was one destined to cause controversy — Dresden was razed to the ground in a cataclysmic firestorm, echoing that of Hamburg in 1943.

Both air forces made a significant contribution to victory. Air superiority over the fighting fronts made the liberation of Europe possible. The strategic bomber offensive forced Germany to

divert huge resources of guns, aircraft and manpower to defend the Reich. Industrial output continued until the end, but enough damage was done, especially to fuel stocks and the transport infrastructure, that military operations and planned weapon production had to be drastically cut back, with devastating consequences for Hitler's armies.

(Page 108)
Spitfire Mk Vs of 417 Squadron, Royal Canadian Air Force, flying over the arid Tunisian desert on an escort mission, April 1943. Spitfires first saw action in North Africa in June 1942, having been brought in to counter the Luftwaffe's Messerschmitt Bf 109F, which was superior to other Allied fighters. Ten additional Spitfire squadrons were transferred from RAF Fighter Command in the UK for the Tunisian campaign. 417 Squadron was the only RCAF unit to take part in the North African campaign. As with other Spitfire squadrons, their principal task was to act as 'top cover' for ground attack aircraft.

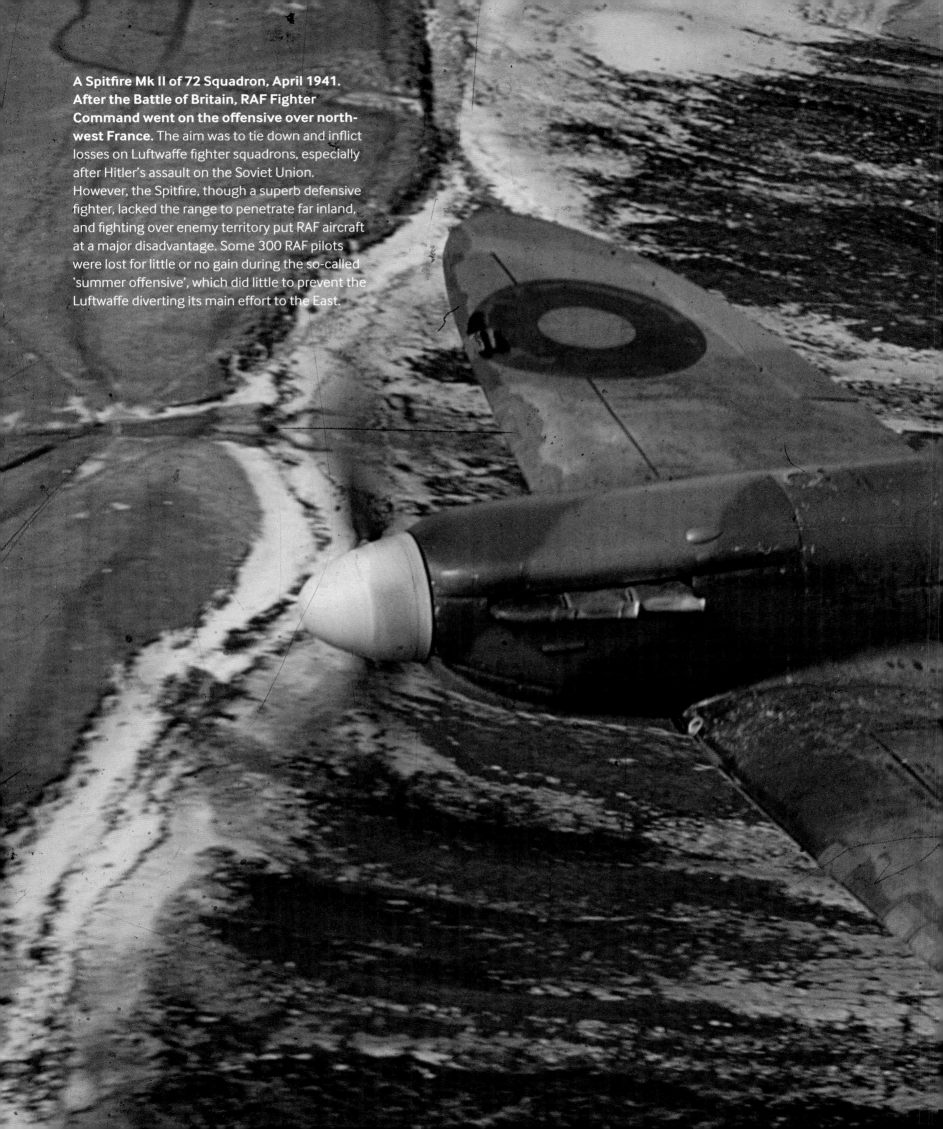

A Spitfire Mk II of 72 Squadron, April 1941. After the Battle of Britain, RAF Fighter Command went on the offensive over north-west France. The aim was to tie down and inflict losses on Luftwaffe fighter squadrons, especially after Hitler's assault on the Soviet Union. However, the Spitfire, though a superb defensive fighter, lacked the range to penetrate far inland, and fighting over enemy territory put RAF aircraft at a major disadvantage. Some 300 RAF pilots were lost for little or no gain during the so-called 'summer offensive', which did little to prevent the Luftwaffe diverting its main effort to the East.

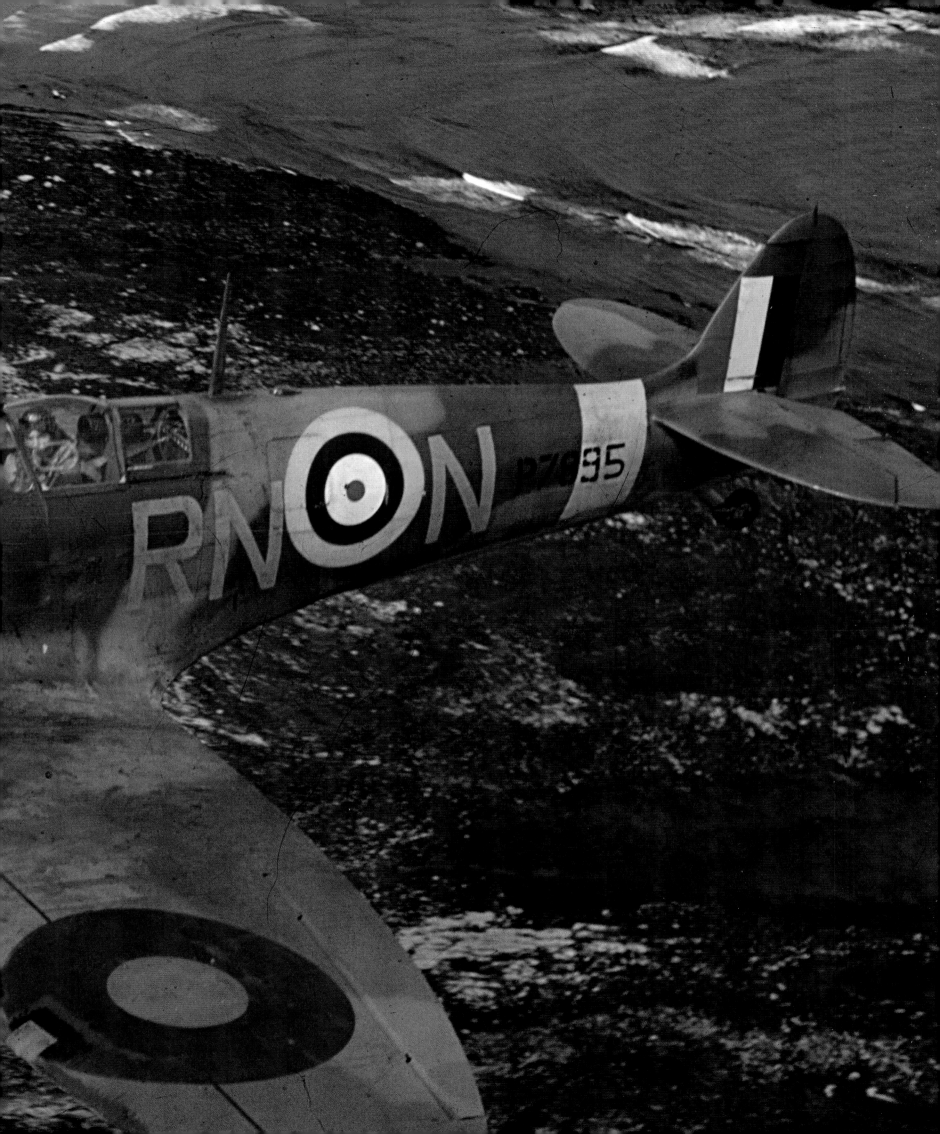

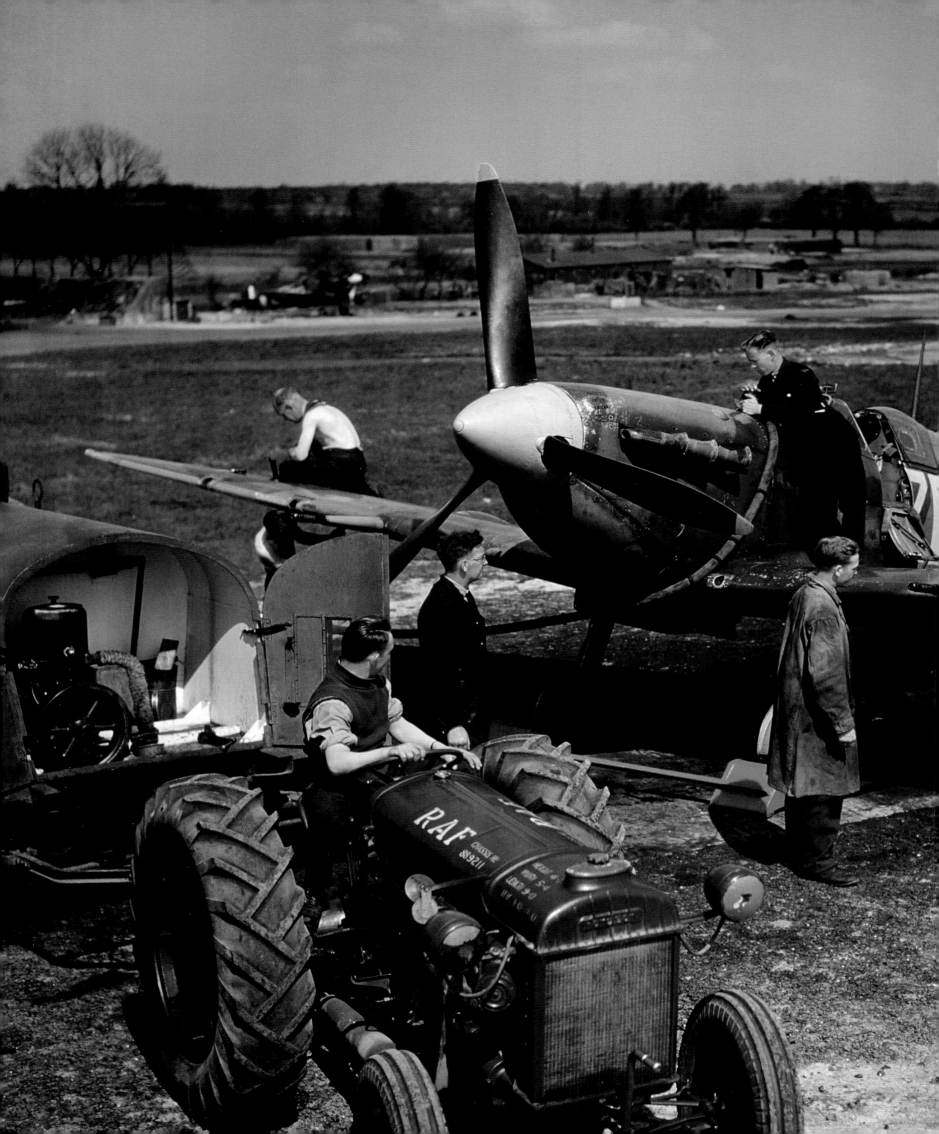

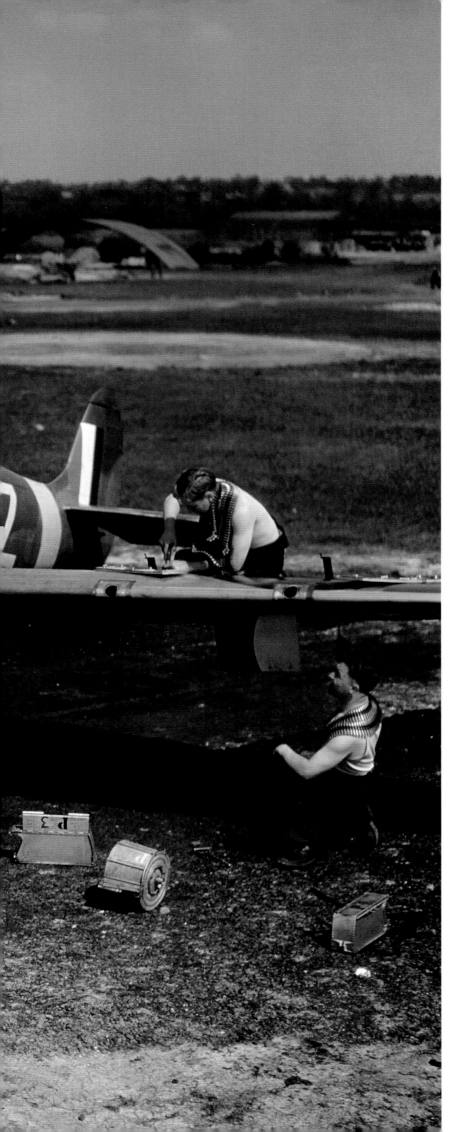

A Spitfire Mk VB of 222 Squadron being refuelled and rearmed at North Weald in Essex, May 1942. Fighter Command's offensive operations continued during 1942, but RAF squadrons continued to suffer heavy losses. The Spitfire Mk V was outclassed by the new German Focke-Wulf Fw 190, which was also used on low-level bombing raids over southern Britain. On 19 August 1942 a large-scale aerial battle was fought in support of the combined operations raid on Dieppe on the French coast. In a day of intensive combat, Fighter Command lost 106 aircraft and 52 pilots, in exchange for only 48 enemy aircraft.

A Hawker Hurricane Mk IIC of 87 Squadron, based at Charmy Down near Bath, flown by the CO, Squadron Leader Denis 'Splinters' Smallwood, May 1942. The Hurricane could no longer compete with the latest German fighters, and was relegated to the night fighting and ground attack role. The Mk IIC was powerfully armed with four 20mm Hispano cannon, while other versions could carry bombs. As well as air defence duties, 87 Squadron flew night 'intruder' sorties over occupied France, shooting up airfields, transport and other targets of opportunity. It was transferred to the Mediterranean in November 1942.

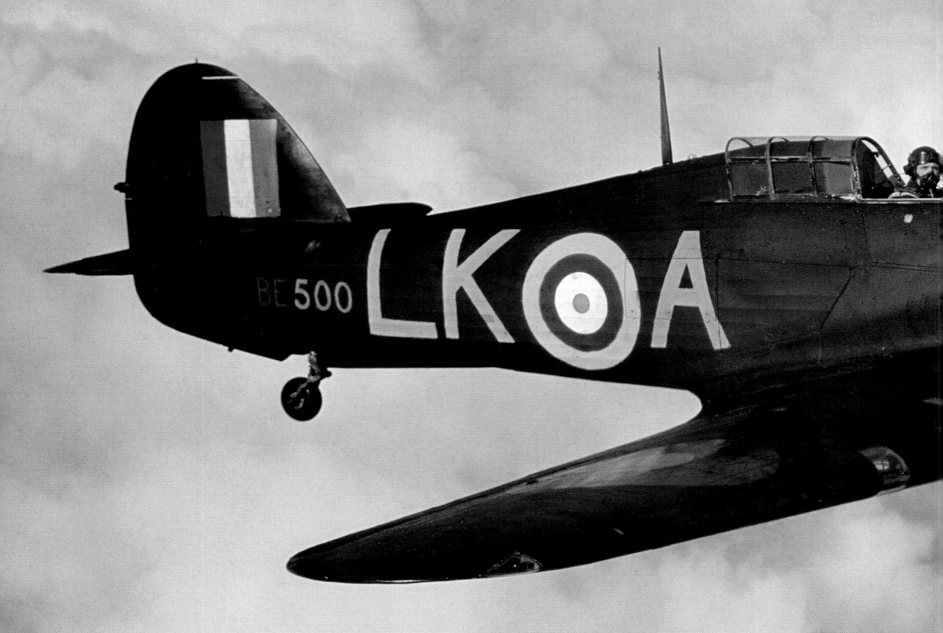

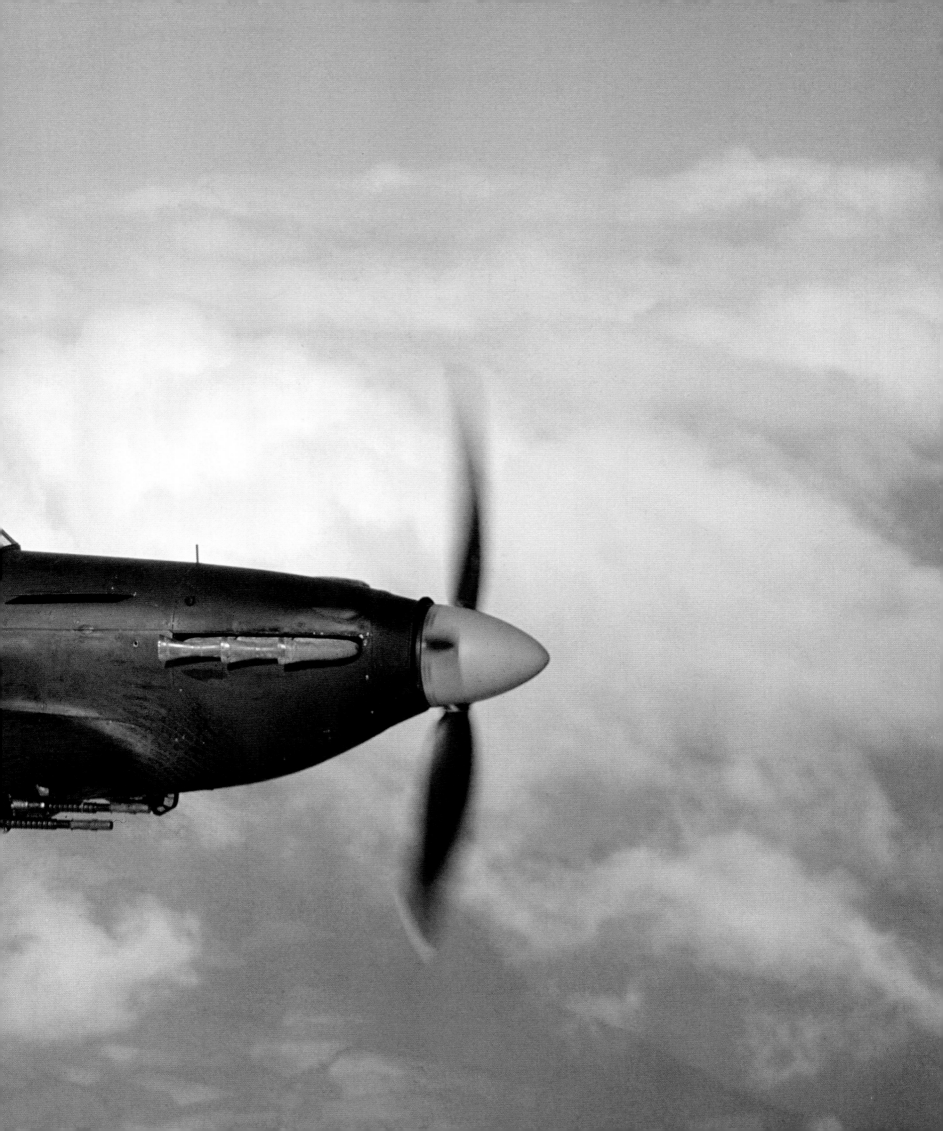

Ground staff working on a Hawker Typhoon Mk IB of 175 Squadron at Colerne in Wiltshire, spring 1943. The new Typhoon – successor to the Hurricane – proved disappointing as an interceptor, but its speed at low level meant it could catch the Fw 190 fighter bombers raiding targets in southern Britain. However, the Typhoon was soon switched to the tactical support role which would make it famous. Armed with bombs or rockets, the 'Tiffy' became the RAF's foremost ground attack aircraft, and an important factor in the success of Allied ground forces in north-west Europe after D-Day.

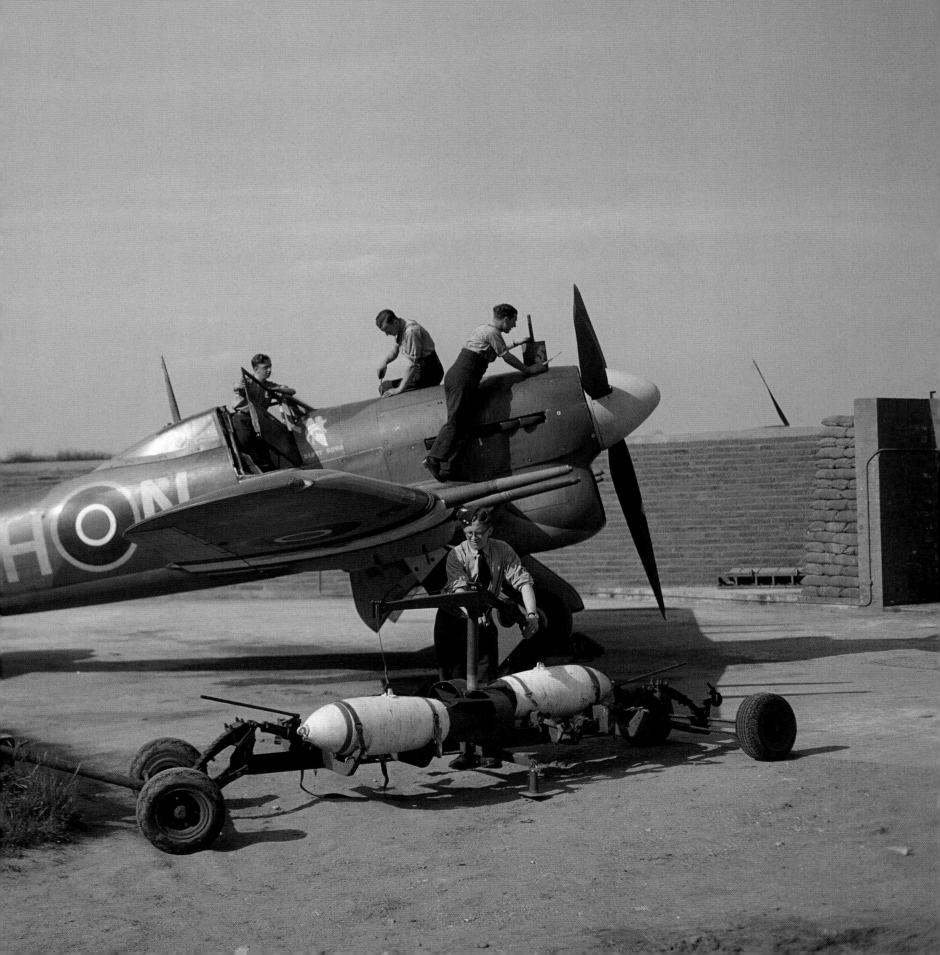

A brand new de Havilland Mosquito FB Mk VI at de Havilland's factory at Hatfield in Hertfordshire, 1943. The Mosquito, known as the 'Wooden Wonder' on account of its construction, was a radical design, conceived before the war as an unarmed, high-speed bomber. Its stunning performance meant it was in great demand for other tasks too, and Mosquitoes were used as day and night fighters, as well as in reconnaissance, intruder and maritime strike roles. This particular aircraft, HJ728, served with 23 and 108 Squadrons in the Mediterranean, but was written off in a landing accident on Malta in May 1944.

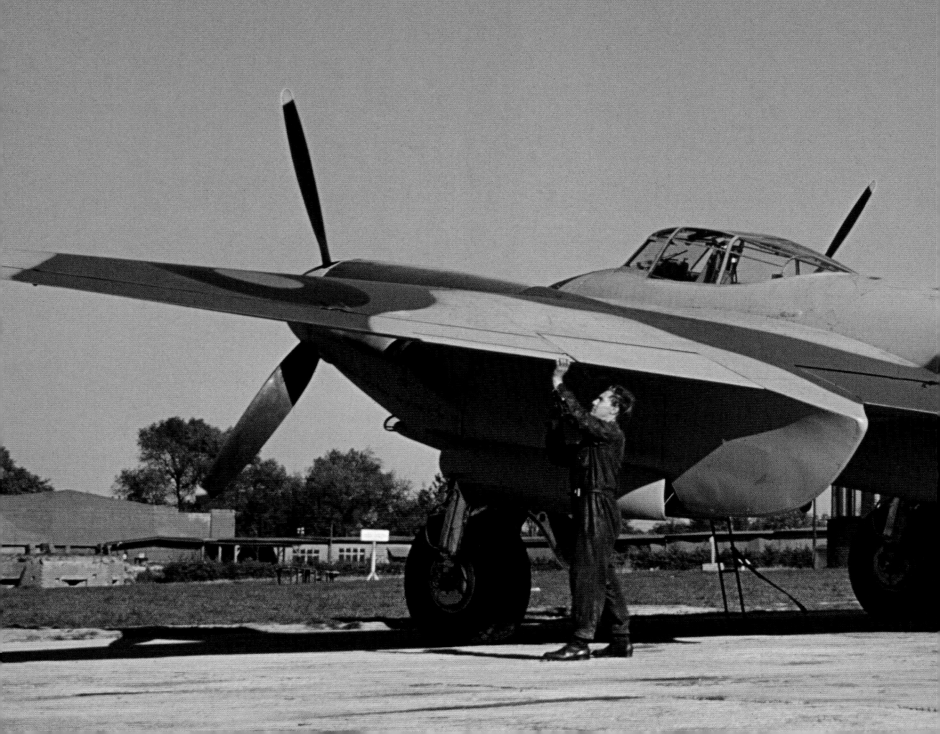

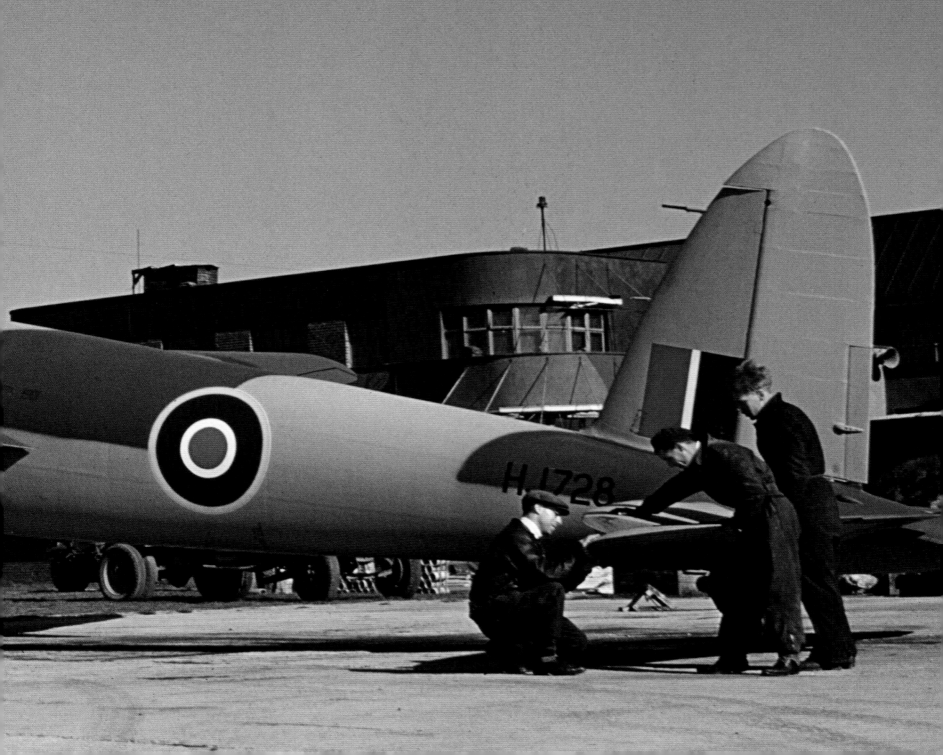

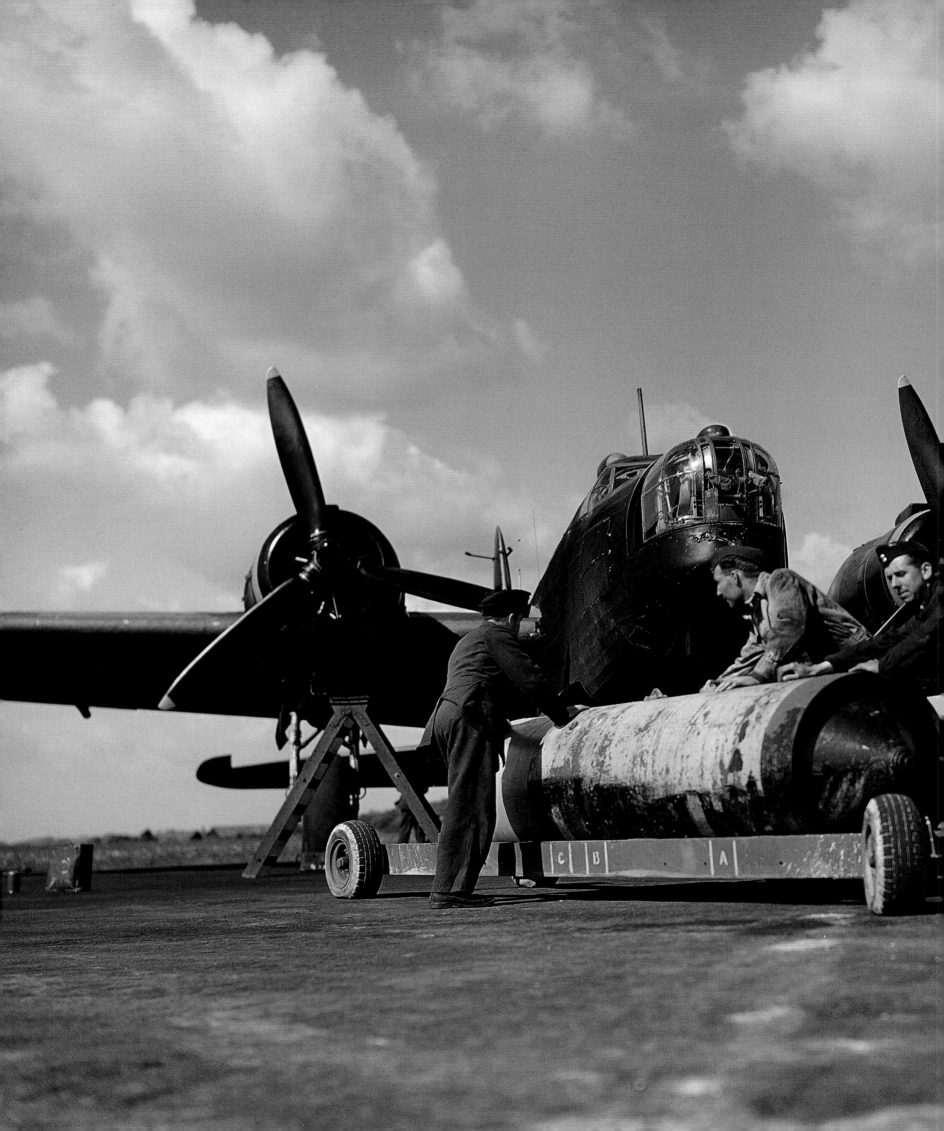

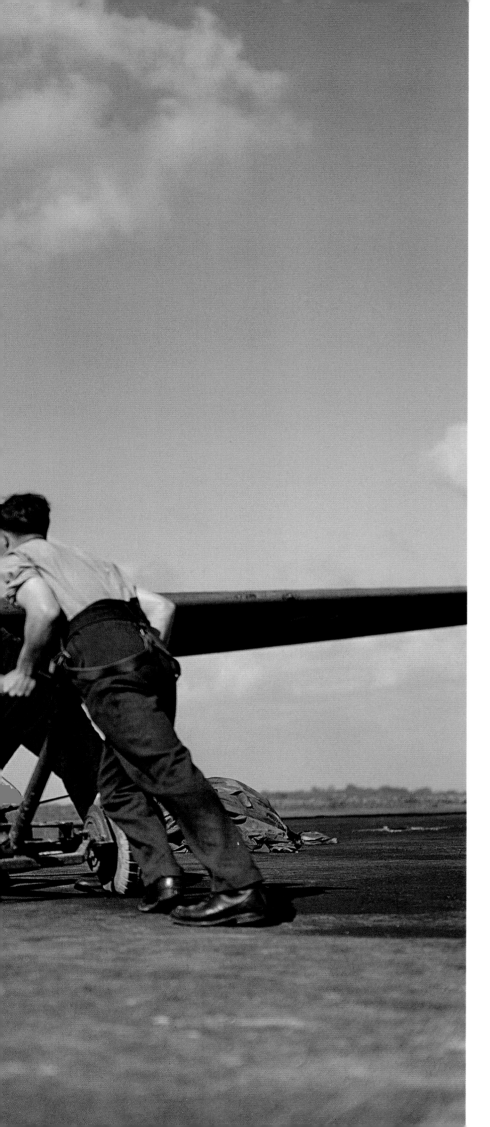

Armourers 'bombing up' a Vickers Wellington of 419 Squadron at Mildenhall, May 1942. The Wellington was the most effective RAF bomber at the start of the war, and remained in front-line service until October 1943. After costly daylight operations in 1939, Bomber Command switched to night bombing attacks. The darkness offered a measure of protection, but pin-point bombing accuracy was impossible, which led to the policy of 'area bombing'. The 4,000lb high-capacity blast bomb or 'Cookie' seen in the photo was designed for maximum explosive effect. 419 Squadron was one of 15 Canadian squadrons to operate in Bomber Command, the largest of all its Commonwealth and Allied contingents.

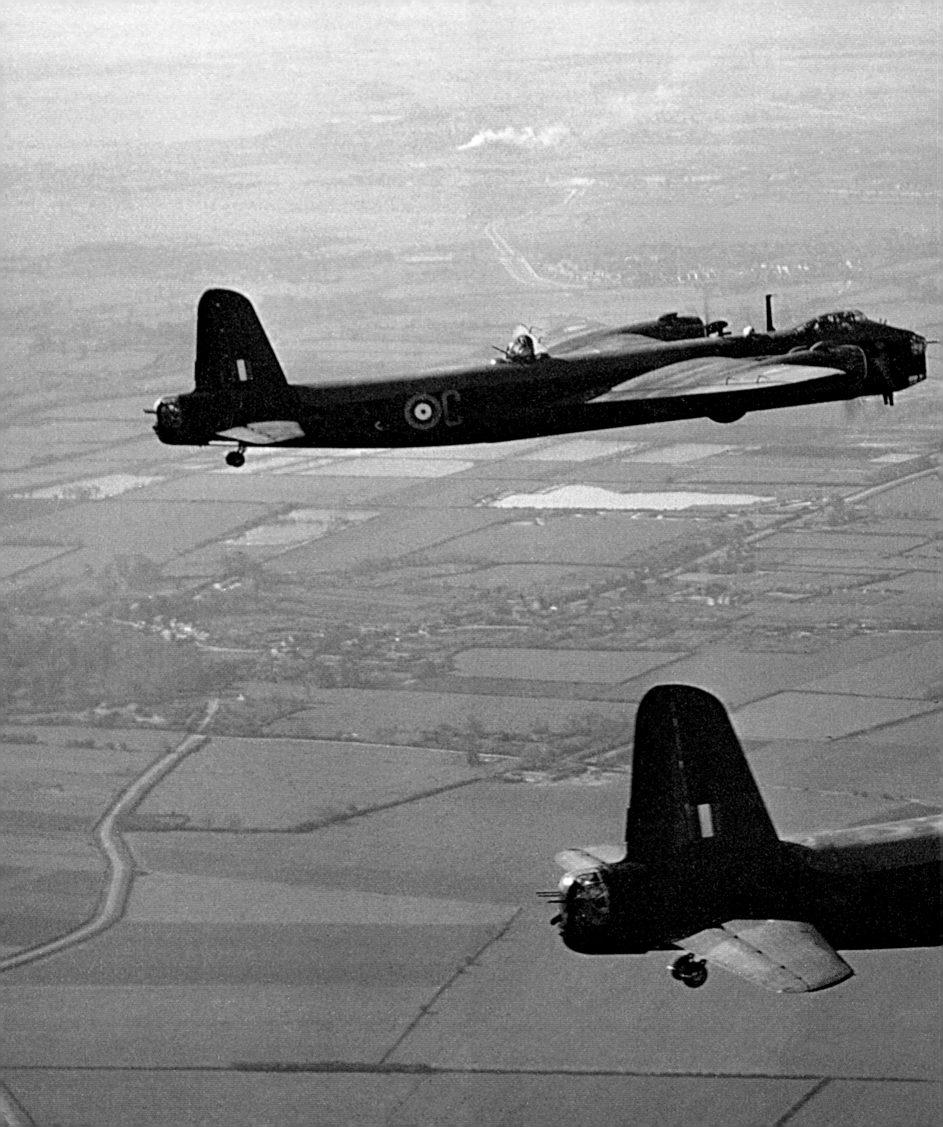

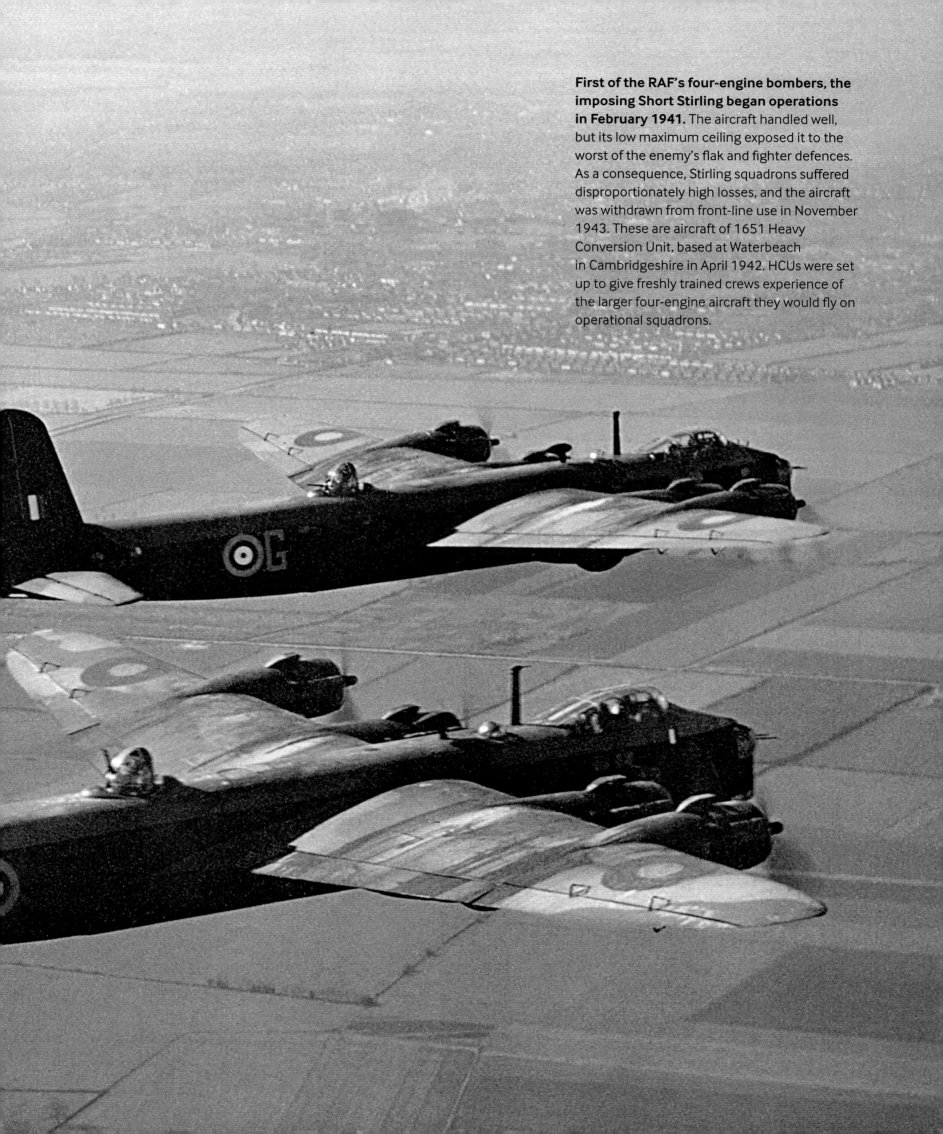

First of the RAF's four-engine bombers, the imposing Short Stirling began operations in February 1941. The aircraft handled well, but its low maximum ceiling exposed it to the worst of the enemy's flak and fighter defences. As a consequence, Stirling squadrons suffered disproportionately high losses, and the aircraft was withdrawn from front-line use in November 1943. These are aircraft of 1651 Heavy Conversion Unit, based at Waterbeach in Cambridgeshire in April 1942. HCUs were set up to give freshly trained crews experience of the larger four-engine aircraft they would fly on operational squadrons.

A Lancaster bomber crew at RAF Waddington, October 1942. All Bomber Command aircrew were volunteers, and a quarter were from Canada, Australia, New Zealand and other nations. They suffered the worst casualty rate of any group of Allied servicemen. Only a quarter would survive a normal tour of 30 operations. Of approximately 125,000 men who saw service, 55,220 were killed on 'ops' or in training. Two lesser members of the crew in this photo are the homing pigeons housed in their yellow boxes. They could be used for emergency communication if the aircraft crash-landed or ditched at sea.

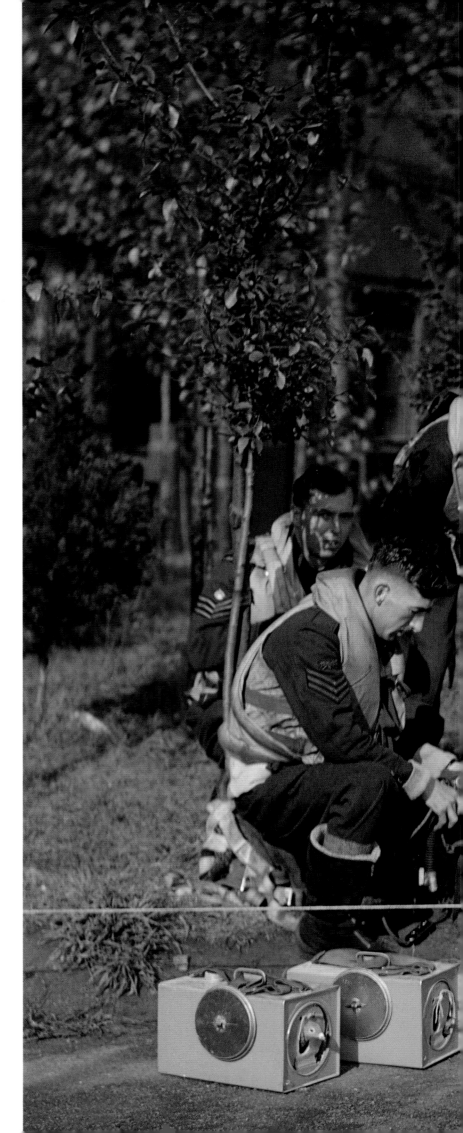

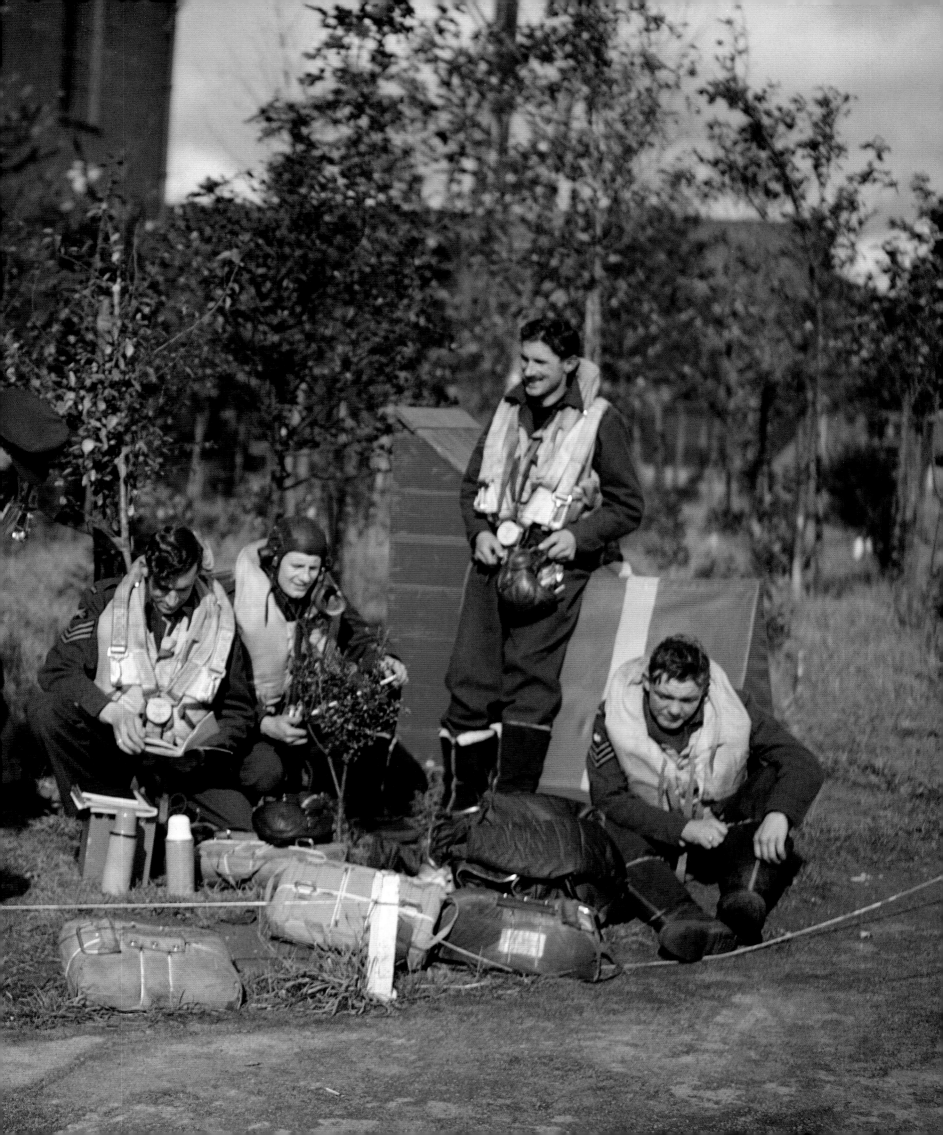

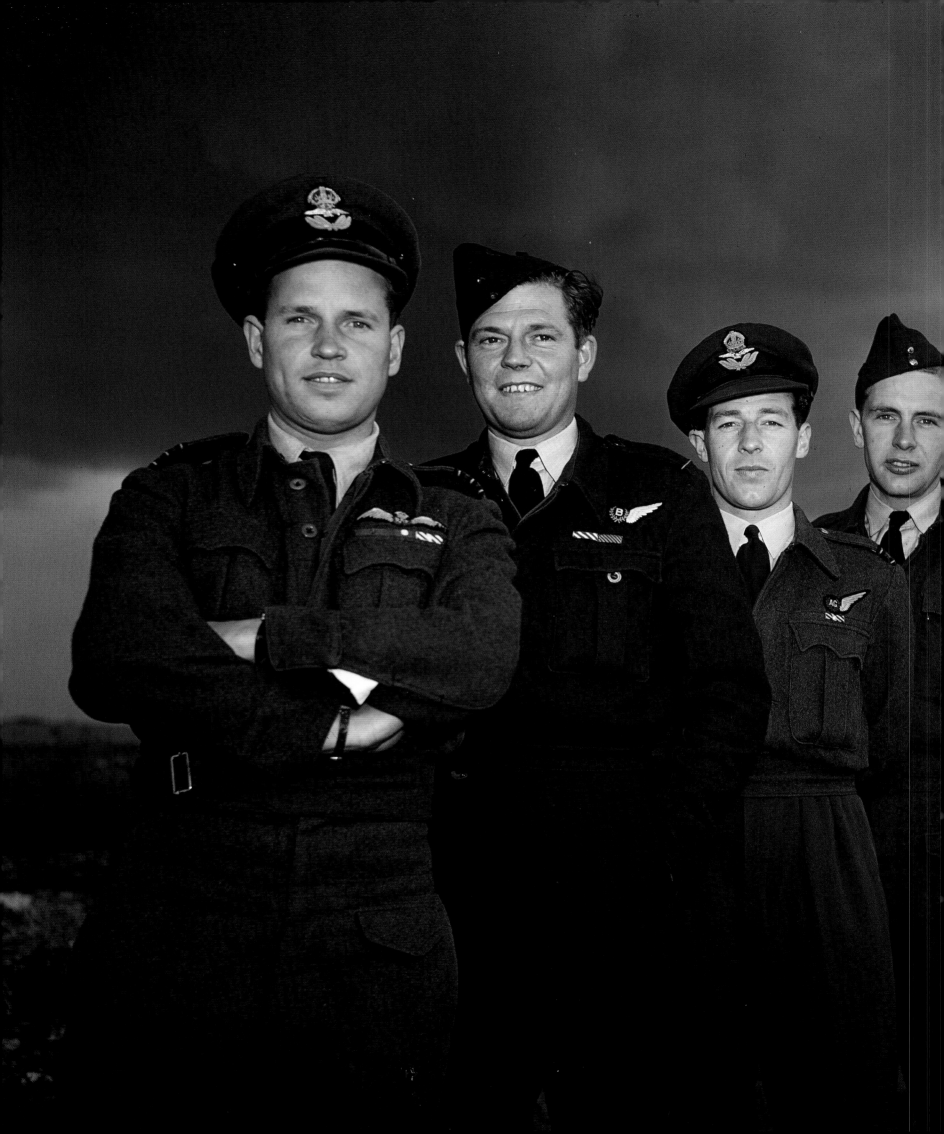

Wing Commander Guy Gibson (far left) and members of his crew at RAF Scampton, July 1943. Gibson led 617 Squadron's celebrated attack on the Ruhr dams in Germany in May of that year, which became known as the Dambusters raid. Soon after this photo was taken, he embarked on a public relations tour around Canada and America. The other men seen here — Fred 'Spam' Spafford, Robert Hutchison, George Deering and Harlo 'Terry' Taerum — died in September 1943 while flying with another pilot on a raid by 617 Squadron to breach the Dortmund-Ems canal. Gibson returned to operations in 1944, but was killed when his Mosquito crashed in the Netherlands.

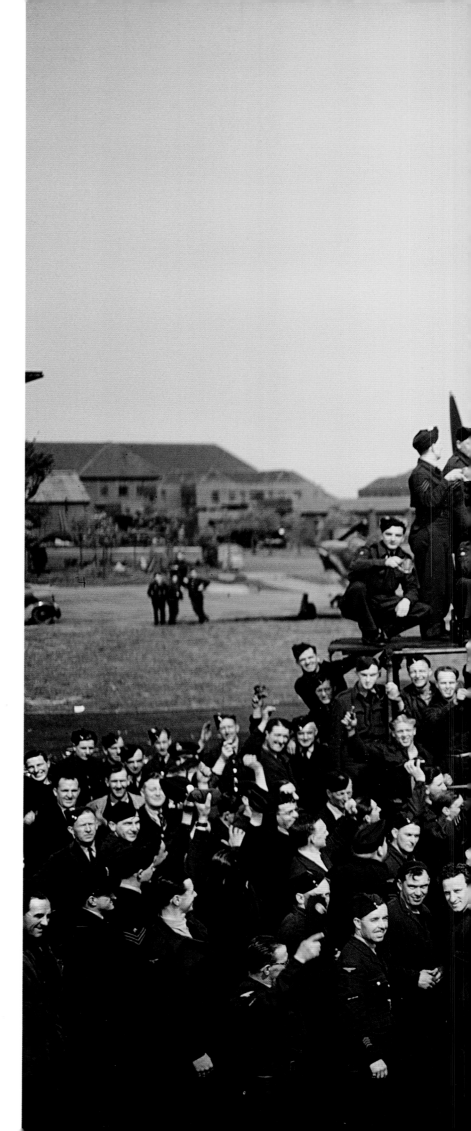

The Lancaster was the RAF's most important night bomber of the war. Of the 7,366 that were built, 3,400 were lost through enemy action. Some aircraft, however, lead charmed lives. This aircraft, R5868, completed 68 operations as 'Q-Queenie' with 83 Squadron, then reached the magic hundred mark as 'S- Sugar' while serving with 467 Squadron. Celebrations were held at Waddington to mark the event in May 1944, with new bomb symbols and Hermann Goering's infamous boast, 'No enemy plane will fly over [the] Reich territory' painted below the cockpit for the occasion. 'S-Sugar' went on to complete 132 missions and now resides in the Royal Air Force Museum in London.

(Next spread)
RAF pilots in training with the Embry-Riddle Company at Carlstrom Field near Arcadia in Florida, 1941. Behind them are their colourfully marked Stearman PT-17s. Embry-Riddle was one of a number of private flying schools contracted by the US government to supply elementary pilot training. The cadets could not wear uniforms at this stage as America was still neutral. Some 18,000 RAF pilots were trained in the United States during the war, either by the US Army Air Corps in what was named the 'Arnold Scheme' after its commander, General Henry 'Hap' Arnold, or in 7 British Training Flying Schools.

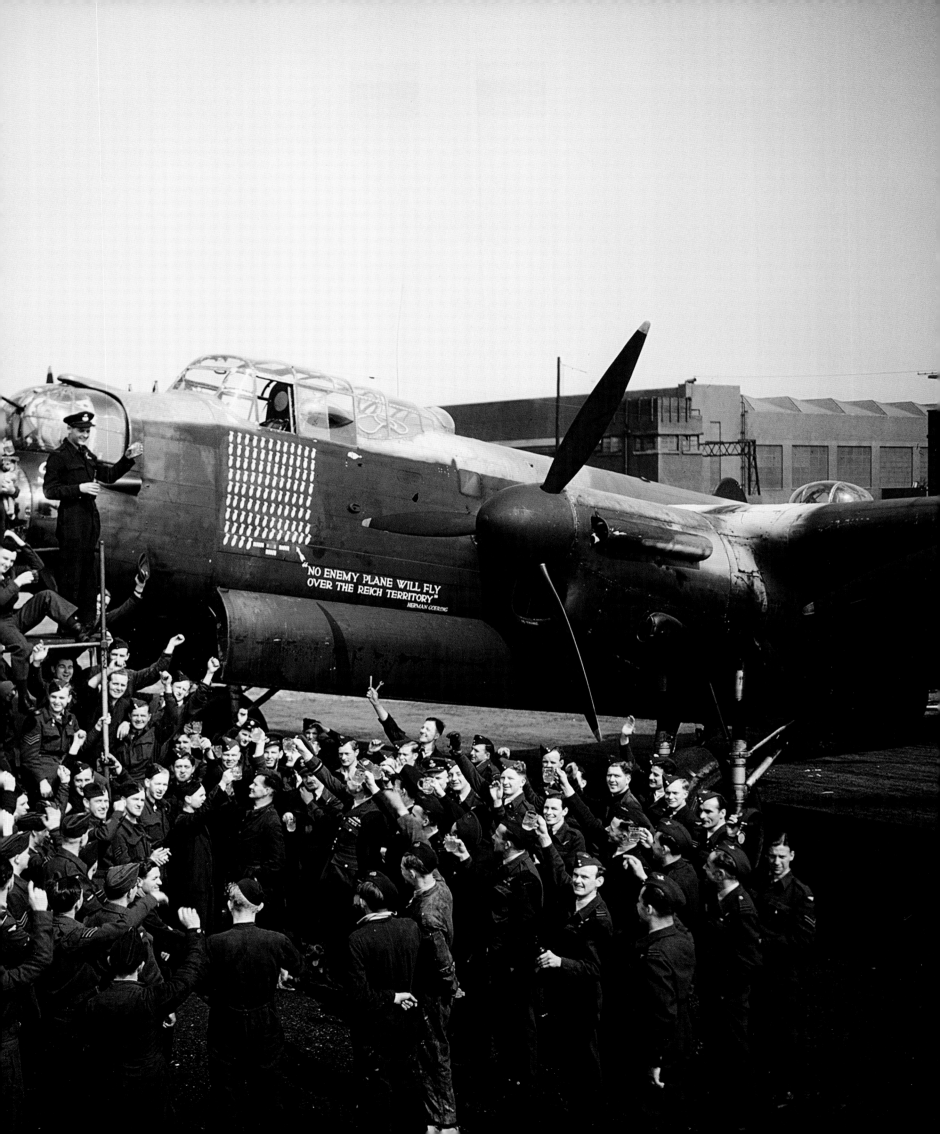

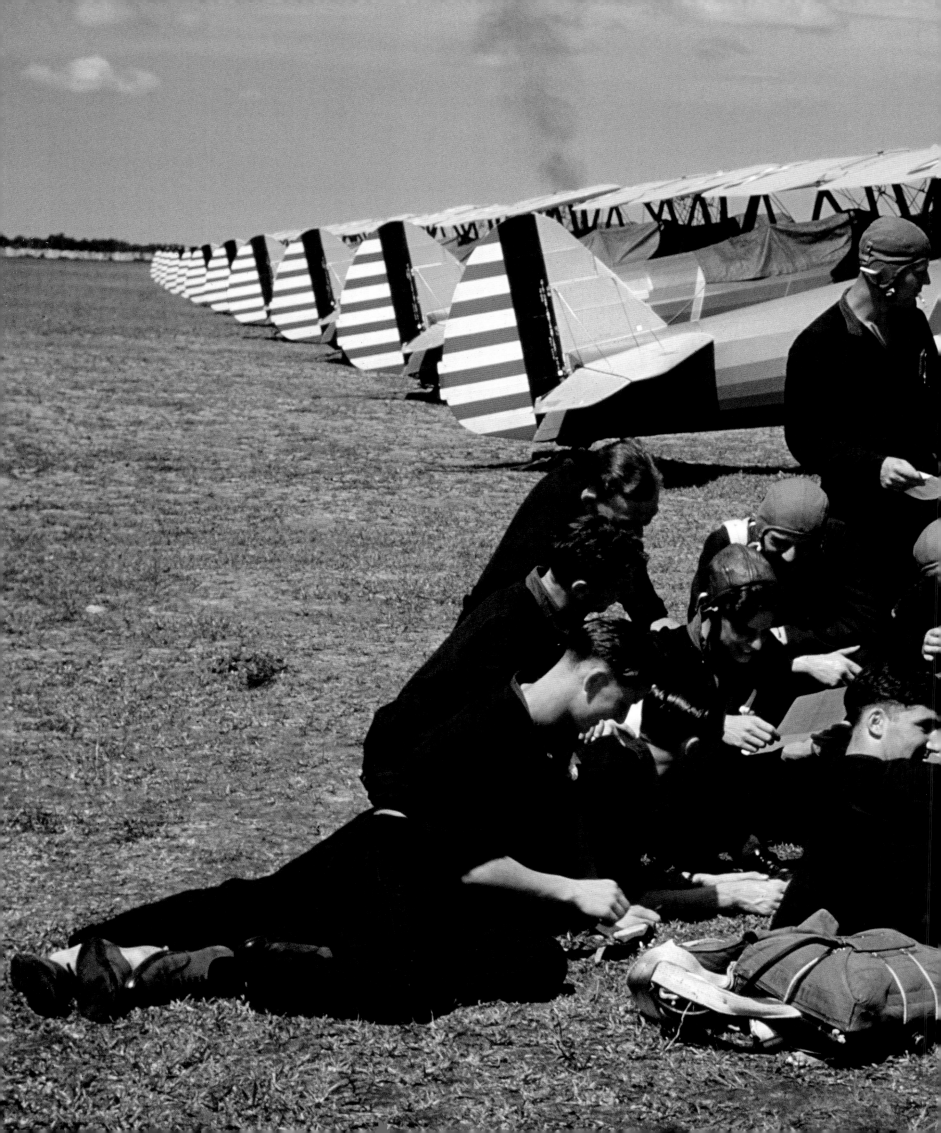

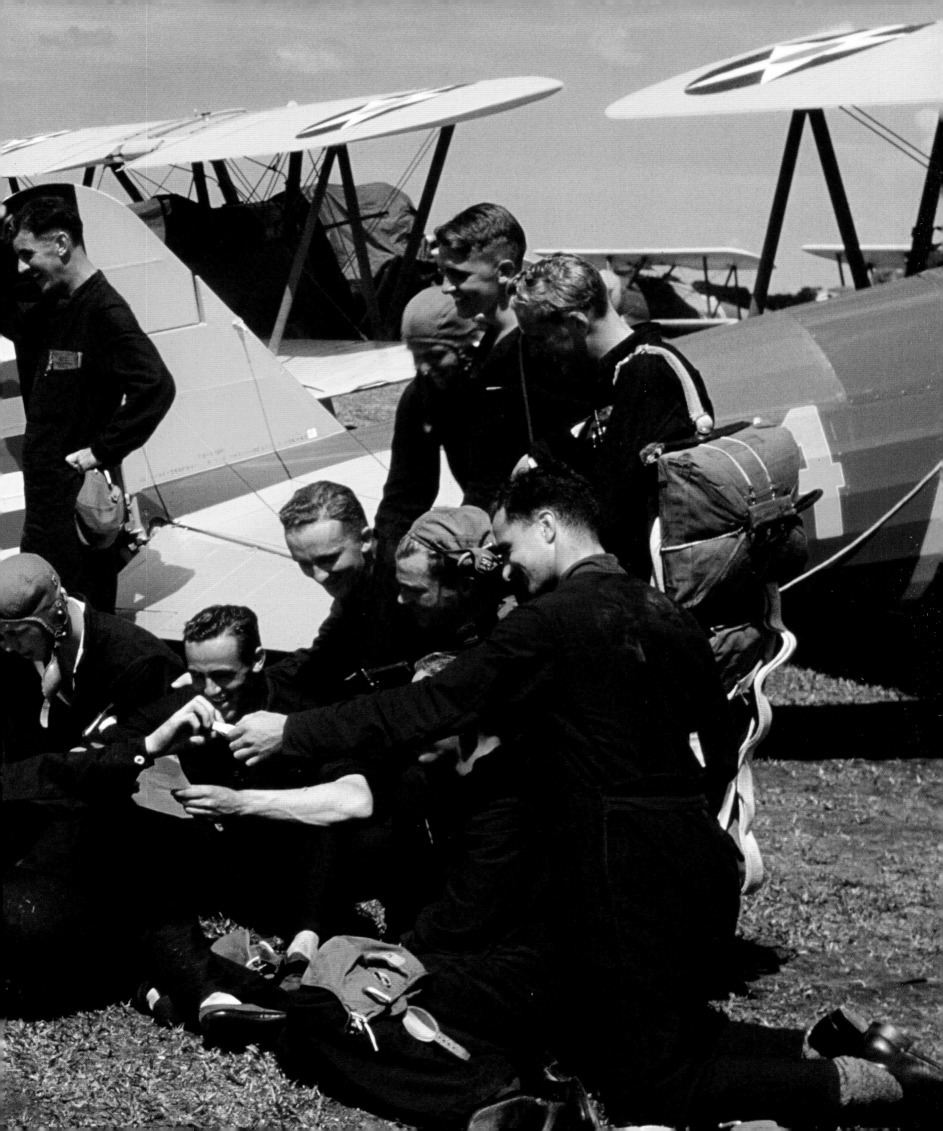

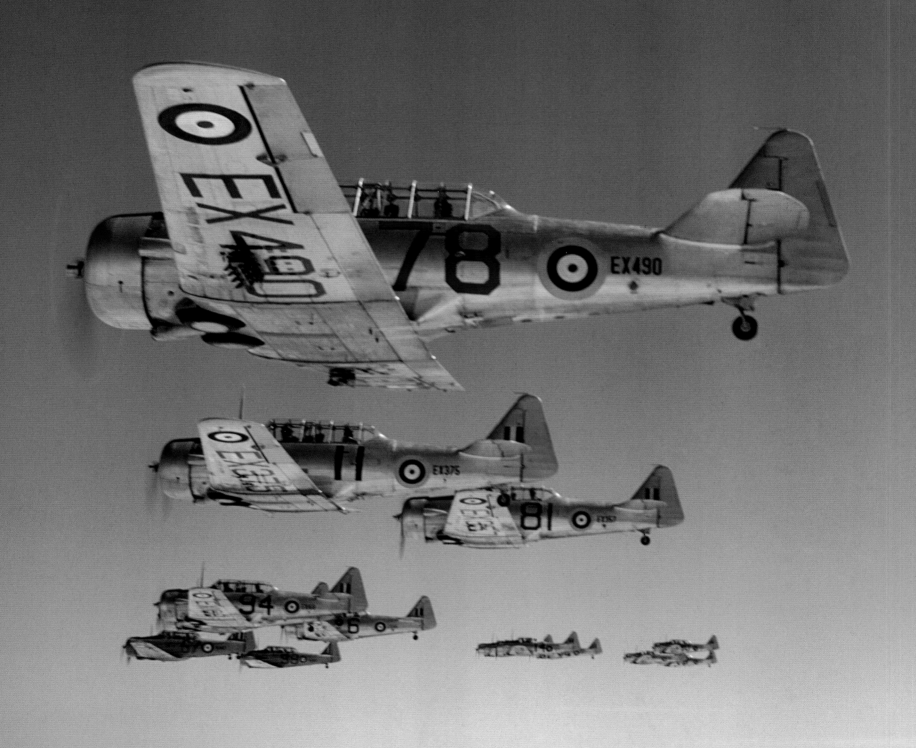

North American Harvard Mk IIAs of No. 20 SFTS (Service Flying Training School) based at Cranbourne, Salisbury, Southern Rhodesia, 1943. Because of Britain's changeable weather, blackout and exposure to enemy air attack, the decision was taken to base most pilot and aircrew training overseas. The British Commonwealth Air Training Plan, also known as the Empire Air Training Scheme, was established in December 1939. Canada was the main contributor, producing 131,533 pilots and aircrew, but Australia, New Zealand and South Africa were also involved. Southern Rhodesia trained 8,235, of whom 446 were killed in accidents.

Boeing B-17F Flying Fortress Mary Ruth – Memories of Mobile alongside other aircraft of the 91st Bomb Group, Eighth Air Force, en route to attack the U-boat pens at Lorient, May 1943. Unlike RAF heavy bomber squadrons, USAAF bomber crews were trained to fly in close formation for mutual protection. Their aircraft were heavily armed with defensive machine guns. However, the concept of the self-defending bomber formation was soon discredited. Losses to enemy fighters on unescorted missions threatened to derail the US bomber offensive. Mary Ruth was one of the casualties – shot down on 22 June on her seventh mission.

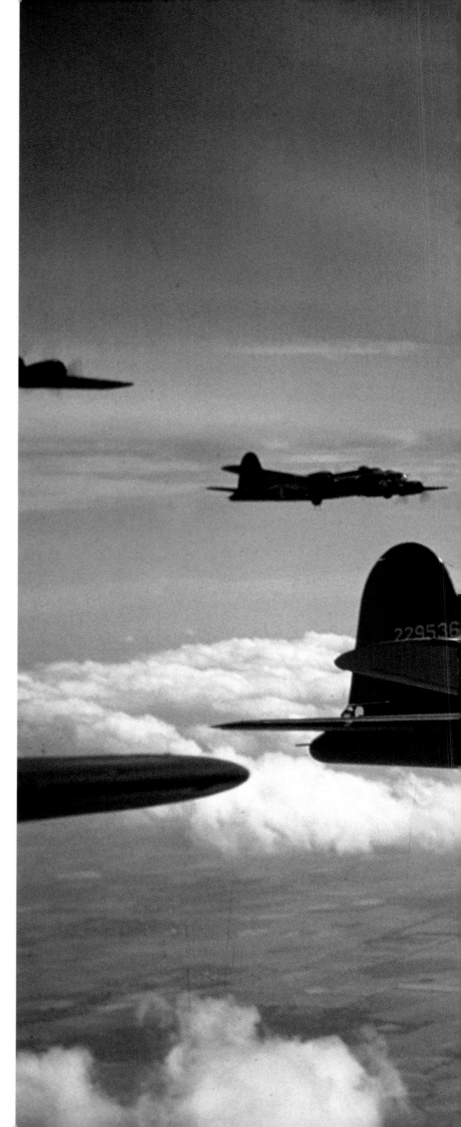

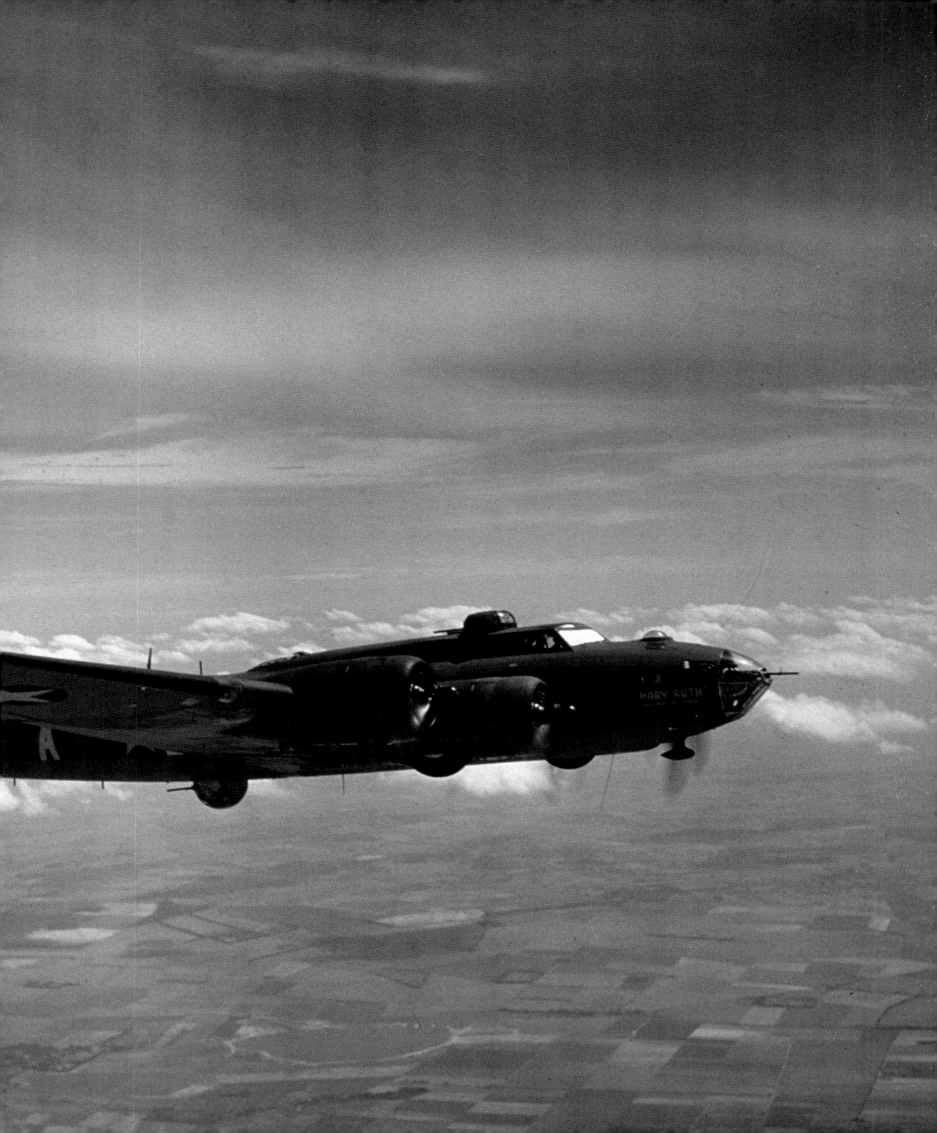

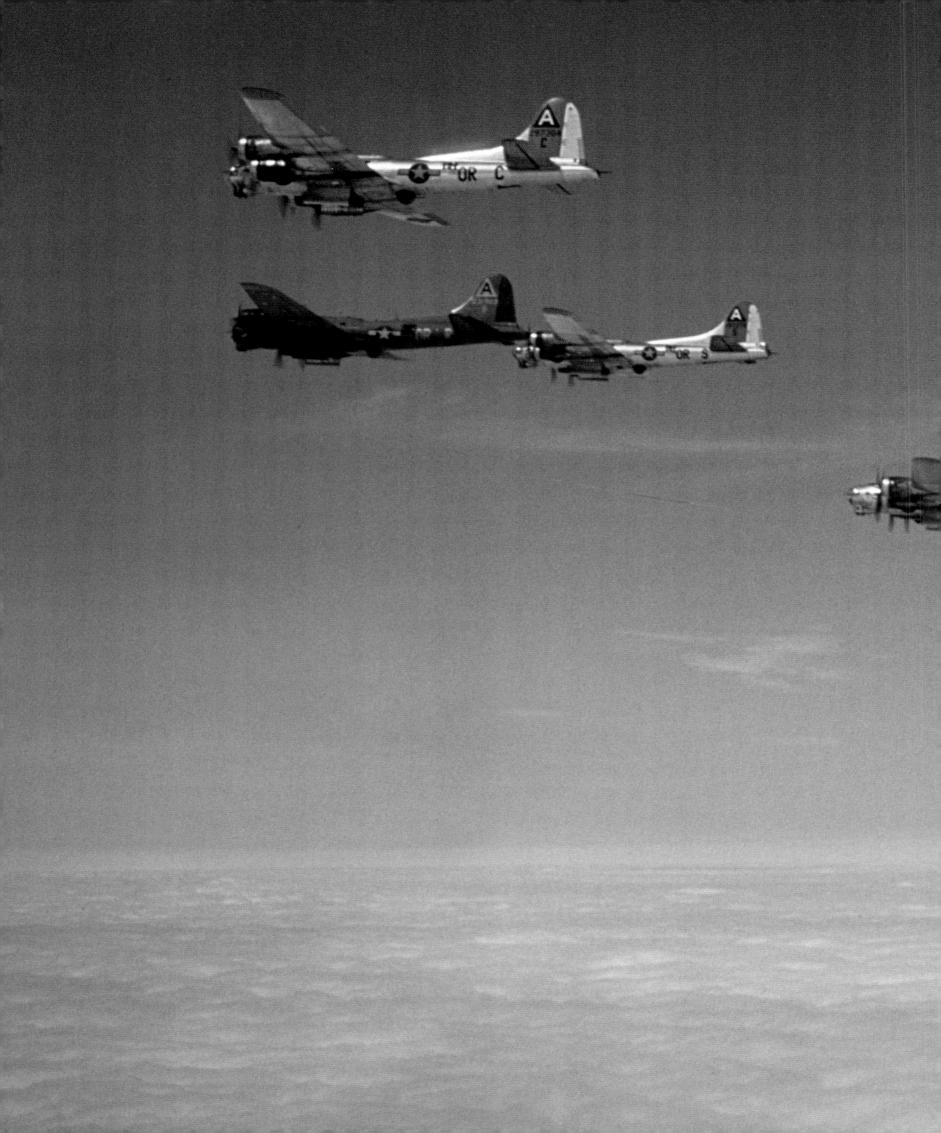

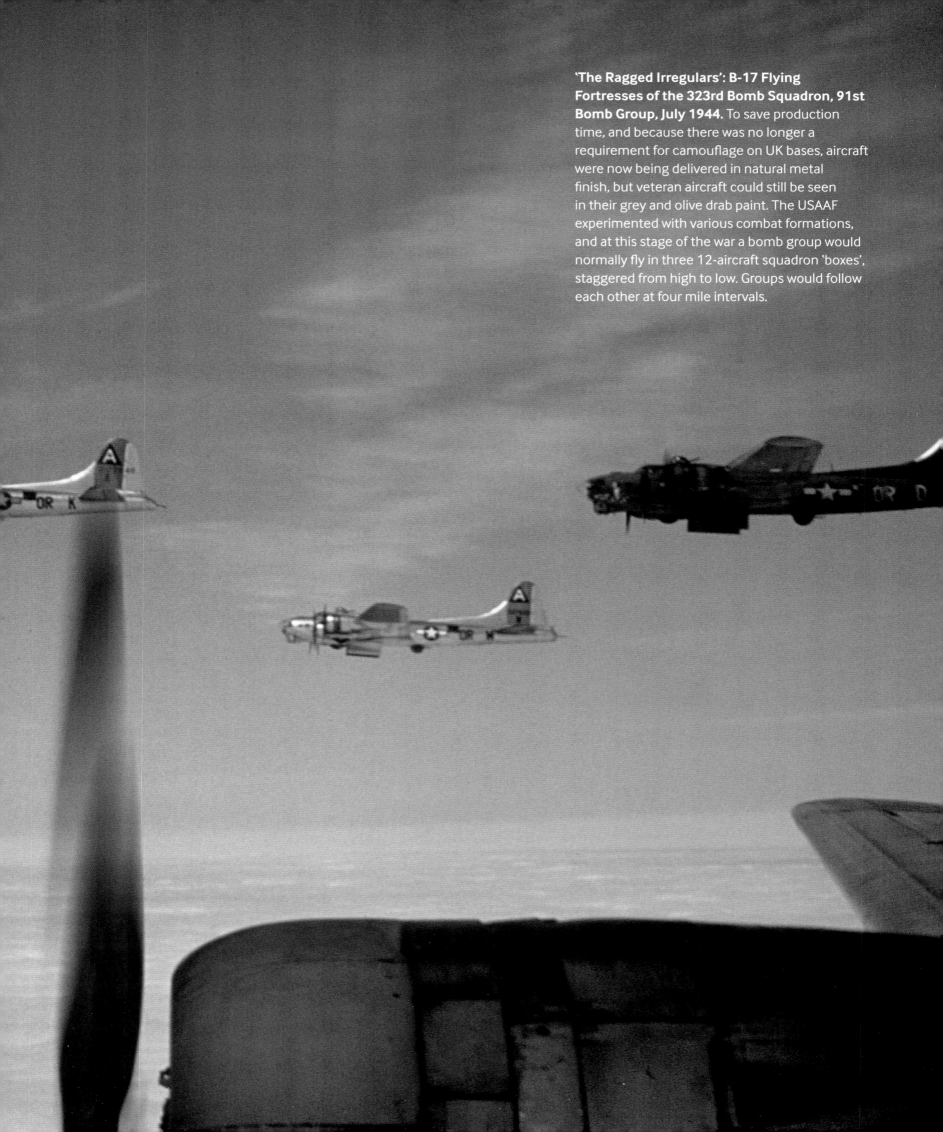

'The Ragged Irregulars': B-17 Flying Fortresses of the 323rd Bomb Squadron, 91st Bomb Group, July 1944. To save production time, and because there was no longer a requirement for camouflage on UK bases, aircraft were now being delivered in natural metal finish, but veteran aircraft could still be seen in their grey and olive drab paint. The USAAF experimented with various combat formations, and at this stage of the war a bomb group would normally fly in three 12-aircraft squadron 'boxes', staggered from high to low. Groups would follow each other at four mile intervals.

Identified by their scarlet nosebands, P-47D Thunderbolts of the 63rd Fighter Squadron, 56th Fighter Group, prepare to take-off on an escort mission from Boxted in Essex, 1944. The 56th FG was known as the 'Wolfpack' and had more ace pilots in its ranks and destroyed more enemy aircraft in the air than any other Eighth Air Force fighter group. The foreground aircraft is *Anamosa II*, flown by Captain Russell B Westfall. The 'bubble hood' canopy and cut down rear fuselage of this latest model of P-47 gave the pilot greater visibility to the rear compared with the earlier 'razorback' version, as seen behind.

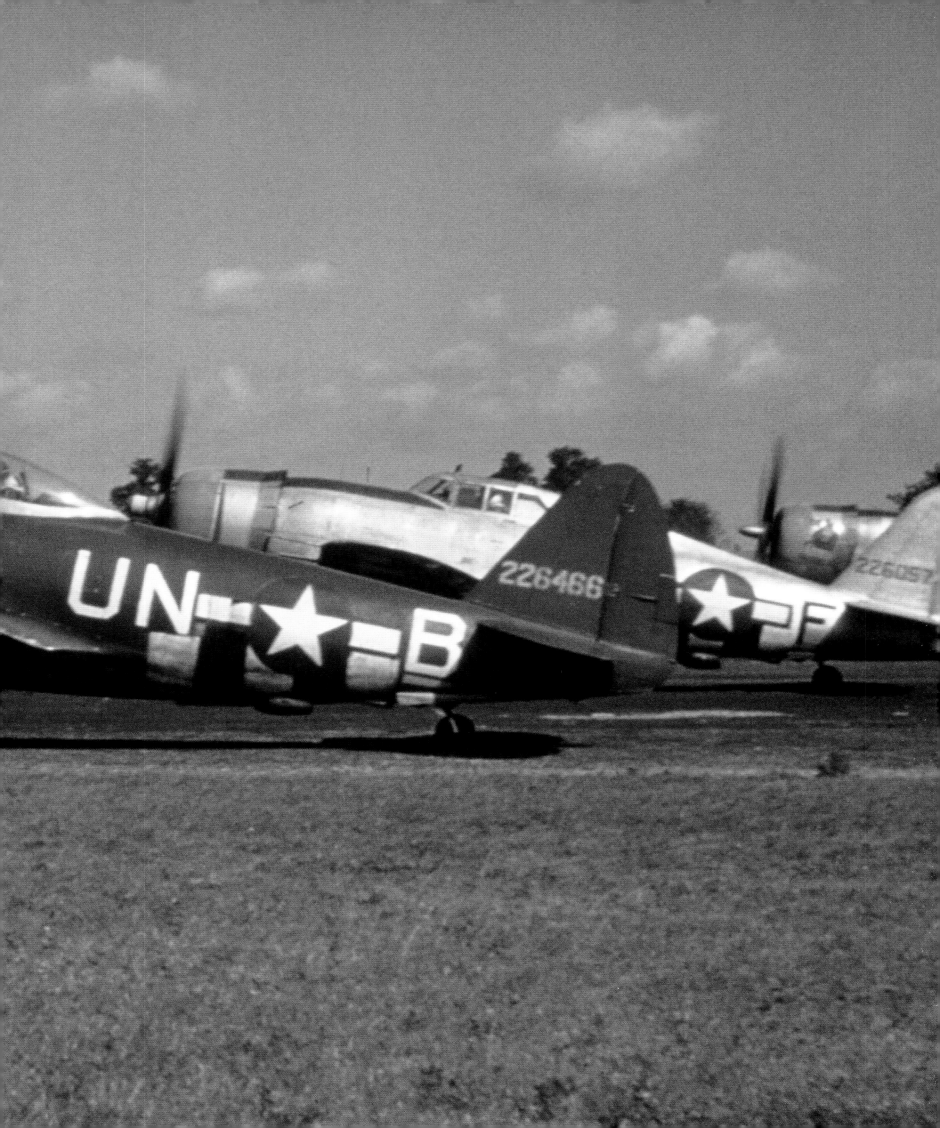

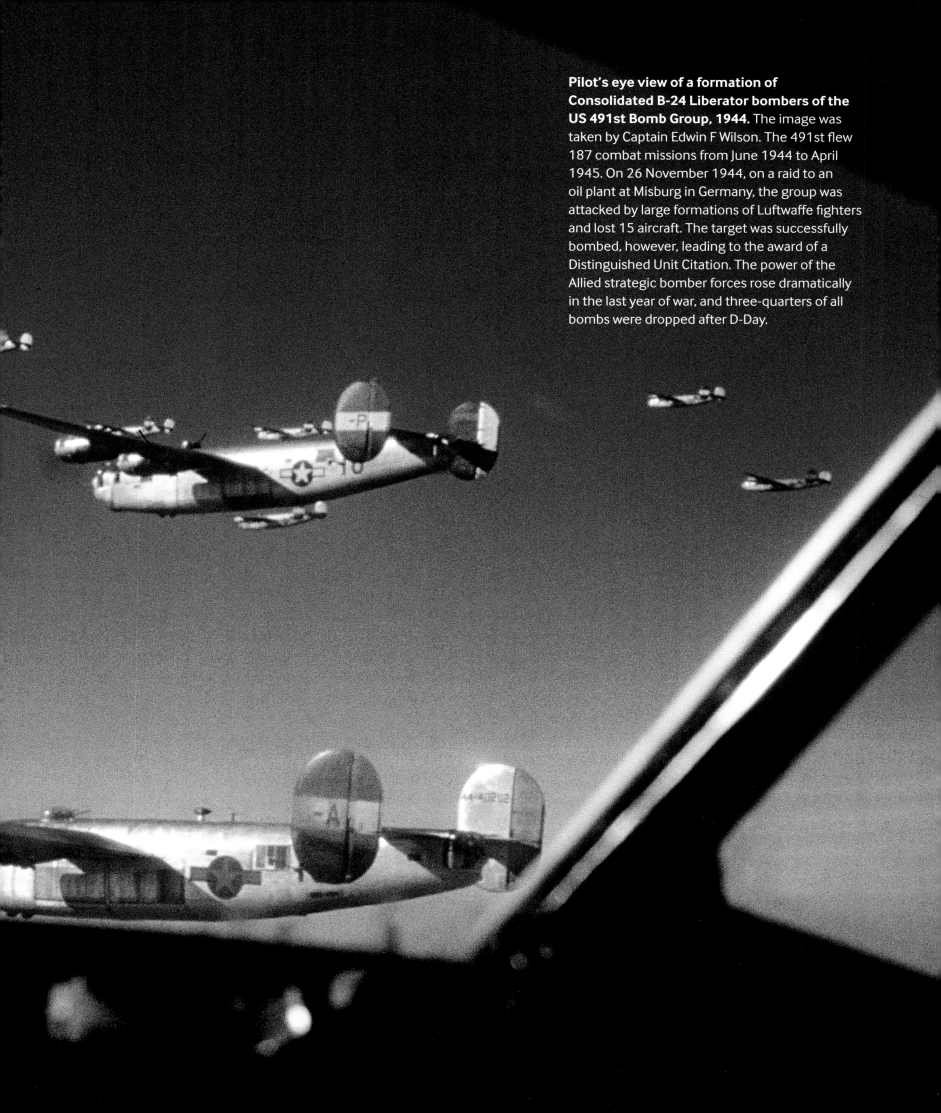

Pilot's eye view of a formation of Consolidated B-24 Liberator bombers of the US 491st Bomb Group, 1944. The image was taken by Captain Edwin F Wilson. The 491st flew 187 combat missions from June 1944 to April 1945. On 26 November 1944, on a raid to an oil plant at Misburg in Germany, the group was attacked by large formations of Luftwaffe fighters and lost 15 aircraft. The target was successfully bombed, however, leading to the award of a Distinguished Unit Citation. The power of the Allied strategic bomber forces rose dramatically in the last year of war, and three-quarters of all bombs were dropped after D-Day.

P-51D Mustang *Jackie* of the 360th Fighter Squadron, 356th Fighter Group, flown by Captain John W "Wild Bill" Crump, March 1945. The Mustang was the war's supreme escort fighter. Fitted with drop-tanks, it could go anywhere the bombers went. Once given free rein to hunt and destroy Luftwaffe fighters on the ground as well as in the air, Mustangs made a more decisive contribution to Allied victory than bomber attacks on the German aircraft factories themselves. The 356th FG became known as the 'hard luck' fighter group, suffering a higher loss-to-kill rate than any other unit in the Eighth Air Force — 201 aerial victories for the loss of 122 aircraft.

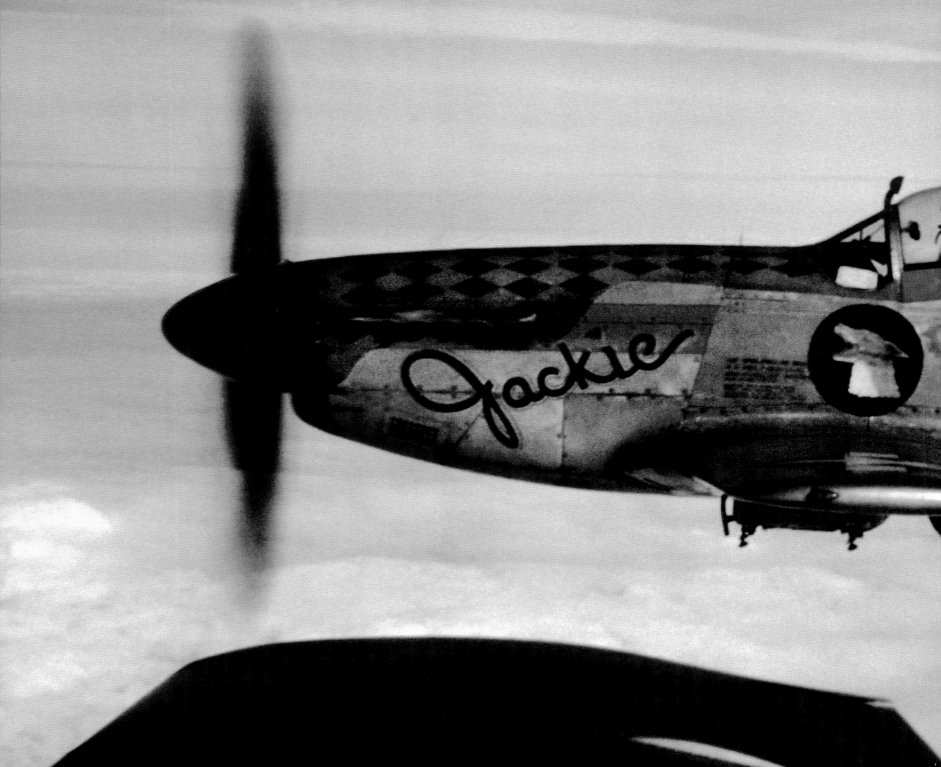

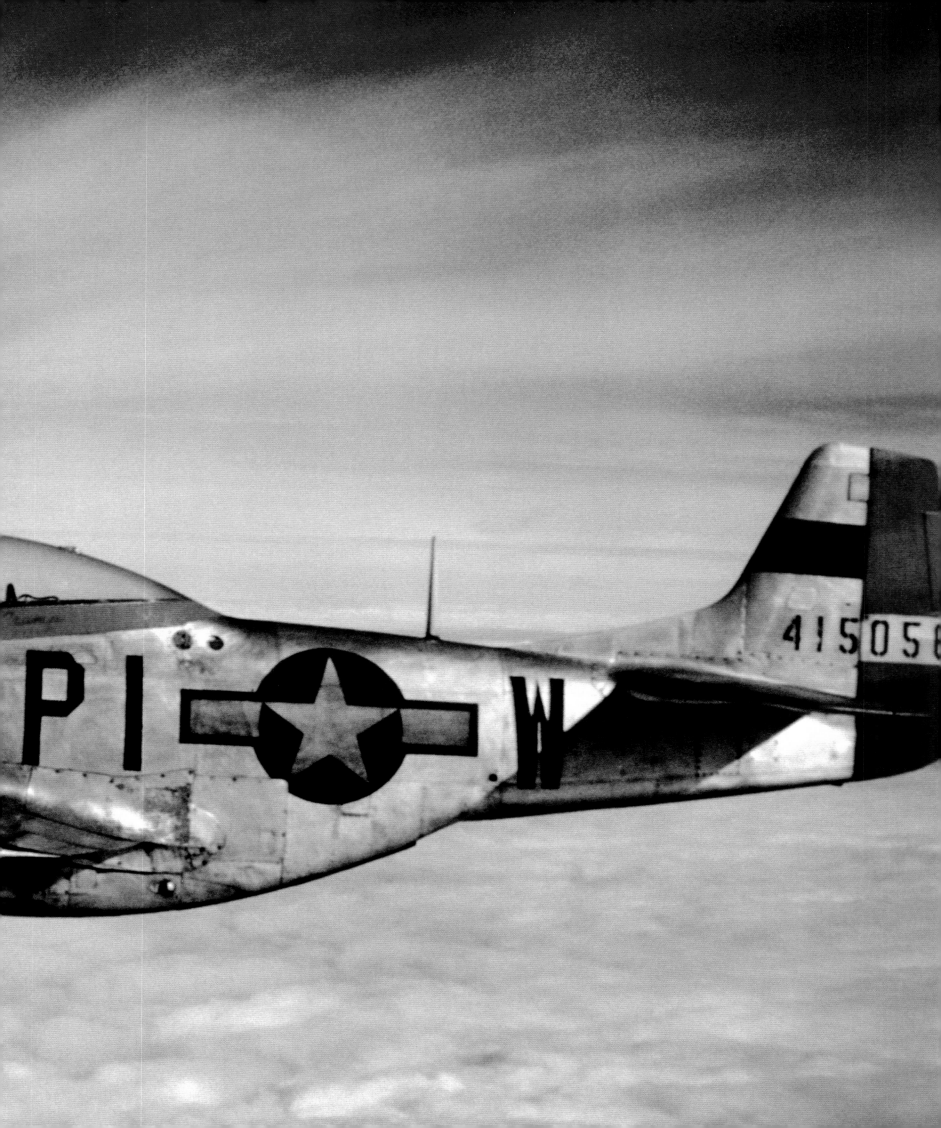

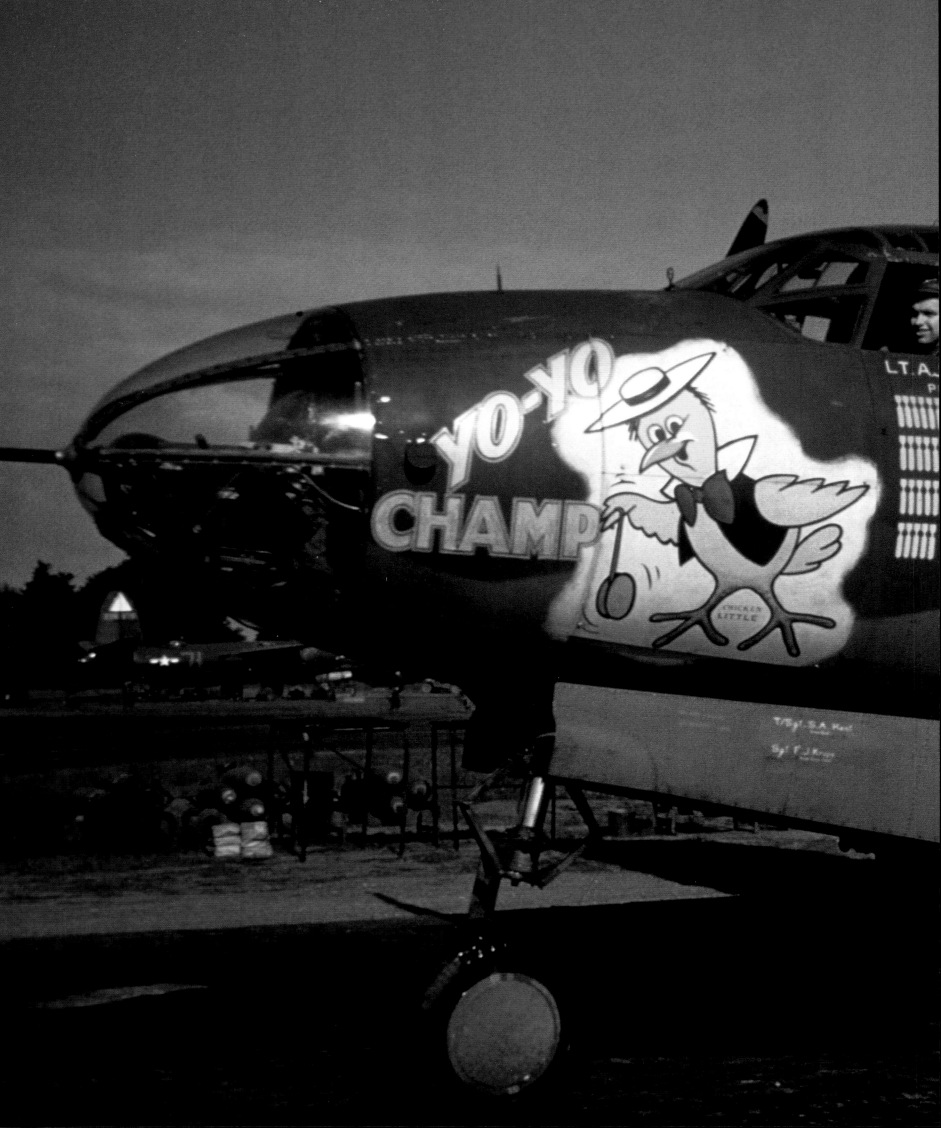

First Lieutenant A J Wood of the 497th Bomb Squadron, 344th Bomb Group, US Ninth Air Force, in the cockpit of his B-26B Marauder *Yo-Yo Champ* at Stansted Mountfitchet in Essex, 1944. The Ninth Air Force was dedicated to tactical operations in support of Allied ground forces in north-west Europe, using fighters and medium bombers like the B-26. Severely damaged in July 1944, this aircraft was repaired and later transferred to the 17th BG. It was shot down by Luftwaffe Me 262 jet fighters over Schwabmünchen in Bavaria on 24 April 1945.

Douglas Boston Mk IIIs of 24 Squadron, South African Air Force, at a typical spartan landing ground in Tunisia, April 1943. The SAAF formed an important component of the Desert Air Force, which had evolved into a mobile, highly effective tactical air force, despite operating in the harshest of conditions. By the time of El Alamein in November 1942 it comprised 29 British, Australian and South African squadrons, and had achieved aerial superiority over the Luftwaffe. The Boston was fast and manoeuvrable, and could carry a 4,000lb bomb load. Four squadrons were equipped with it in the Tunisian campaign, two South African and two British.

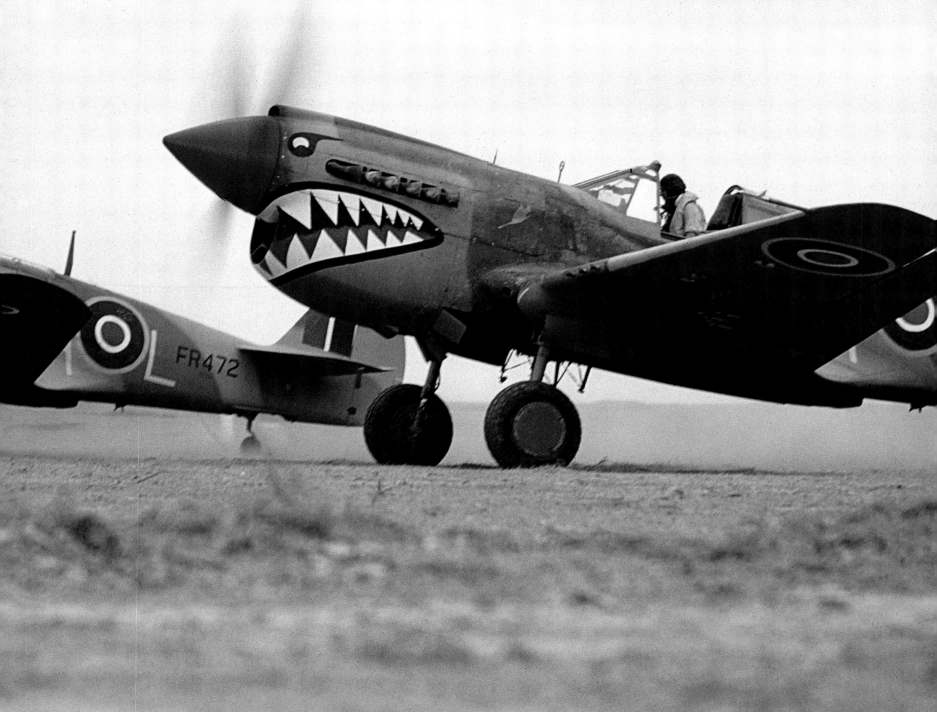

Spitfire Mk Vs of 417 Squadron, Royal Canadian Air Force, flying over the arid Tunisian desert on an escort mission, April 1943. Spitfires first saw action in North Africa in June 1942, having been brought in to counter the Luftwaffe's Messerschmitt Bf 109F, which was superior to other Allied fighters. Ten additional Spitfire squadrons were transferred from RAF Fighter Command in the UK for the Tunisian campaign. 417 Squadron was the only RCAF unit to take part in the North African campaign. As with other Spitfire squadrons, their principal task was to act as 'top cover' for ground attack aircraft.

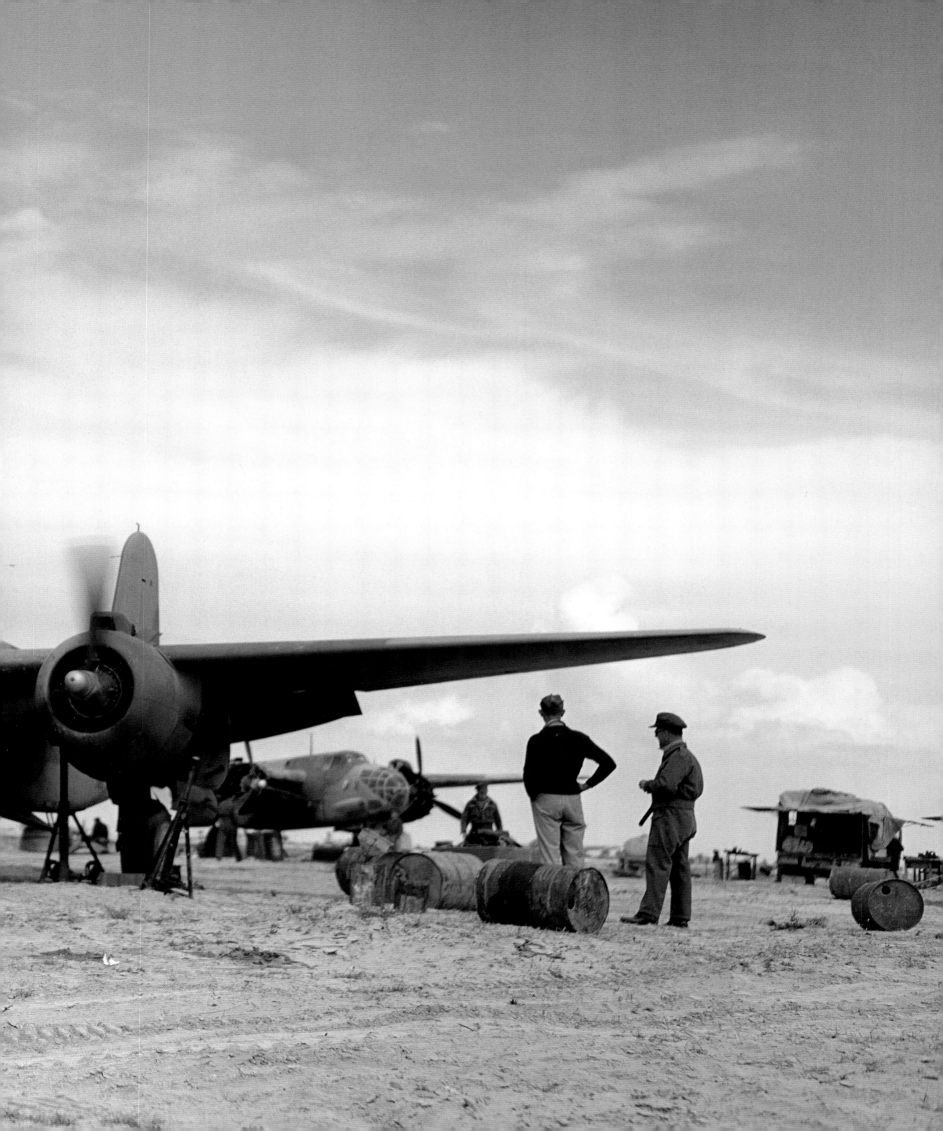

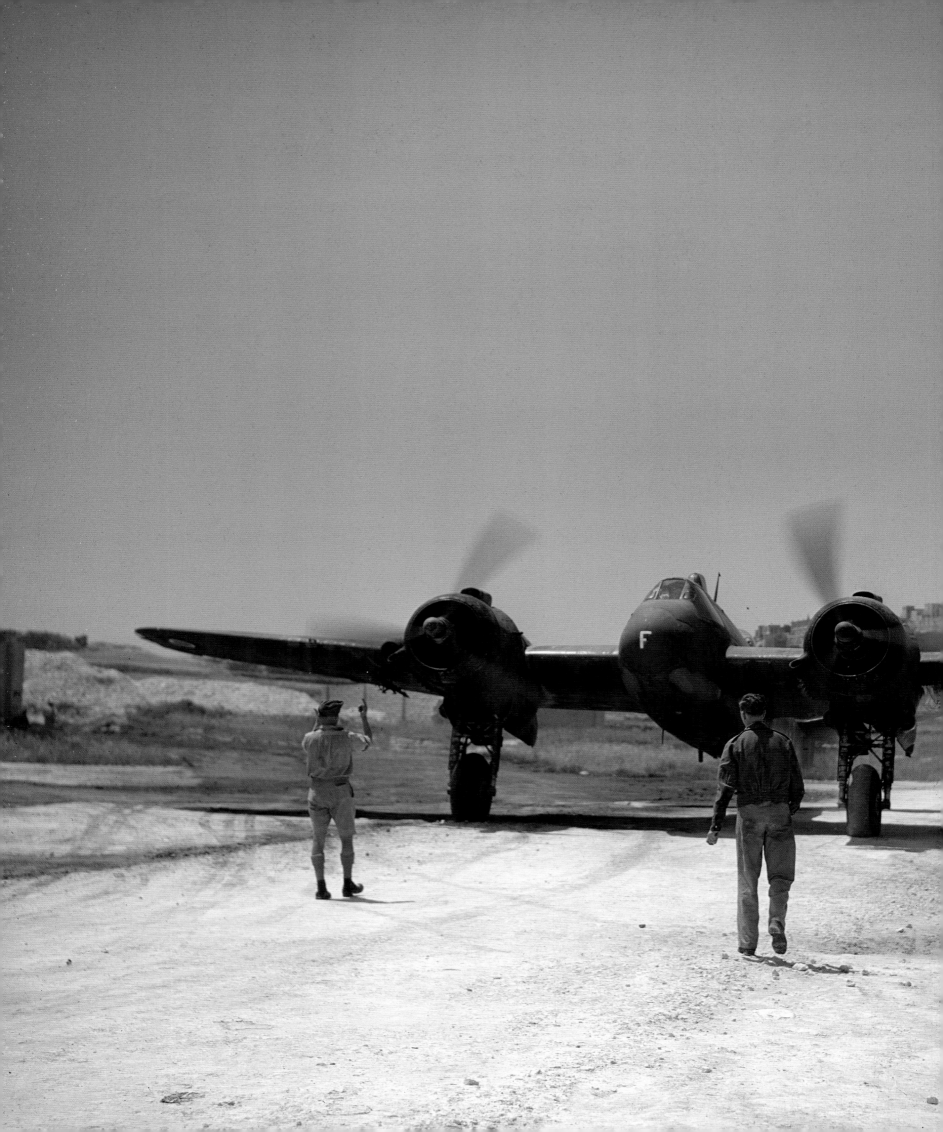

A Bristol Beaufighter Mk VIC of 272 Squadron taxiing at Takali on Malta, June 1943. The strategically vital island of Malta had long been a thorn in the side of Axis forces in North Africa, despite suffering intense bombing attacks. It later served as an important base from which Allied squadrons could support the invasion of Sicily. The Beaufighter was conceived as a long-range fighter but also served successfully in the anti-shipping role. In Britain, Beaufighter squadrons were grouped into 'strike wings' and carried out low-level attacks on German ships off the coast of occupied Europe using a combination of cannon fire, torpedoes and rockets.

A pair of Spitfire Mk IXs from 241 Squadron skirt the imposing slopes of Mount Vesuvius, looming above Naples, January 1944. That month the Allies launched an amphibious assault at Anzio, in an attempt to outflank the German 'Gustav Line' and capture Rome. As ever, air support was a key part of the plan, with many Allied squadrons involved in attacks to disrupt the movement of German reinforcements. 241 Squadron specialised in tactical reconnaissance, but also flew ground attack and escort missions. From 18 March the violence of war was briefly eclipsed by that of the volcano, which was the scene of a major eruption over several days.

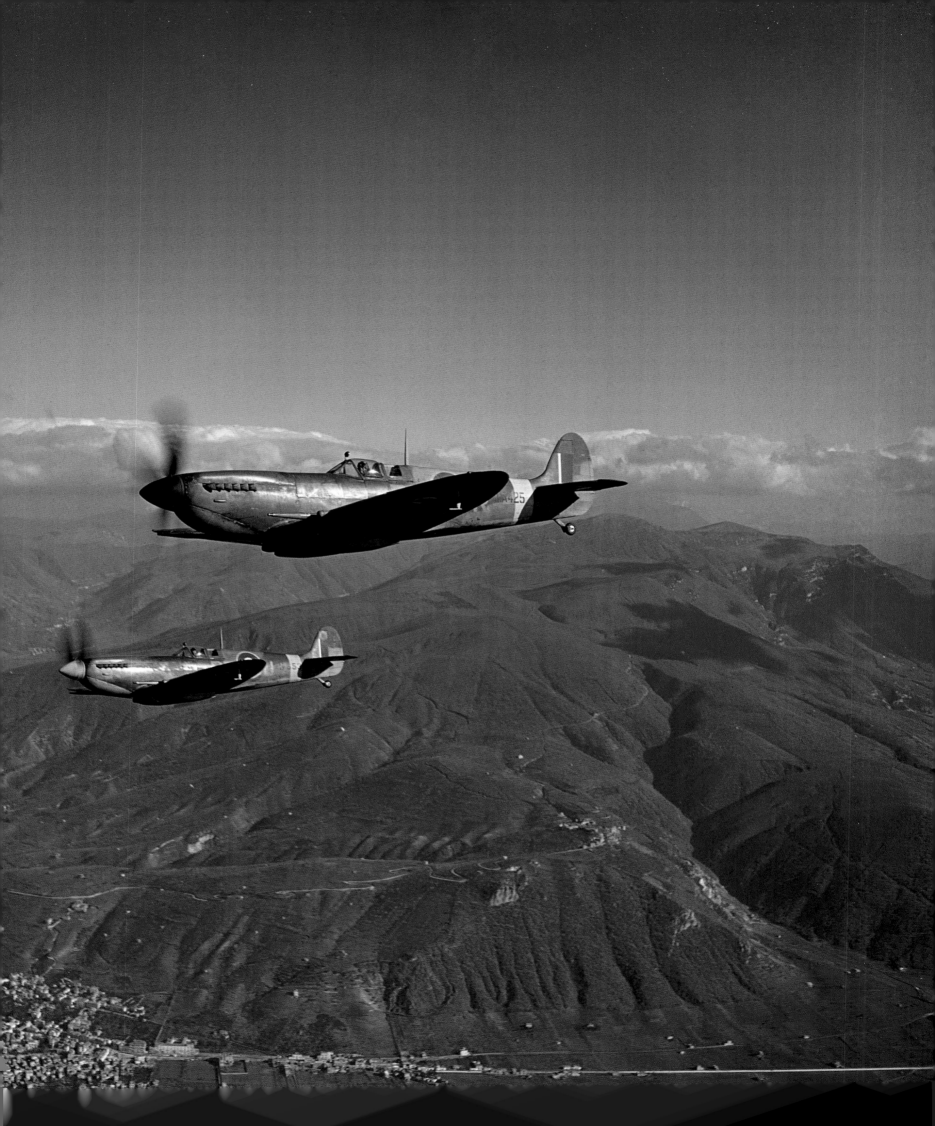

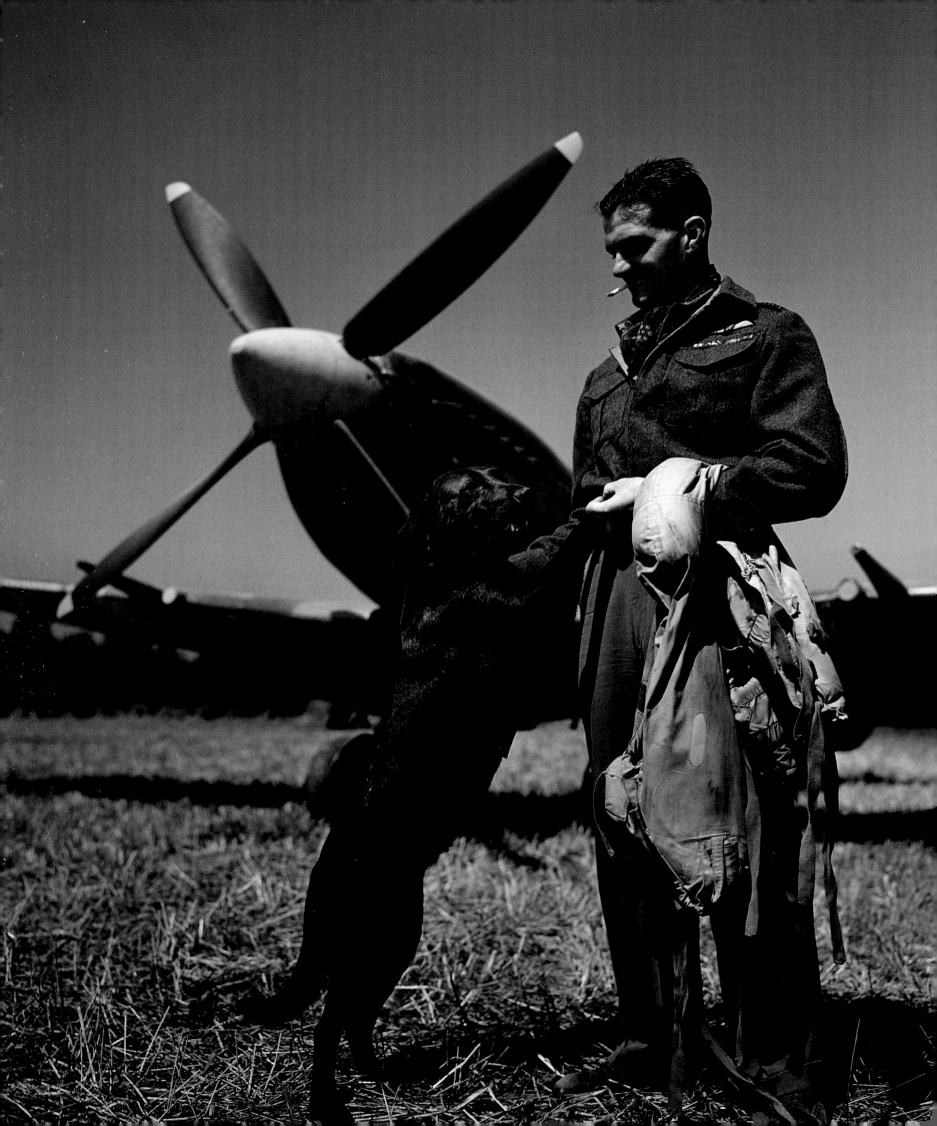

Wing Commander James 'Johnnie' Johnson with his pet Labrador 'Sally' and a Spitfire Mk IX at 'B-2' ALG (Advanced Landing Ground) at Bazenville in Normandy, July 1944. Within hours of D-Day the first airstrips were being built so that Allied aircraft could deploy to France. Johnson, commanding the four Canadian squadrons 127 Wing, was the RAF's top scorer with 31 confirmed kills. The Spitfire Mk IX, rushed into service in June 1942 to counter the Luftwaffe's Focke-Wulf Fw 190, was only ever intended as a stop-gap, but ended up as the most numerous version of the famous fighter, eventually equipping 90 RAF squadrons and serving until the end of the war.

An RAF Thunderbolt Mk II pilot of 30 Squadron is helped into his cockpit at Jumchar, near Chittagong in India, at the start of a sortie over Burma, January 1945. The RAF was heavily involved in support of the British Fourteenth Army's successful offensive against the Japanese between late 1944 and mid-1945, flying bombing, ground attack and supply dropping missions. A total of 16 squadrons were equipped with the sturdy American-built Thunderbolt, which was used for ground attack or long-range escort duties. This aircraft wears the standard white identification markings for the Far East theatre.

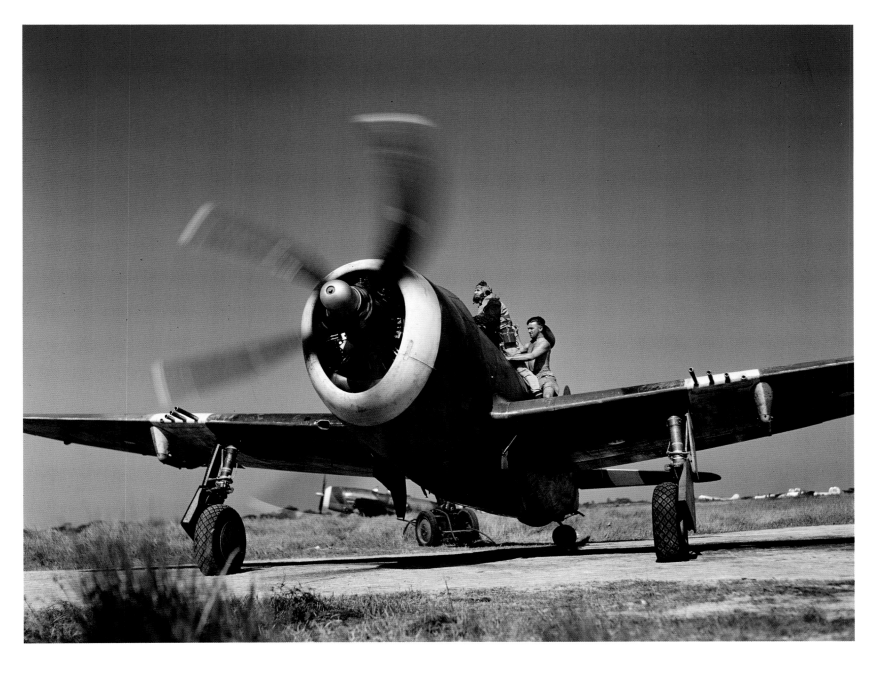

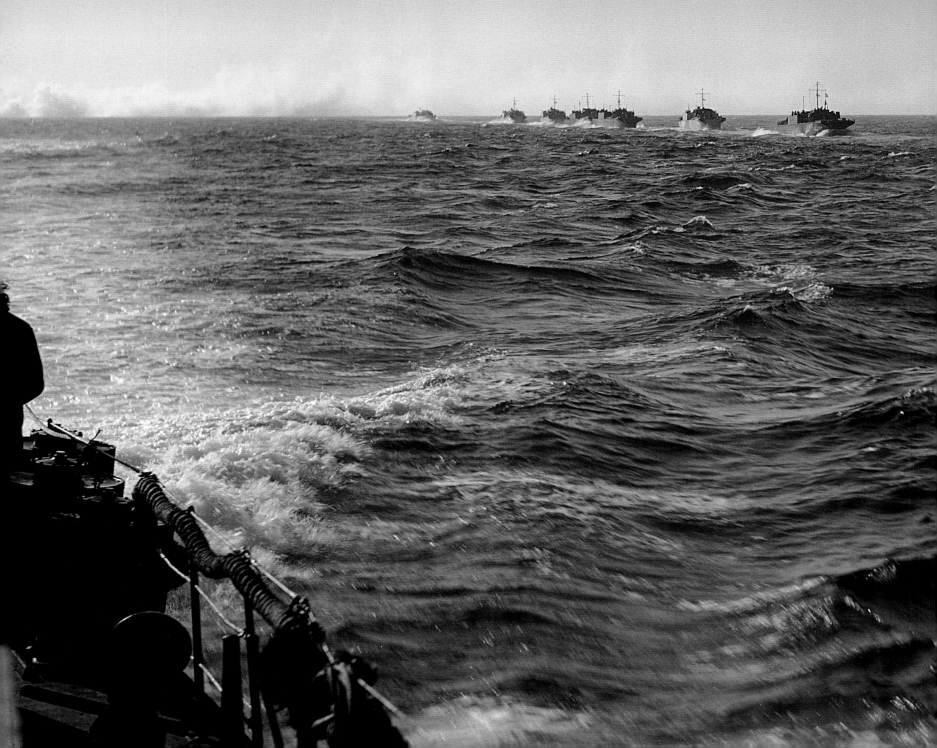

CHAPTER FOUR

THE WAR AT SEA

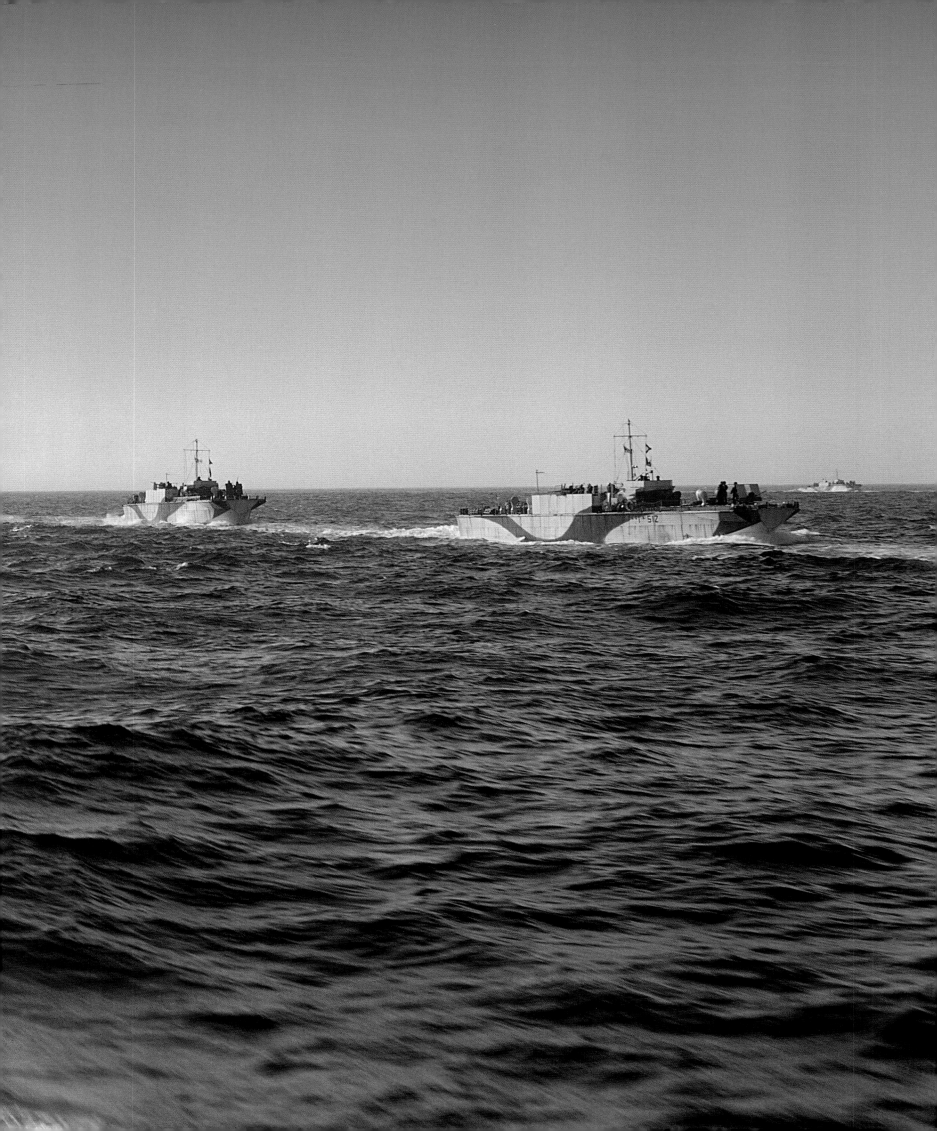

The Royal Navy was in action from the very start of the war, and its traditional fighting spirit immediately apparent. A crucial task was the imposition of an economic blockade on Germany, a measure which had been so successful during the First World War. The overriding strategic priority, however, was safeguarding Britain's own maritime links with its Allies and overseas dominions. The defence of seaborne trade and communications became a vital and prolonged battle of attrition, one that saw huge changes in the technology and tactics of naval warfare.

The war at sea saw the demise of the battleship as the dominant naval weapon, and the rise of aircraft, whether carrier or shore based, as the primary instrument of control over the oceans. The vulnerability of warships to air attack was revealed early on, with the Royal Navy suffering heavy losses during troop evacuations from Dunkirk and Crete. Some believed heavily armed battleships would be able to defend themselves, but the sinking of HMS *Prince of Wales* and HMS *Repulse* by the Japanese in 1941 proved that to be a fallacy.

From the start, Hitler's U-boats were the most prolific and dangerous enemy. Their aim was to sink enough merchant ships to starve Britain into submission, and the occupation of western French ports gave them direct access to the main Allied convoy routes. The Battle of the Atlantic was the pivotal campaign of the war. Britain's very survival, and ultimately the success of any future Allied military operations in the Mediterranean and Europe, depended on maintaining links with America and Canada. Great effort was also expended sending aid to the Soviet Union, which led to major convoy battles in Arctic waters.

The U-boats, operating in 'wolf packs' against the convoys, were spectacularly successful at first, but there were never enough of them to gain a strategic advantage, and their constant radio communications made them vulnerable to detection. America's entry into the war helped win the tonnage battle as US shipbuilding outpaced losses of merchant shipping. Allied countermeasures, including radar, new anti-submarine weapons and specialised escort vessels eventually prevailed. In 1943, after several climactic convoy battles, the U-boats retreated into European waters.

Germany's much smaller surface fleet suffered irreparable losses at the hands of the Royal Navy during the 1940 Norwegian campaign, and the few major warships it had available enjoyed little success. Most famous was the battleship Bismarck, which sank HMS *Hood*, the Royal Navy's most prestigious ship, in dramatic fashion during a sortie to attack Atlantic shipping in May 1941. Bismarck was in turn hunted down and sent to the bottom. Another was *Scharnhorst*, sunk after a night battle off northern Norway in December 1943. HMS *Duke of York* became the last British capital ship to sink another in a surface engagement.

Unlike the German U-boats far out in the Atlantic, British submarines fought their war mostly in the shallow, dangerous waters near hostile coastlines, including the North Sea, the Mediterranean and the Far East, where mines and enemy patrols were a constant hazard. They were involved in supply runs and clandestine activities too, landing agents and small raiding parties. Royal Navy submarines based on Malta took a heavy toll of Axis shipping bringing supplies to Axis forces in North Africa, but at great cost to themselves.

The Mediterranean was always a major focus for the Royal Navy, where it fought for control against Italian naval forces. A significant victory was won in March 1941 at Cape Matapan off Greece, after which Italy's powerful fleet rarely ventured out. The Royal Navy's key mission here was to escort convoys to Egypt and the besieged island of Malta, where the main threat was posed by Axis aircraft and submarines. Operation 'Pedestal' was the most famous of many costly attempts to keep Malta supplied, during which nine merchant ships, an aircraft carrier and two cruisers were sunk.

Whether in the Atlantic or the Mediterranean, air power was always the most significant factor in naval operations. The Royal Navy began the war with seven aircraft carriers, four of which were due for retirement, and only a few hundred antiquated aircraft. But six new modern fleet carriers were already under construction, all of which would see extensive service. Despite its early disadvantages, the Fleet Air Arm carried out many notable operations, including a strike by Swordfish aircraft on the Italian fleet at Taranto in November 1940, and several attacks on the

battleship *Tirpitz*, holed up for much of the war in a Norwegian fjord and a major threat to the Arctic convoys. The Royal Navy would also eventually deploy over 40 small 'escort carriers' which provided much needed air cover for the all-important convoys.

The RAF had its own air component, which played a vital role in the Battle of the Atlantic. Coastal Command evolved from small beginnings into a powerful maritime air force, which cooperated effectively with the Royal Navy to protect the Atlantic convoy routes. Range was the limiting factor, but the establishment of RAF bases in Iceland, West Africa and the Azores greatly extended air cover. Long-range, land-based aircraft equipped with depth charges, airborne radar and even searchlights took an increasing toll of enemy submarines, and helped to close the so-called 'Atlantic Gap', that area of ocean where hitherto they had been able to operate with relative impunity.

The Royal Navy became increasingly involved in amphibious warfare as Allied armies went on to the offensive. The invasion of North Africa in November 1942 was the first large-scale combined operation of this kind, and was followed by further landings in Sicily and Italy in 1943. The Royal Navy helped escort assault troops and their follow-up waves, supplied air cover over the anchorages, and contributed to the massive fire support needed to suppress enemy defences. The most significant event was Operation 'Neptune', the invasion of Normandy on 6 June 1944.

Meanwhile, on the other side of the world, Japan had crippled the US fleet at Pearl Harbor and had enjoyed a brief period of dominance before US forces began a long fight-back, which included costly assaults on Japanese held islands. The Royal Navy, on the defensive in the Indian Ocean since the fall of Singapore in February 1942, had little involvement, but in 1945 a powerful new task force, the British Pacific Fleet, joined the Americans for the final stages of the Pacific campaign.

(Page 160)
Infantry landing craft on an amphibious exercise in the English Channel, 1943. In the lead is LCI(S) 512, destined to be lost in action during the D-Day landings. Most landing craft were built in America, but these particular vessels were designed by Fairmile Marine in the UK and assembled in various small boatyards. They were used by the commando forces and each could carry 100 men. Operation 'Neptune', the codename for the naval mission on D-Day, depended on the availability of a host of specialised landing craft, from huge ocean-going tank landing ships to the small 'Higgins boats' that carried a platoon of assault troops.

(Right)
A Royal Navy officer uses a sextant aboard a Town-class destroyer on convoy escort duty, 1942. This ship was one of 50 mothballed American First World War destroyers provided to Britain as a result of the 'destroyers for bases' agreement of September 1940. In exchange, the United States was granted leases to establish air and naval bases in the British West Indies, Newfoundland and Bermuda. The ships themselves were in poor condition, and of limited usefulness. The most famous was HMS *Campbeltown*, which was used to ram and destroy the dry dock at St Nazaire during a daring raid in March 1942.

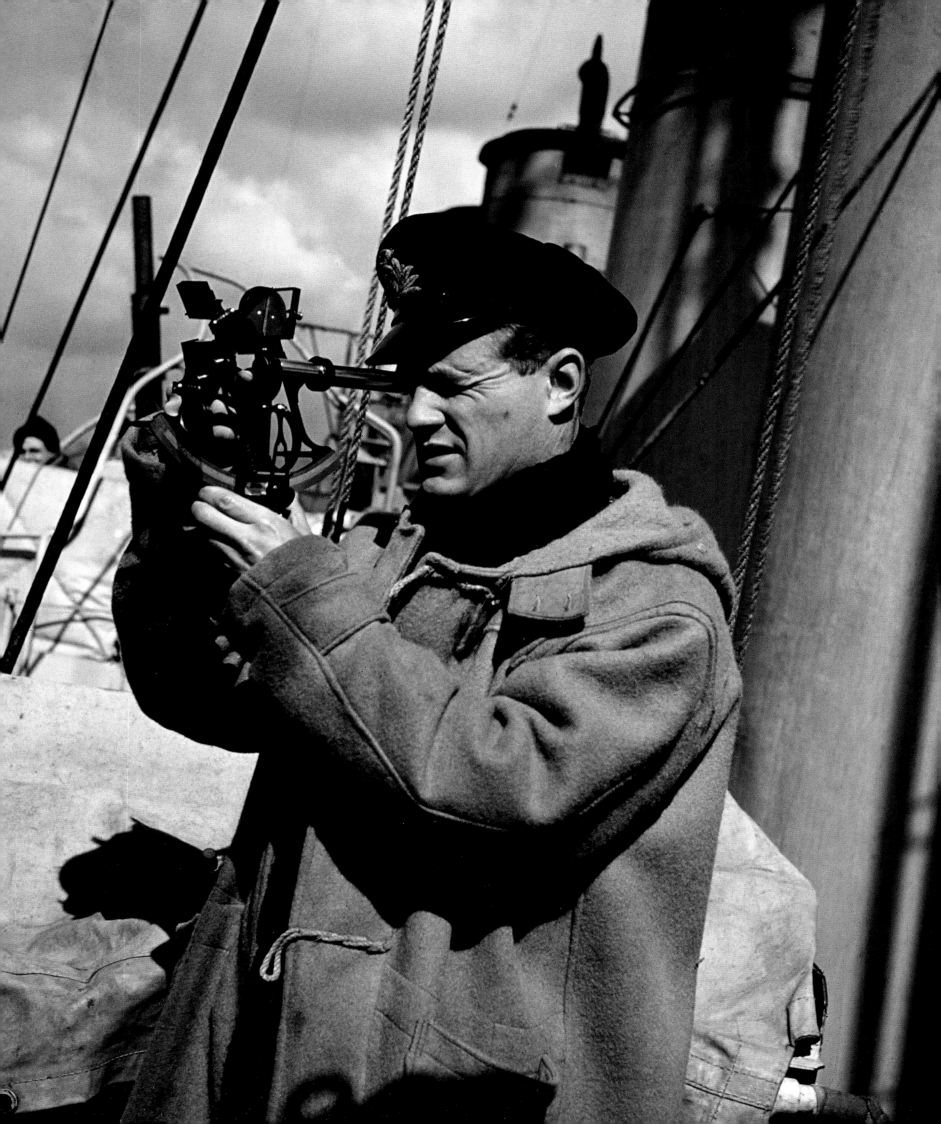

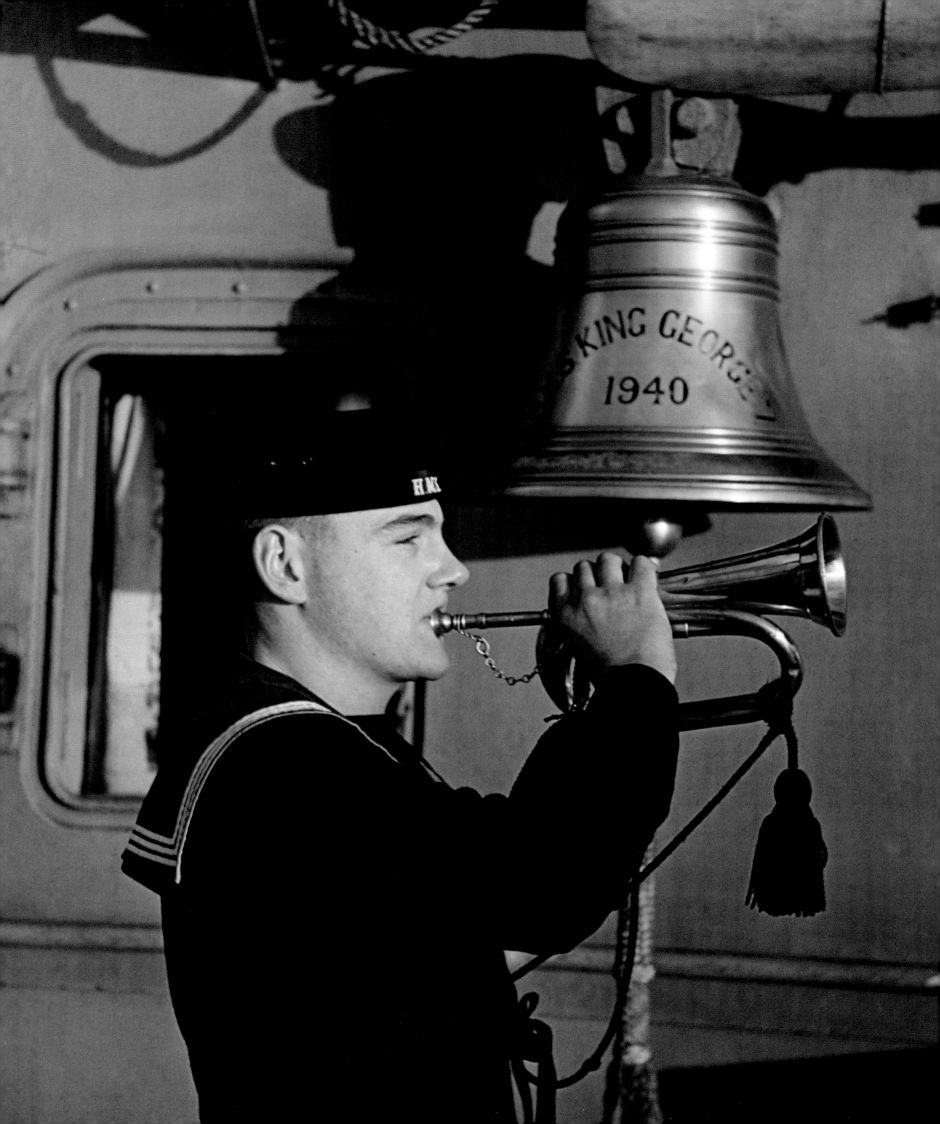

Images taken on board the battleship HMS King George V at the Royal Navy's base at Scapa Flow in Scotland, 1942. 'KGV' was the lead ship in a class of five modern British battleships launched at the start of the Second World War. As part of the Home Fleet, her main task was to provide distant cover for Atlantic and Arctic convoys, helping to deter attacks by German capital ships. In May 1941 she took part in the destruction of the German battleship Bismarck. She later served in the Mediterranean, supporting the Allied invasions of Sicily and Italy. In 1945 she was part of the British Pacific Fleet, serving in the anti-aircraft cover and shore bombardment role during the final offensive against Japan.

A bugler in front of the ship's bell on the quarterdeck, which displays the year of her commission. Bugles were used to sound instructions and alerts throughout the ship, in this case relayed by a microphone and speaker system. 'KGV' had an official complement of up to 1,631 officers and men.

A comparison in firepower: a sailor poses with a Bren gun. Behind is 'B' turret with two 14-inch guns. 'A' and 'Y' turrets had four 14-inch guns each. The design of the King George V-class had been constrained by the Second London Naval Treaty of 1936, the last in a series of international treaties that sought to limit the size, number and armament of capital ships. Britain proposed an upper gun calibre limit of 14 inches, and stuck to it even though foreign navies were building larger, more powerful vessels. But opting for heavier guns would have delayed production of the Royal Navy's new battleships, and add weight that could be better used for armour protection.

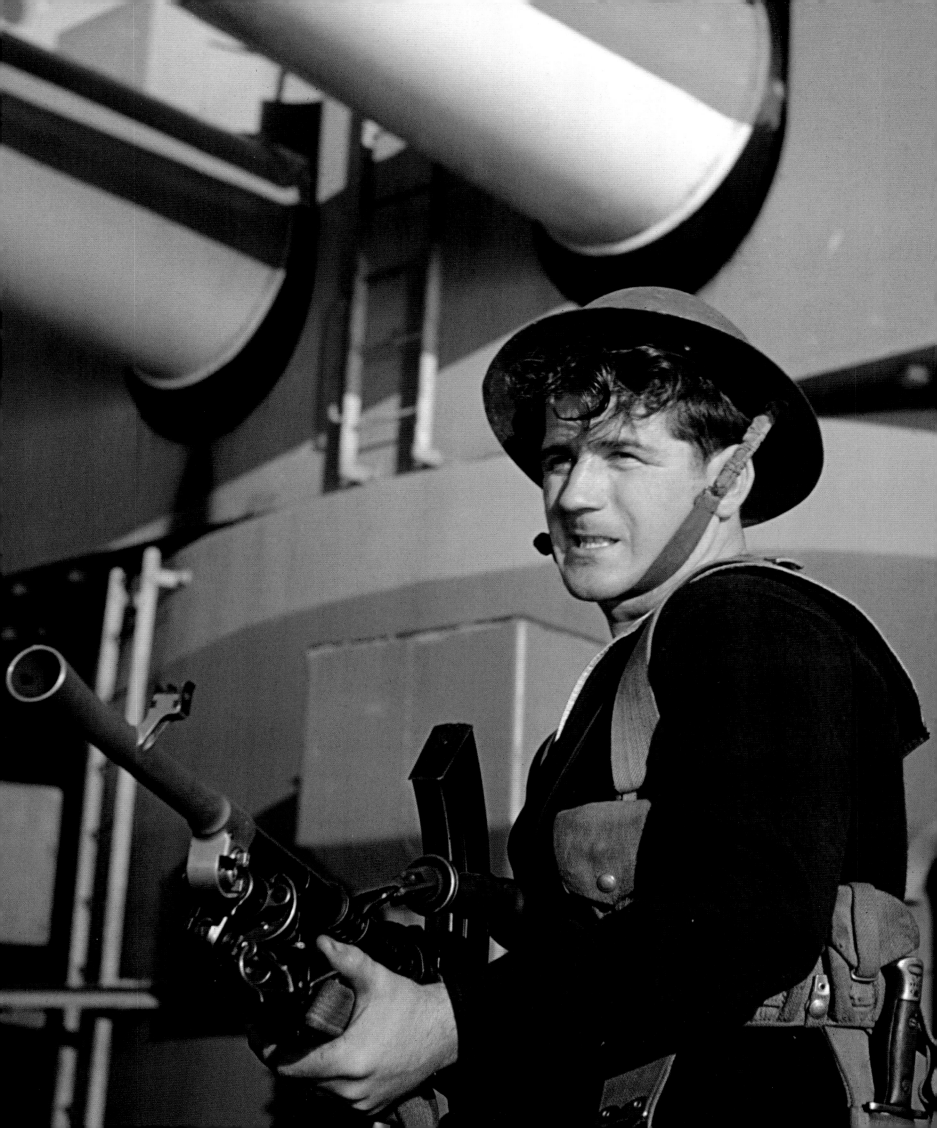

On 11 October 1942, HMS *King George V* hosted a visit to Scapa Flow by Winston Churchill, seen here with Admiral Sir John Tovey (left), Commander-in-Chief Home Fleet, and Sir Stafford Cripps. The Prime Minister spent three days inspecting units of the Home Fleet, and was keen to spend time with some of the ships' companies who had taken part in recent convoys to North Russia. Cripps, formerly the British Ambassador to the USSR, was a pivotal government figure in fostering relations with the Soviet Union.

A chief petty officer at his position in front of voice tubes in one of the battleship's gun turrets. The turrets were connected to the control tower high up in the ships' structure, from where the target was sighted, and the transmitting station in the bowels of the ship where bearing and elevation calculations were made using an analogue computer. This information was then fed to the turret crews who loaded and aligned the guns, which were then fired remotely. On 27 May 1941, in her most celebrated action, HMS *King George V* fired a total of 339 14-inch shells and 660 5.25-inch shells at the Bismarck, helping to reduce the German battleship to a blazing wreck.

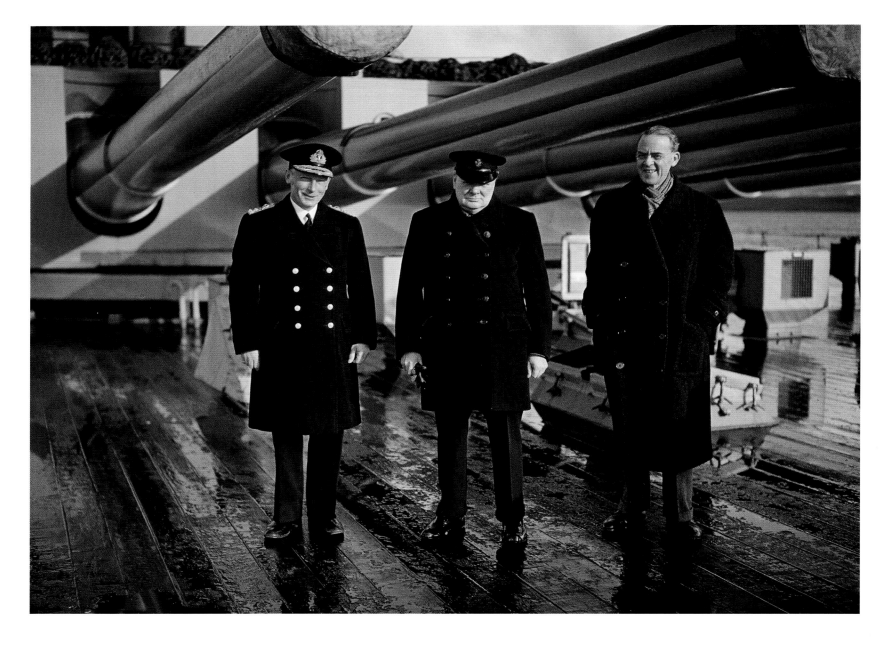

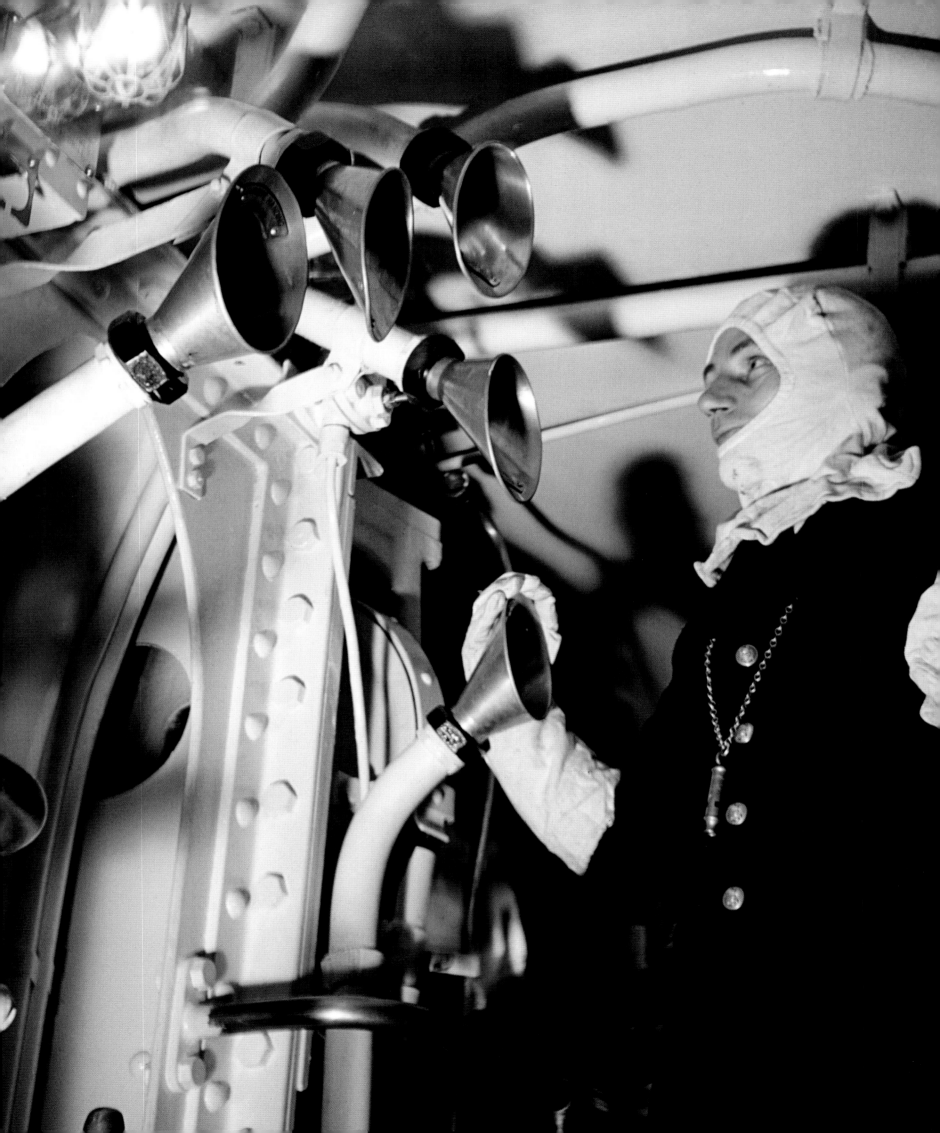

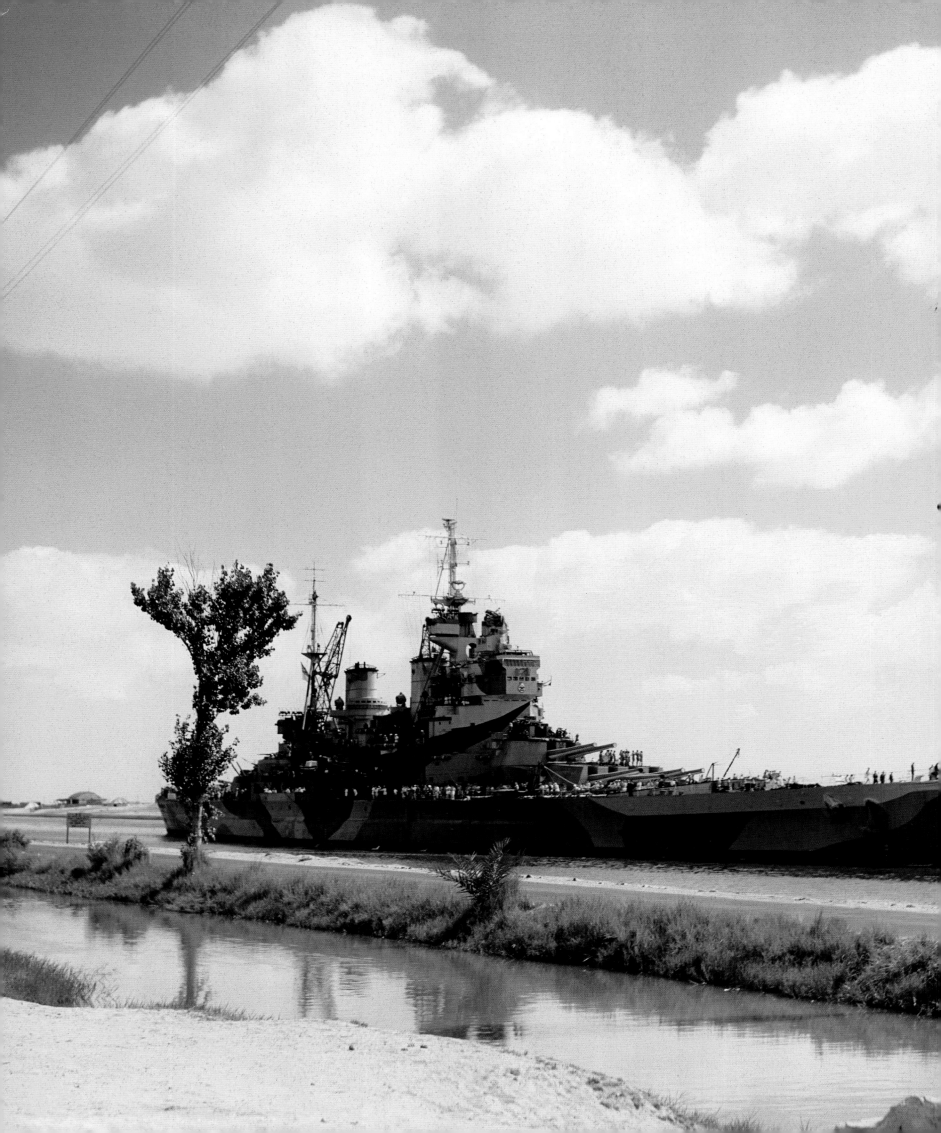

HMS *Howe* passing through the Suez Canal on her way to the Far East, 14 July 1944. Commissioned in June 1942, she was the last of the five *King George V*-class battleships to be completed, by which time one of them, HMS *Prince of Wales*, had been sunk by the Japanese. The British Pacific Fleet eventually comprised four battleships, six large fleet carriers, four light carriers, nine escort carriers, eleven cruisers and a host of destroyers and other vessels, but was destined to play only a subsidiary role. In March 1945 its battleships and carrier aircraft bombarded enemy airfields in the Sakishima Islands at the southernmost tip of Japan, while US forces landed on nearby Okinawa.

The German heavy cruiser *Admiral Hipper* in dock at Kiel, 19 May 1945. Despite attempts at camouflage, the ship had been badly damaged in an RAF bombing raid. Hitler's grandiose plans for a navy to rival that of Britain were never fulfilled, and in 1939 priority was given to U-boat production. However, during the first half of the war, Hitler's existing capital ships posed a substantial threat, and it was the role of the British Home Fleet to respond should they attempt to break out into the Allied shipping lanes. Fortunately, by the end of 1943, most German warships had either been sunk or were bottled up in ports where they were at constant risk of air attack.

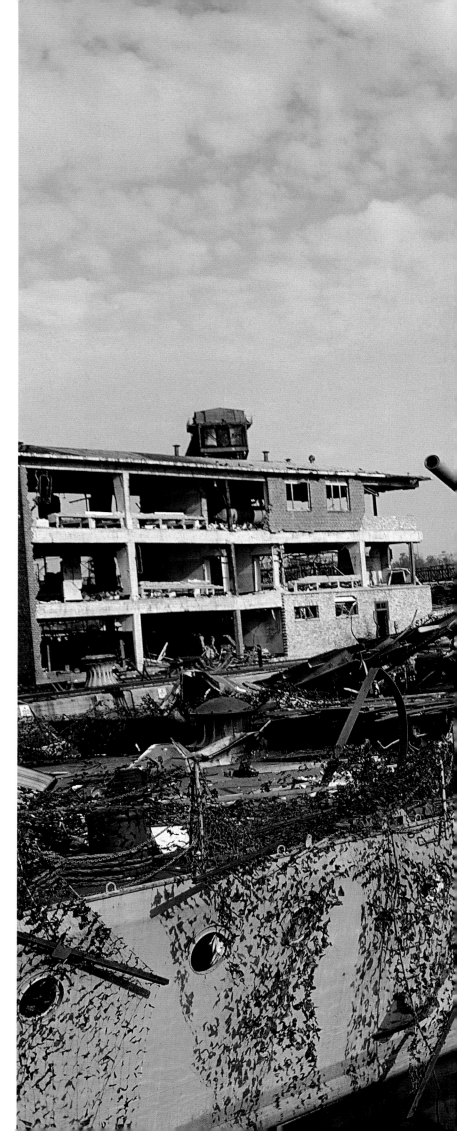

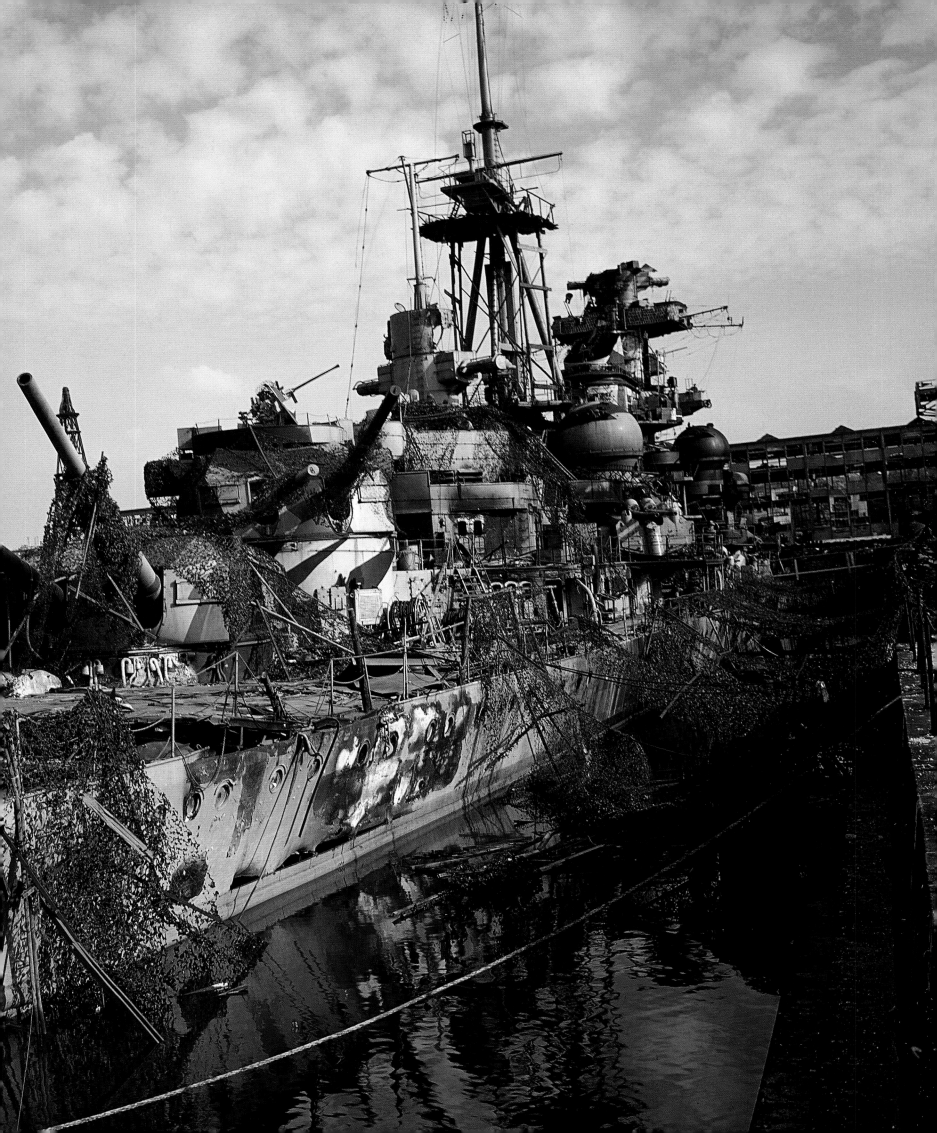

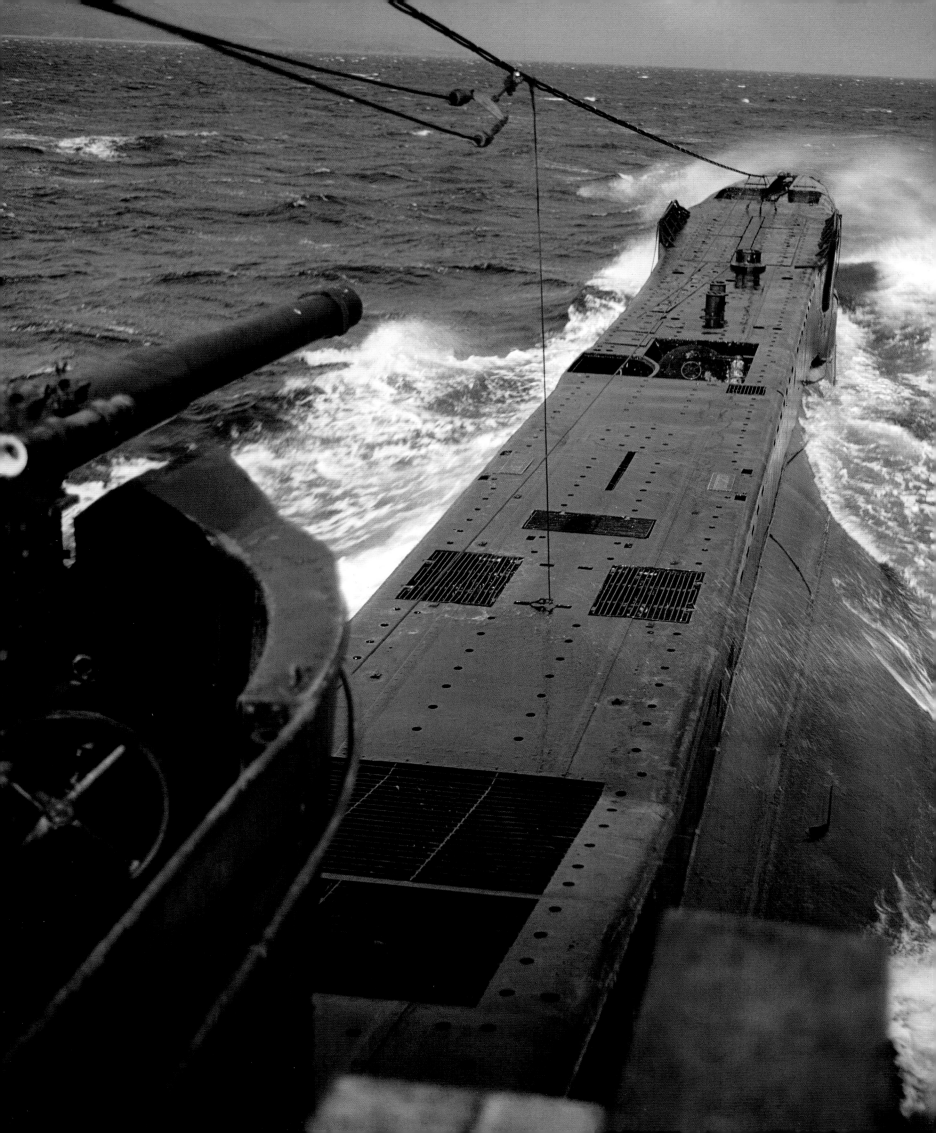

Images taken aboard the Royal Navy T-class submarine HMS Tribune *in August 1942, during the filming of 'Close Quarters', a propaganda film made by the Crown Film Unit and released in 1943. The film depicted an action off the Norwegian coast, in which* Tribune *was renamed HMS* Tyrant, *and included footage of her real crew. A number of colour images were taken for publicity purposes.*

HMS *Tribune* underway in Scottish waters.
The photo was taken from one of the wooden platforms built around her conning tower for camera work, and shows her 4-inch deck gun. *Tribune* was one of 53 T-class submarines built. They were designed originally for operations against the Japanese in the Pacific, although few were actually deployed there. Fifteen were lost on patrol, nearly all in Mediterranean waters. HMS *Tribune* herself had little success, and only managed to damage two enemy merchant ships. She survived the war to be broken up in 1947.

(Next spread)
First Lieutenant Robert Bulkeley, the submarine's second in command, at the forward periscope. *Tribune* carried six internal and four external 21-inch torpedo tubes in her bow, so that she could fire a large salvo for maximum effect, if necessary using ASDIC (sound location) rather than the periscope for aiming. Bulkeley went on to command the submarine HMS *Statesman* in the Far East. Over the space of nine patrols he torpedoed a Japanese tanker, and sank another 44 enemy ships and landing craft by gunfire or boarding.

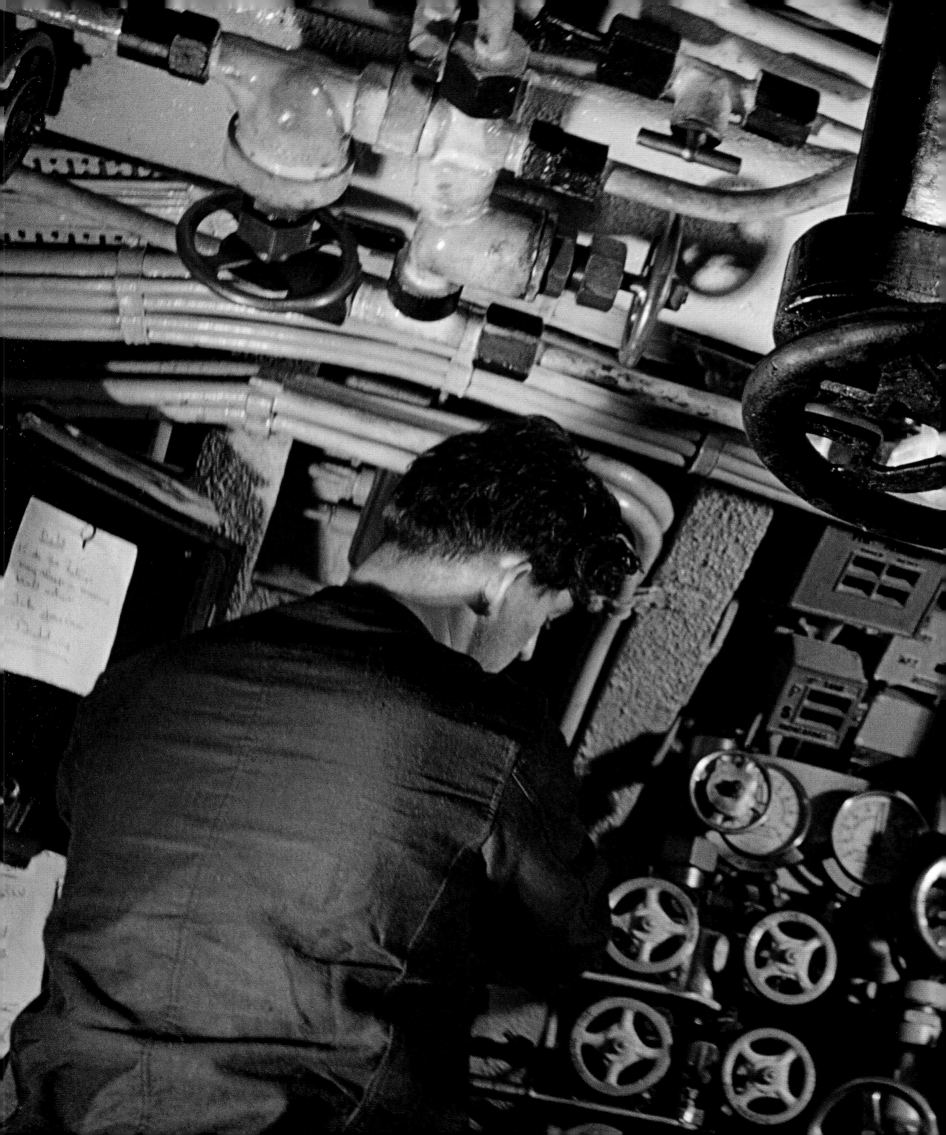

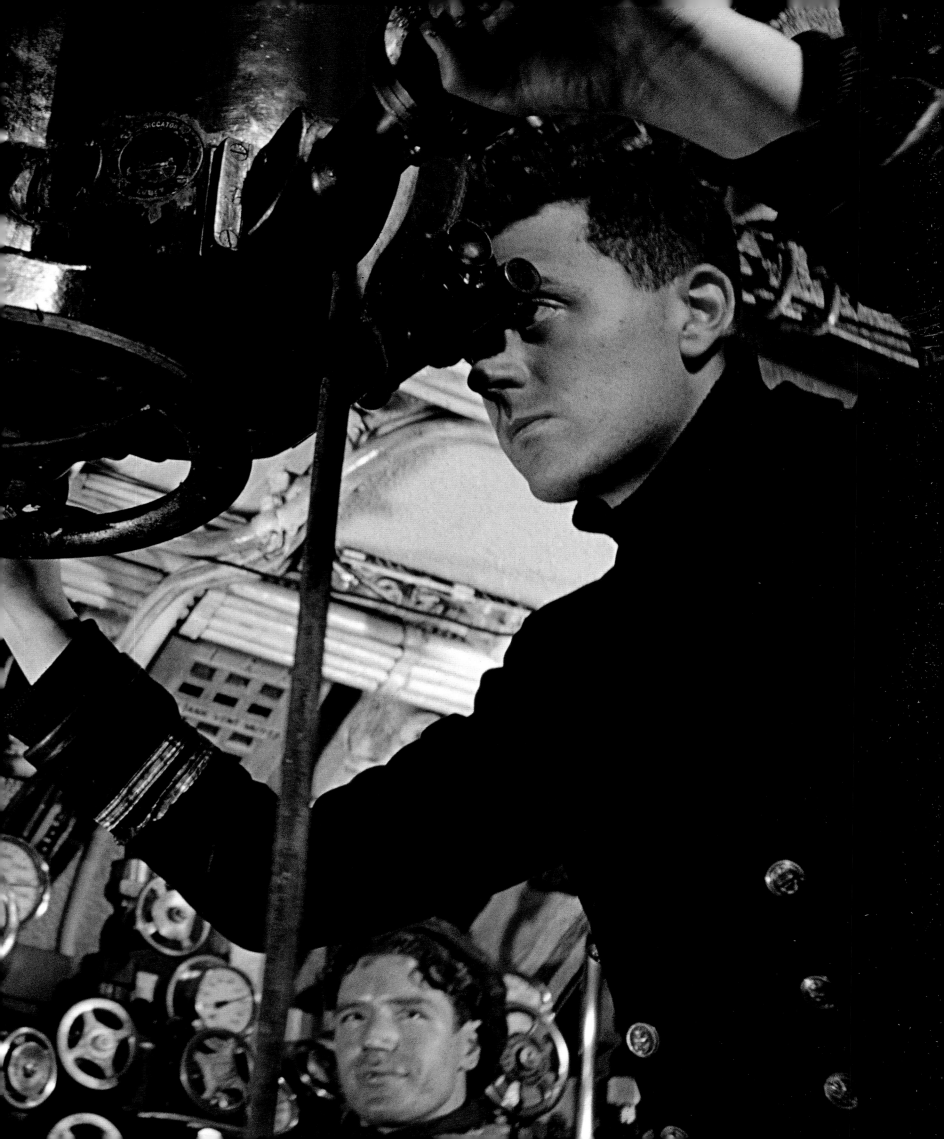

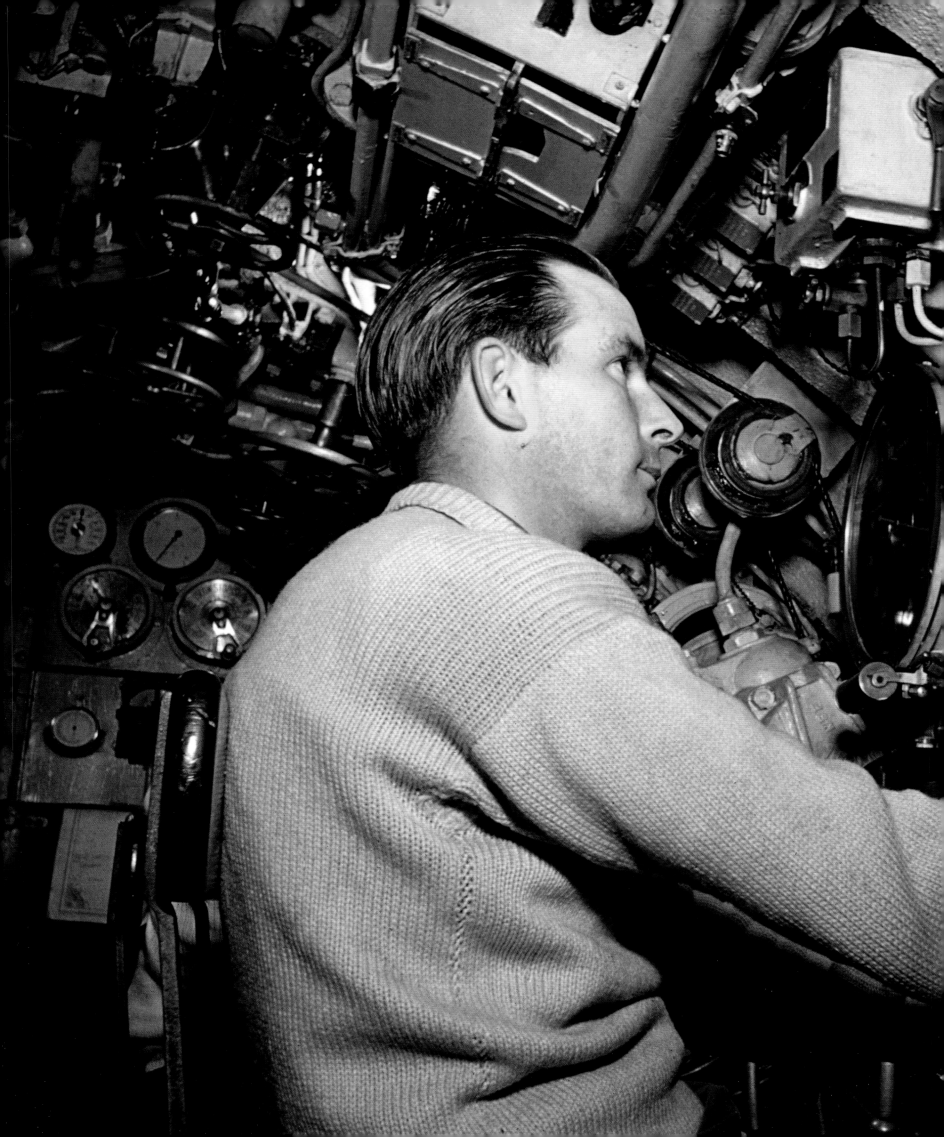

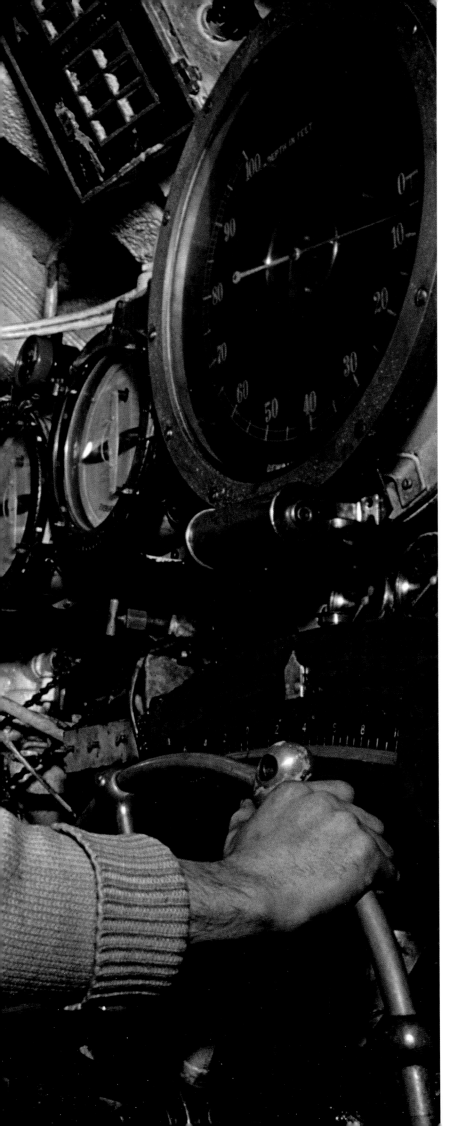

The Second Coxwain, Petty Officer Hedley Woodley, operating the forward hydroplanes at his diving station on board HMS _Tribune_. In front of him is the depth gauge. T-class submarines had an official 'test depth' of 300 ft, although this was exceeded by some boats in wartime conditions. They could travel submerged on battery power for 48 hours travelling at 2 knots, but only one hour at the maximum underwater speed of 9 knots. The submarine's diesel engines enabled a maximum speed of about 15 knots on the surface.

T-class submarines had a normal complement of 48 officers and men, but sadly the names of these five were not recorded. The submarines were built for long oceanic voyages, and later boats had a surfaced range of up to 11,000 nautical miles, so crews were faced with extended periods of time in cramped conditions. Unlike the German U-boats, there were no large convoys to attack, and targets were consequently few and far between. As a measure of their courage and determination, four men serving aboard T-class submarines were awarded the Victoria Cross, Britain's highest decoration for valour.

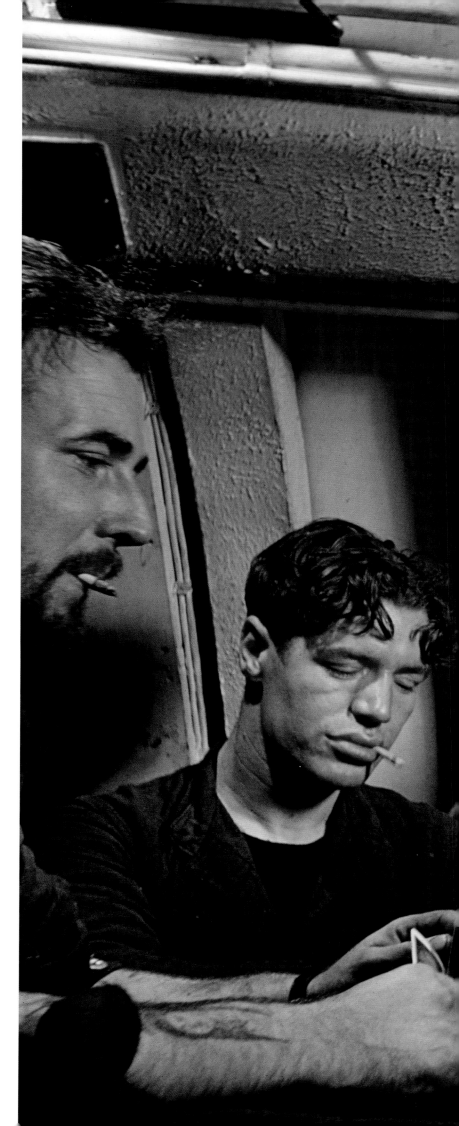

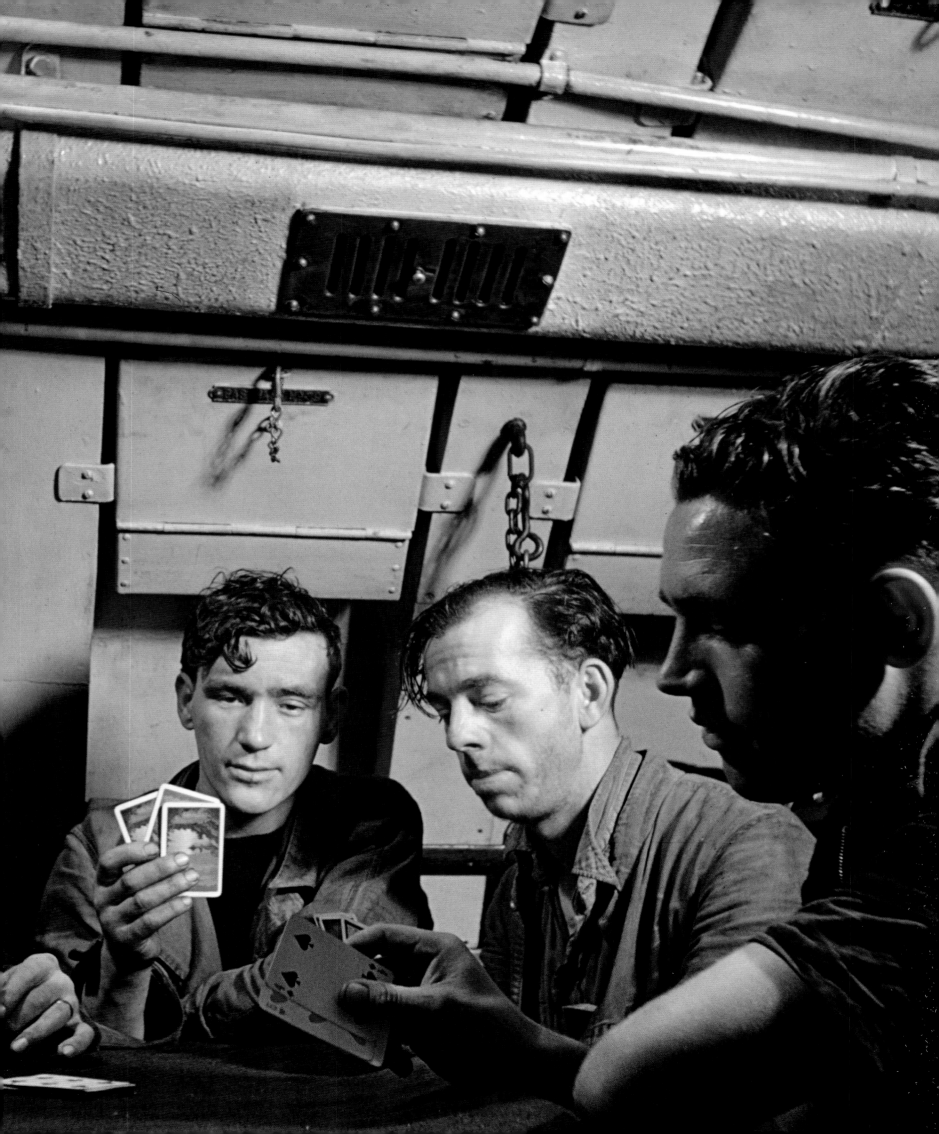

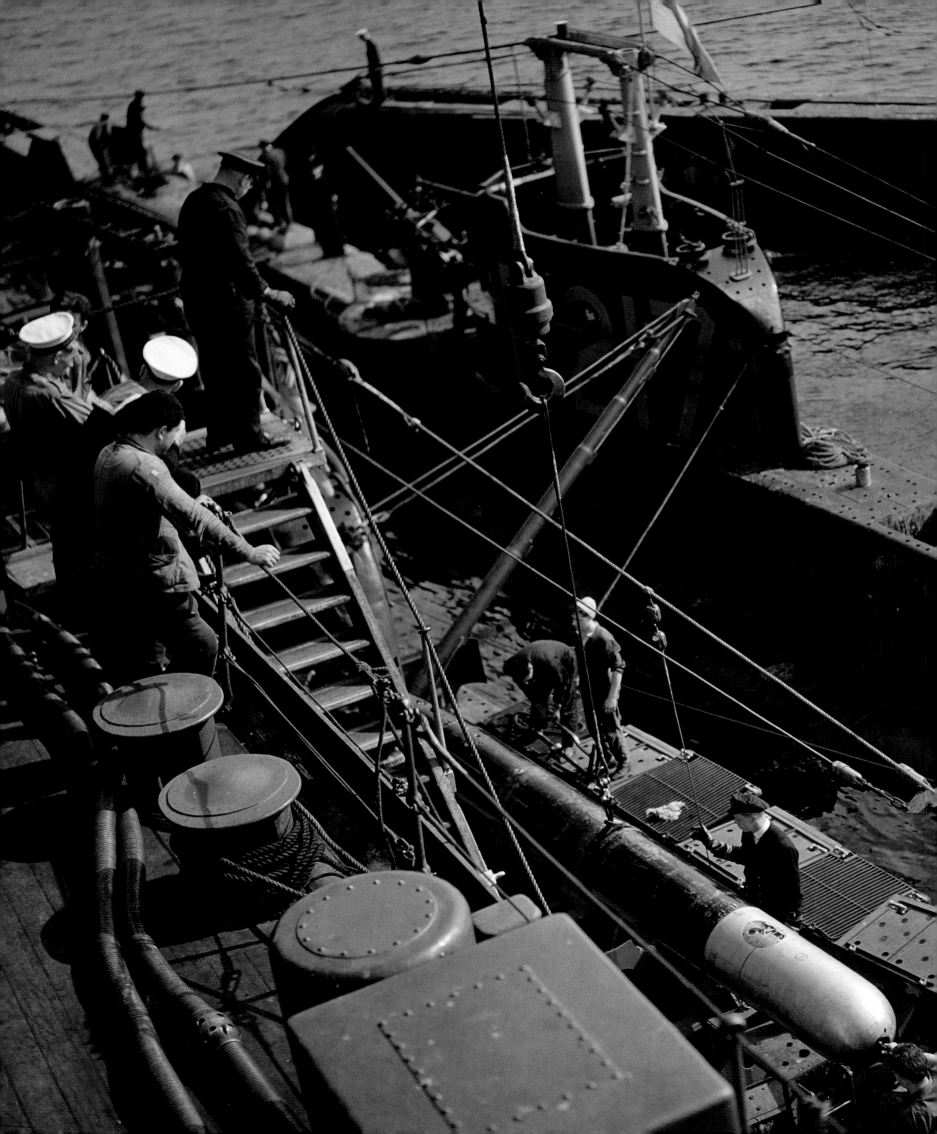

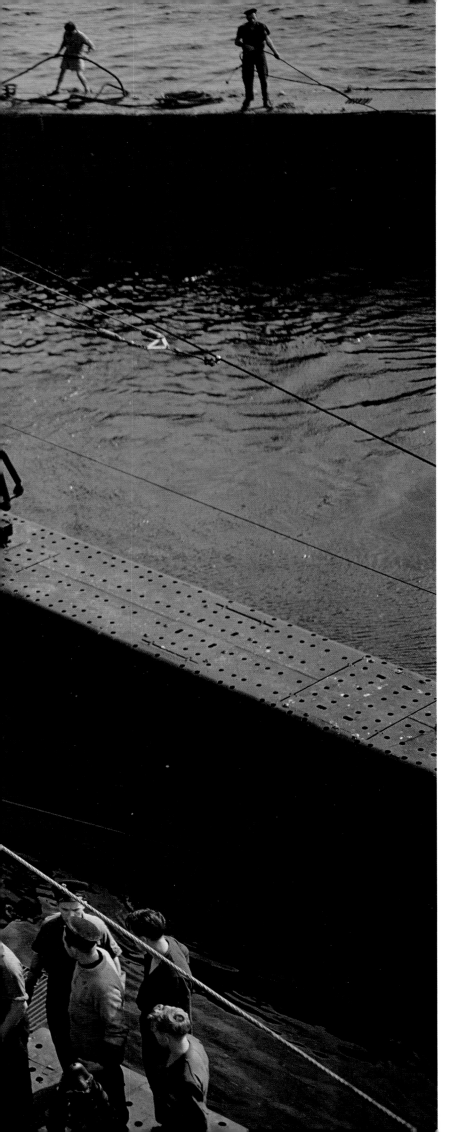

HMS *Tribune* and other submarines of her flotilla were based at Holy Loch in Scotland, and were resupplied from their depot ship HMS *Forth*. Here, a practice torpedo is being loaded aboard P311, a T-class submarine that was sunk with all hands when it struck a mine off Sardinia in January 1943. Alongside is the S-class submarine *Sybil* (P217) which had an altogether more successful career, sinking several ships in the Mediterranean and Far East.

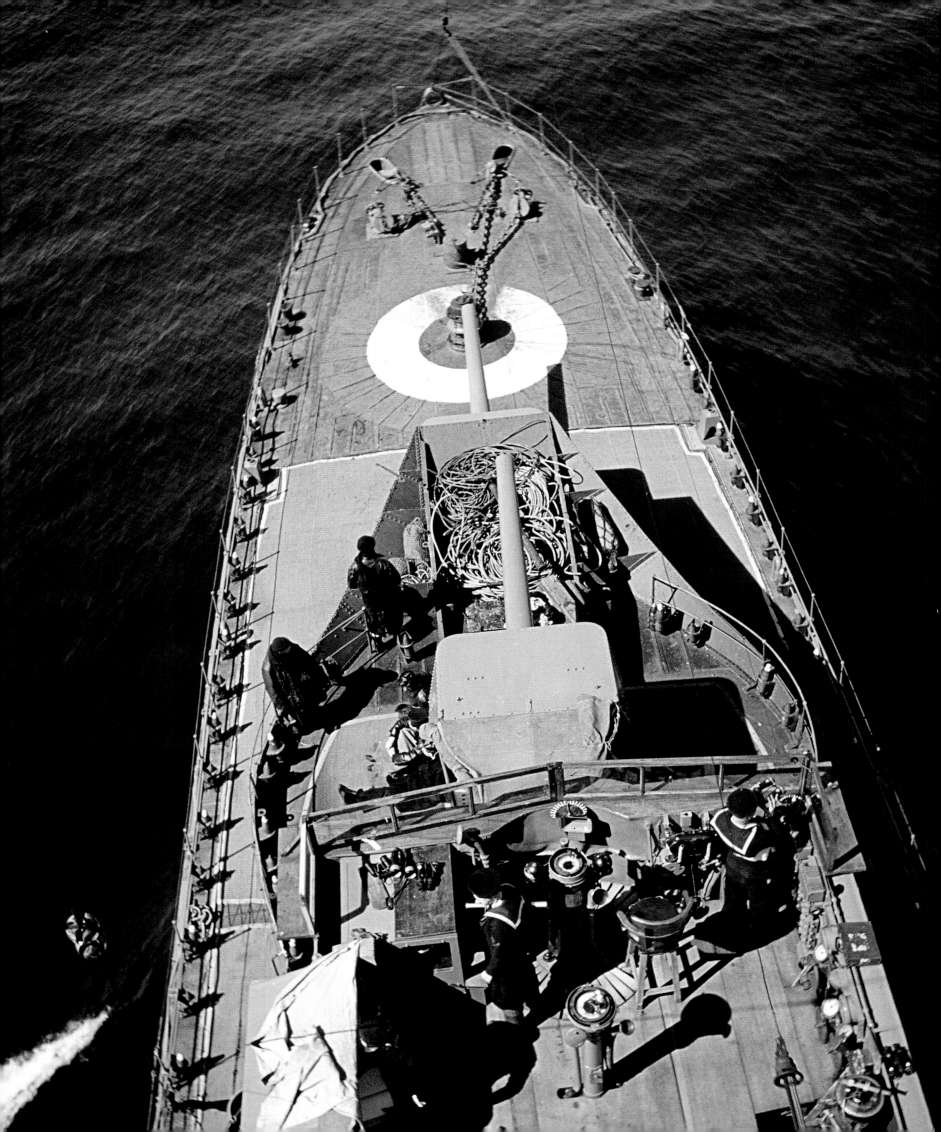

A view of the bridge and forward armament of an unidentified Royal Navy destroyer in 1942, one of the old V&W-class dating back to the First World War. The struggle to protect Britain's lifeline across the Atlantic became one of the key campaigns of the war, but the Royal Navy was initially unprepared. Underwater sound location (ASDIC) was less effective than anticipated, as U-boats tended to attack on the surface at night. Radar became a vital requirement, as did more effective weapons and tactics. Destroyers were always in short supply, so the crucial escort task increasingly fell to specialised corvettes, sloops and frigates.

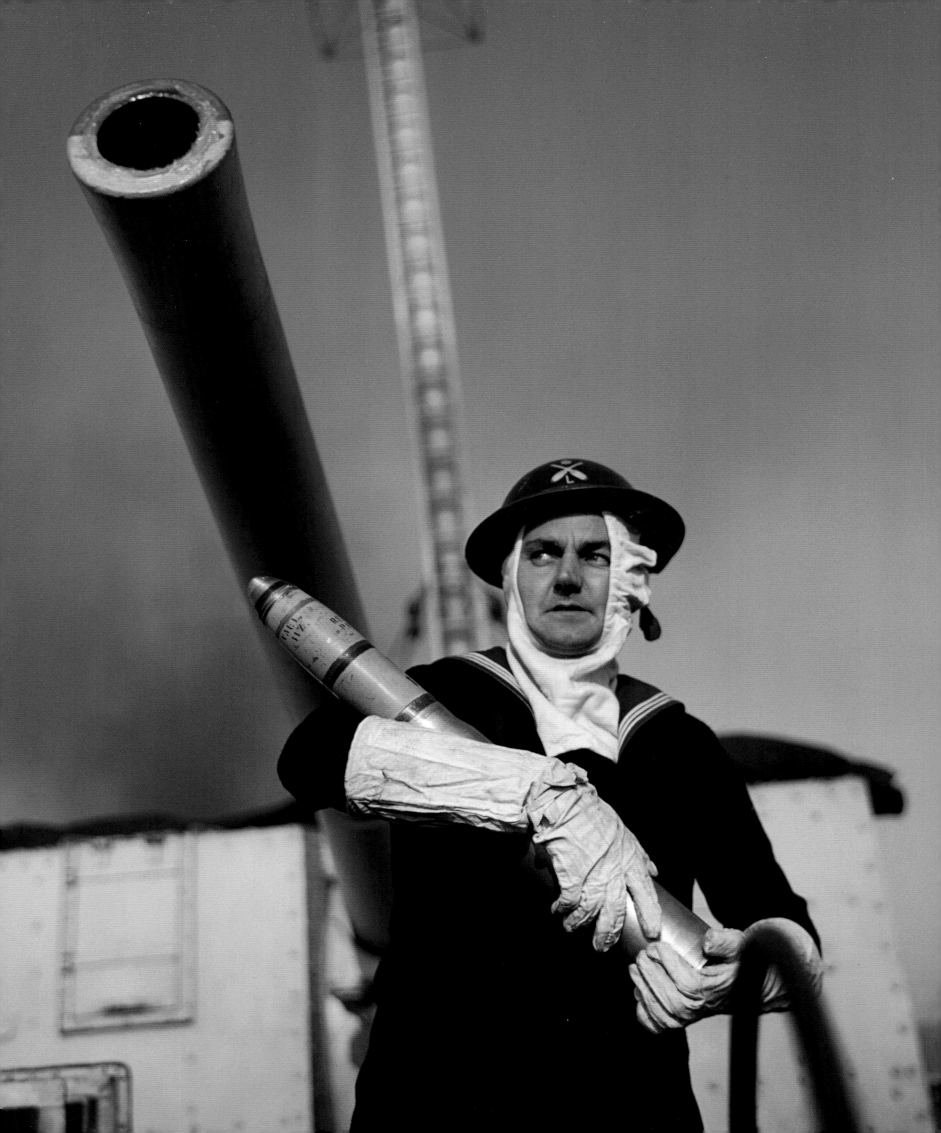

A Royal Navy gunner cradles a 3-inch anti-aircraft shell on the quarter deck of a destroyer, one of the ships of Escort Group B7, Londonderry, November 1943. The turret behind houses a QF 4.7-inch gun, the standard armament on most British destroyers. The Royal Navy deployed seven escort groups, each consisting of destroyers, frigates, sloops and corvettes, and B7 was highly successful during the fierce Atlantic convoy battles of 1942 and 1943, claiming eight U-boats destroyed.

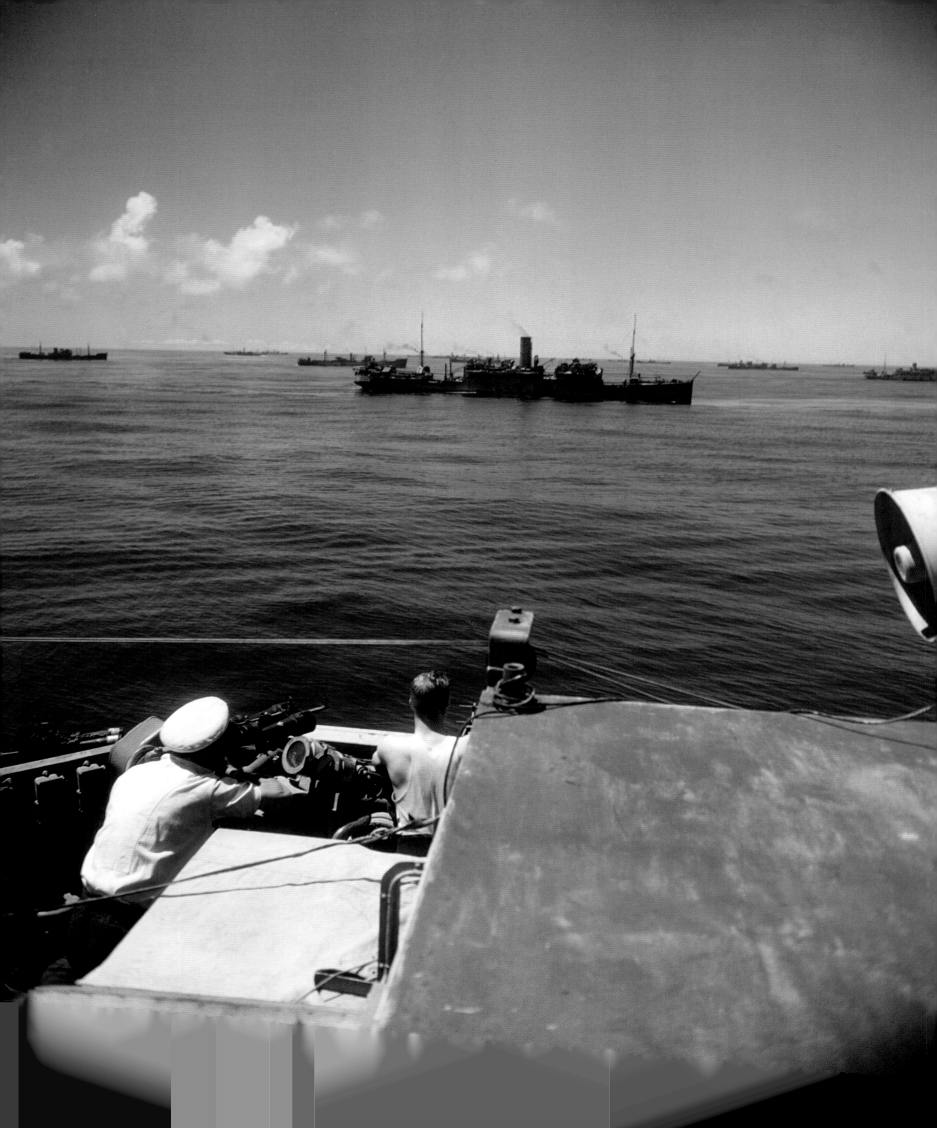

A UK-Freetown convoy in calm waters off the Spanish coast, as seen from a Royal Navy ship, believed to be the cruiser HMS *Scylla*, July 1943. On this route, ships sailing independently from South America, Africa and India would assemble at Freetown in Sierra Leone, from where they were escorted to Britain. The U-boats were very active off the coast of West Africa, and enjoyed a major success in October 1942 when convoy SL-125 was intercepted and 12 ships out of 37 were sunk. Luftwaffe air attacks were another hazard. In 1943, convoys from the South Atlantic would rendezvous with those from the Mediterranean at Gibraltar, so as to combine their escorts for the final leg to Britain.

Merchant ships unloading supplies at the newly captured port of Sfax in Tunisia, April 1943. British success in the North African campaign depended on keeping vital supply lines open, but while the Italian surface fleet remained in port for much of the period, Axis aircraft and submarines effectively closed off the Mediterranean to all but the fastest merchantmen. This meant that most Allied convoys had to take the long route via South Africa to Suez. Only after victory in Tunisia in May 1943 were normal convoy operations restored, which were vital for supporting the subsequent Allied invasions of Sicily and Italy.

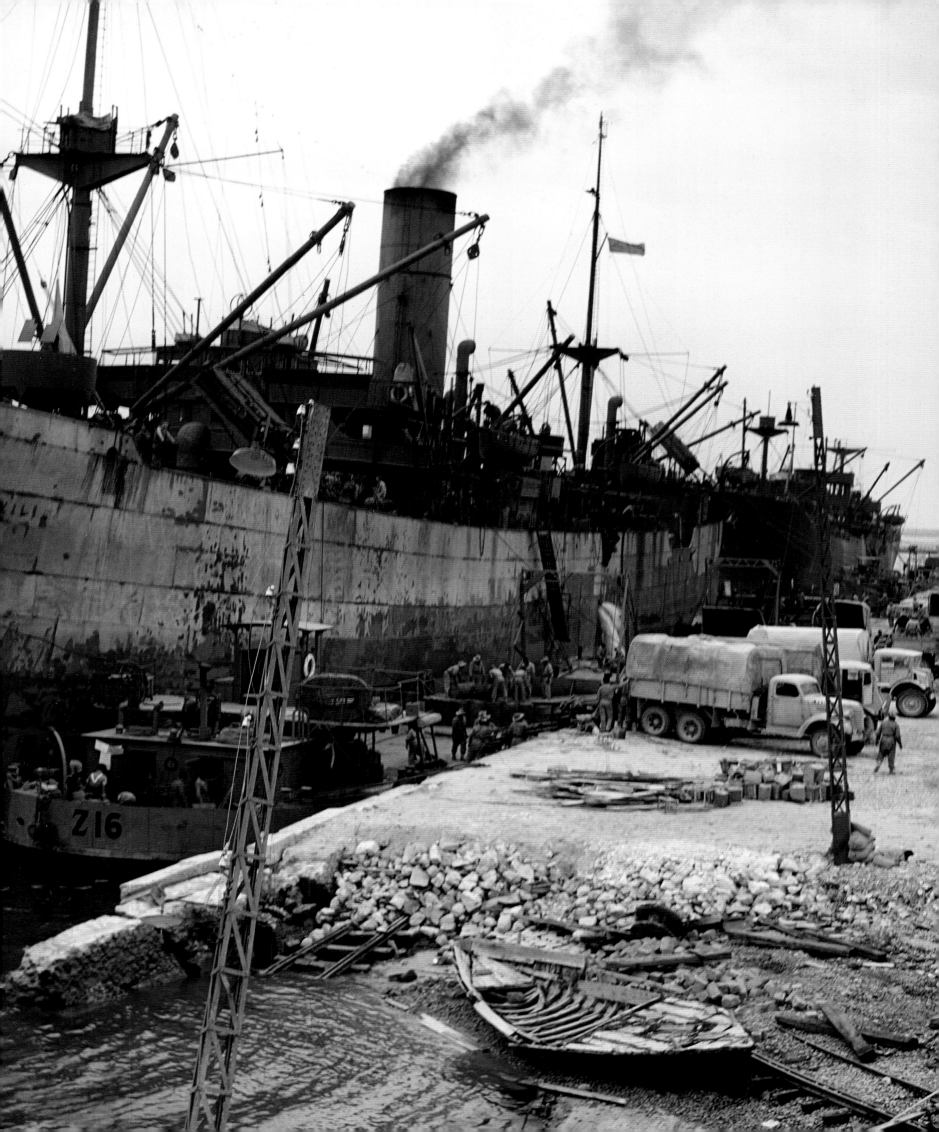

Egyptian dock workers unloading RAF stores at Port Said, August 1944. The United States produced 53 million tons of shipping during the war, including over 5,700 standardised merchant ships, the most famous of which were the 'Liberty Ships', as seen here. These were based originally on a British concept for a low-cost, mass-produced cargo vessel that could be built rapidly in American yards. 2,710 were eventually completed, with an average construction time of only six weeks. Later in the war, construction began on a class of larger, faster vessels, which were named 'Victory Ships'.

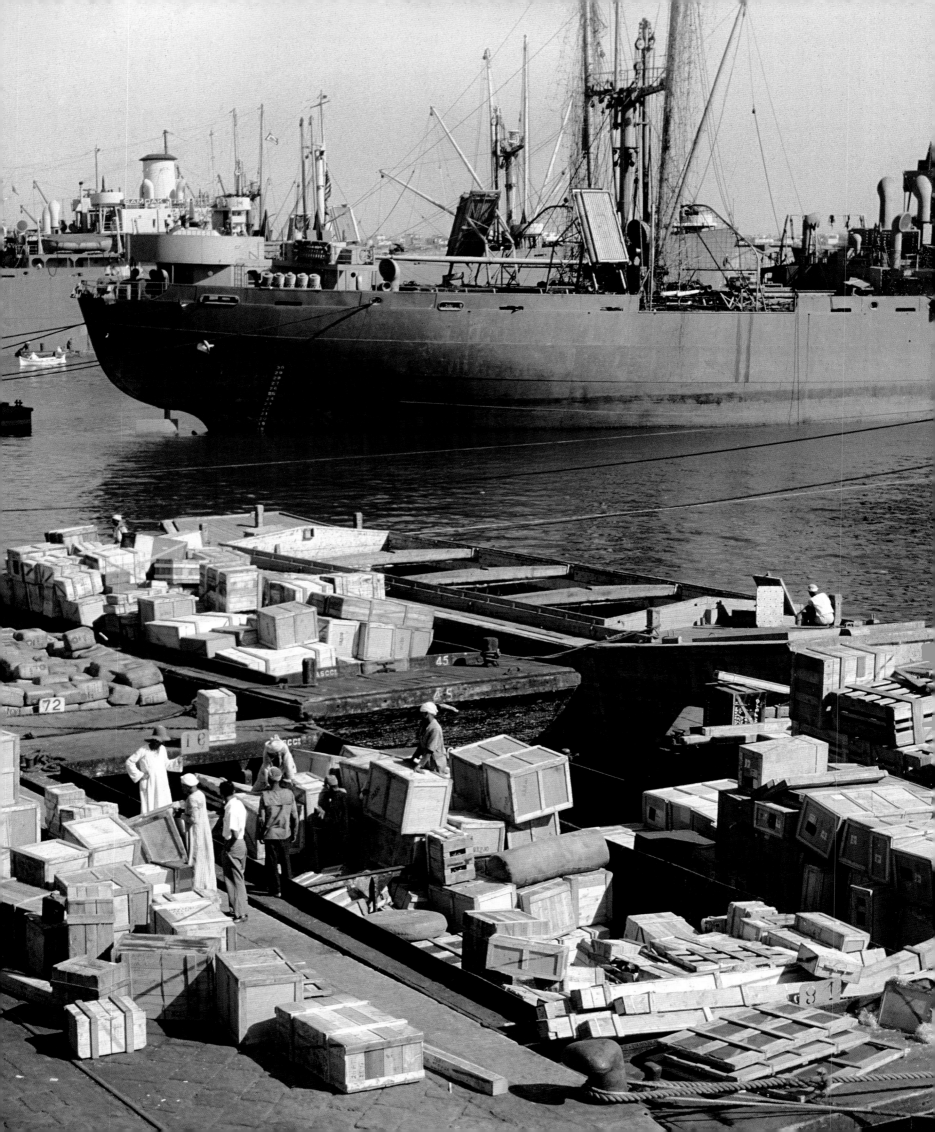

Fairey Swordfish Mk II of 824 Naval Air Squadron. This image was probably taken during anti-submarine operations from the escort carrier HMS *Smiter* in 1944. Despite its antiquated appearance, the 'Stringbag' was one of the more successful British naval aircraft, and won fame in November 1940 when aircraft from HMS *Illustrious* carried out a night torpedo attack on the Italian fleet at Taranto. It soldiered on in service until 1945.

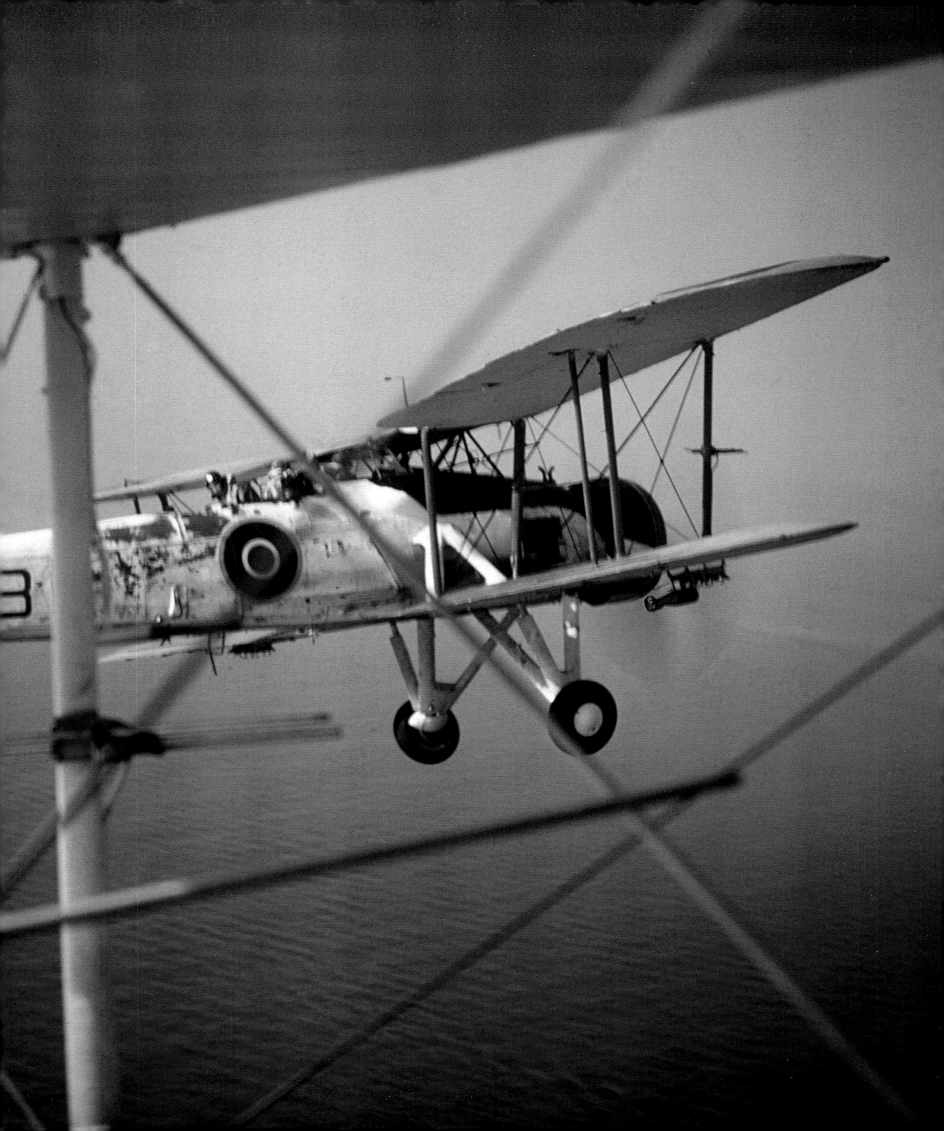

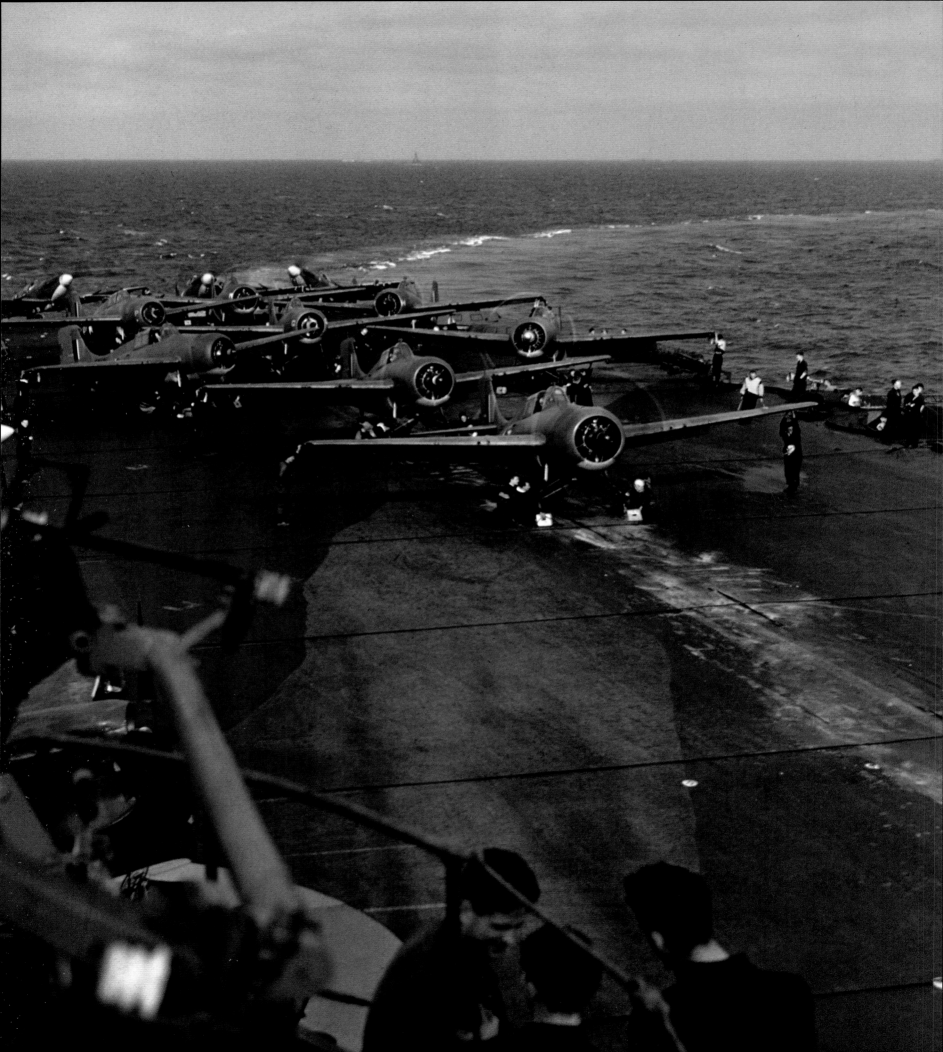

Martlet fighters prepare to take off from HMS *Formidable* during Operation 'Torch' – the Allied landings in Vichy French North Africa, November 1942. 'Torch' was the first major Allied amphibious assault of the war, and carriers provided vital air cover until land-based aircraft were able to operate from captured airfields. The Grumman F4F Wildcat, known to the British as the Martlet, was one of several American-built aircraft employed by the Fleet Air Arm in the absence of effective home-produced designs. *Formidable* later took part in the Allied invasion of Sicily, attacks on the *Tirpitz* in Norway, and served with the British Pacific Fleet in the last months of the war.

Also aboard HMS *Formidable* for Operation 'Torch' was 820 Naval Air Squadron, equipped with Fairey Albacores, one of which is seen here being loaded with 250-lb bombs. *Formidable*'s Albacores were used to attack enemy forces and defensive positions ashore. An aircraft from the squadron also torpedoed and sank U-331, which had been damaged by RAF Hudson patrol planes. That success was a measure of retribution for the Royal Navy as U-331 had torpedoed and sunk the battleship HMS *Barham* a year earlier.

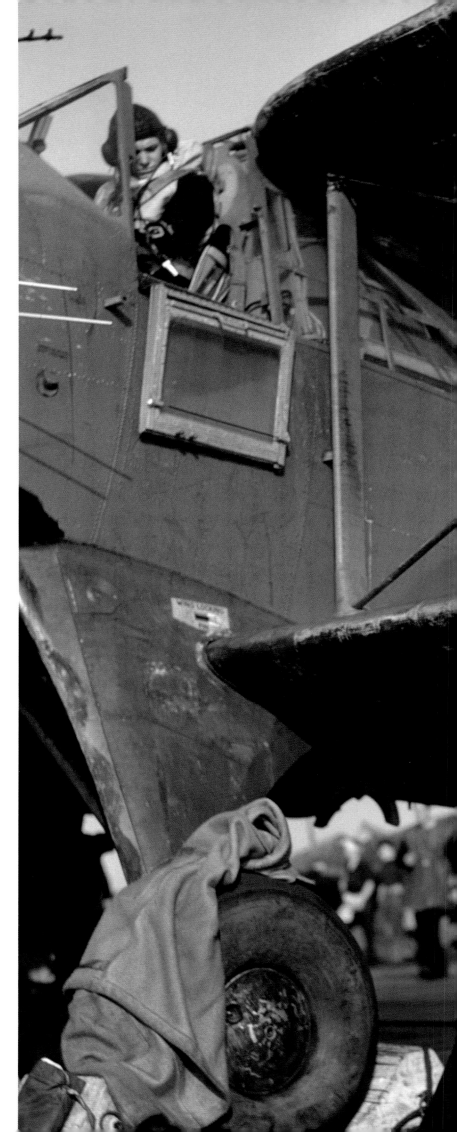

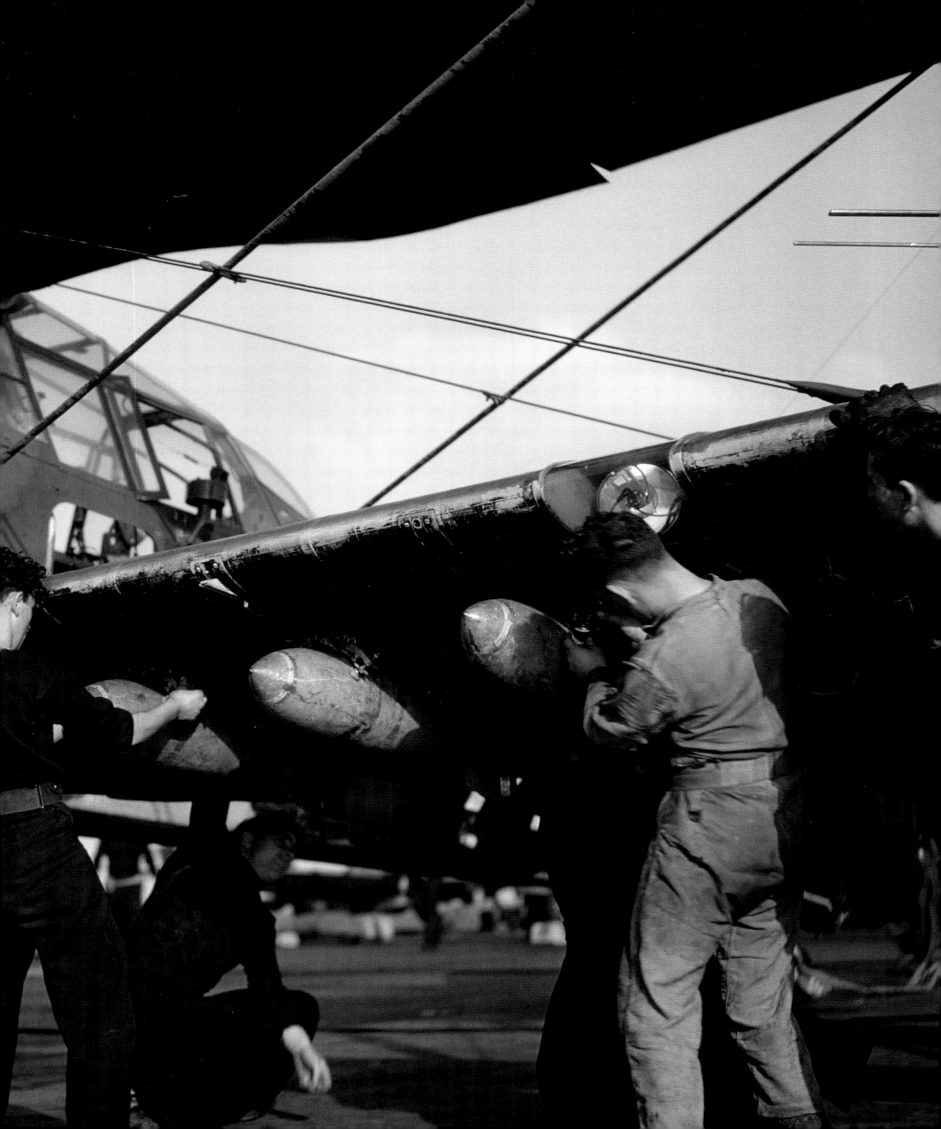

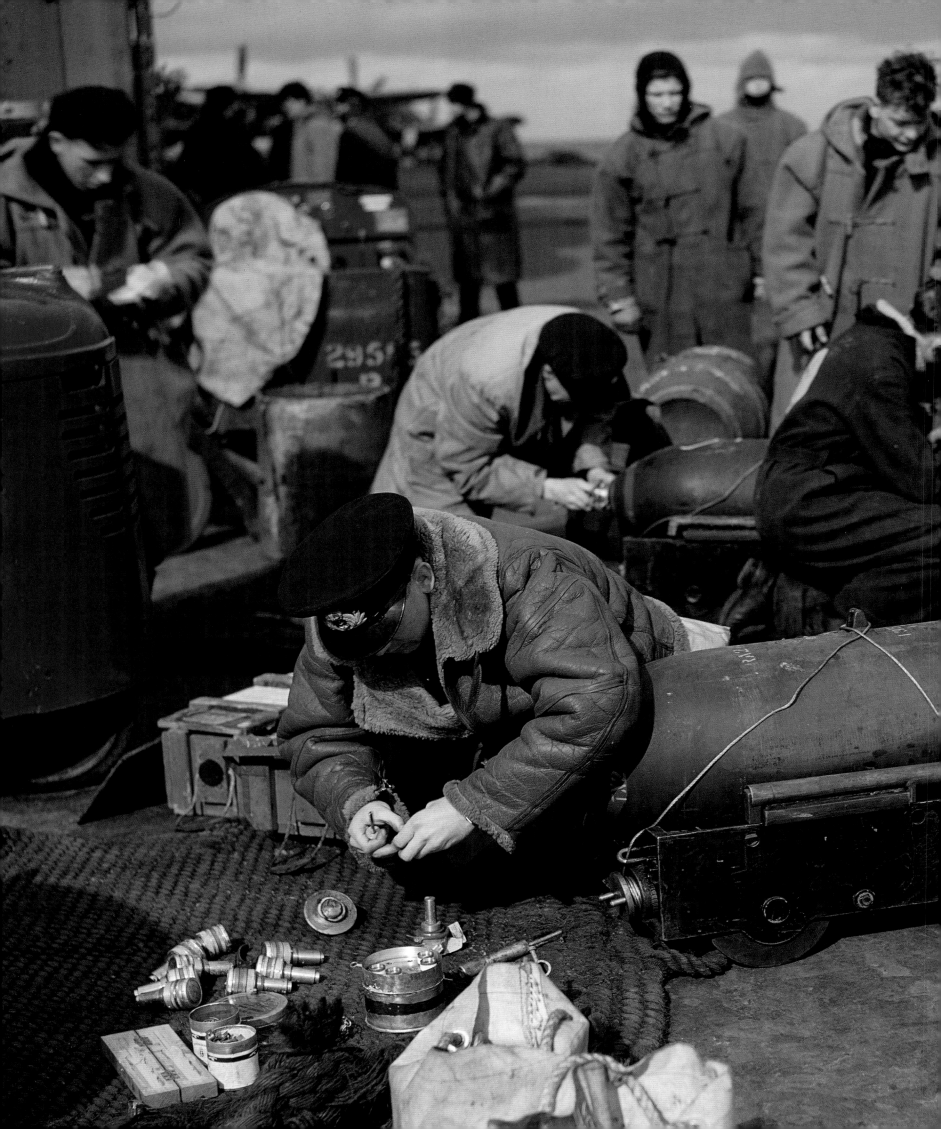

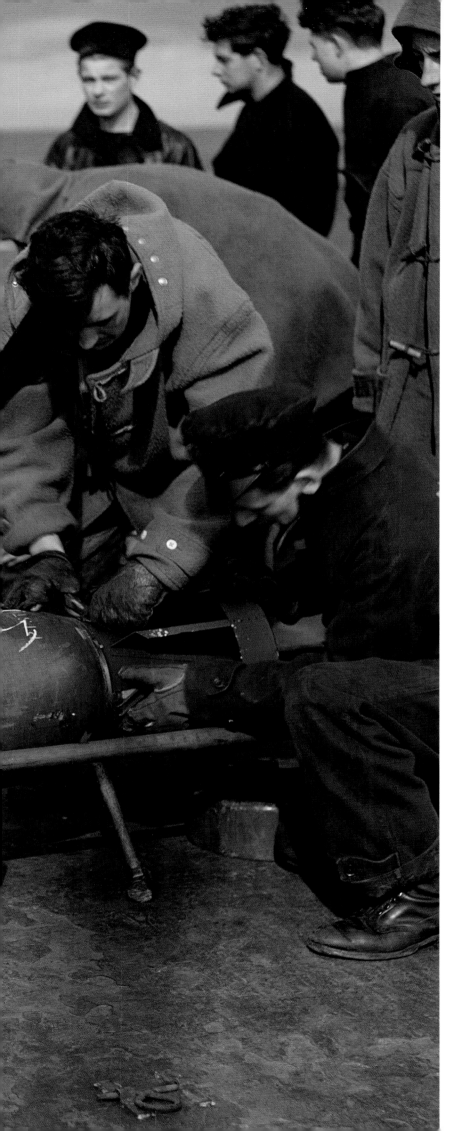

Armourers fusing bombs on board HMS *Victorious* in preparation for Operation 'Tungsten', a major Fleet Air Arm raid on the German battleship *Tirpitz* in Kaafjord, Norway, 3 April 1944. Four squadrons of Fairey Barracudas carried out two dive-bombing attacks, with Wildcat and Hellcat fighters strafing the ship and shore batteries. *Tirpitz* was hit by 15 bombs, and two near misses, which caused widespread damage and inflicted heavy casualties. Follow-up attacks in the summer were unsuccessful, but the ship was kept out of action until it was eventually sunk by RAF Lancasters in November 1944.

Sub-Lieutenant Harold Salisbury prepares for a sortie in a Supermarine Seafire Mk Ib of 736 Naval Air Squadron at RNAS Yeovilton, September 1943. 736 NAS was established as a training unit to teach the latest air combat techniques. The Seafire was a modified version of the Spitfire, adapted for carrier operations – the arrestor hook of this aircraft is just visible beneath the rear fuselage. Salisbury later served with 899 NAS aboard the escort carrier HMS *Khedive* during the invasion of Southern France in August 1944, and ended the war instructing Australian naval aviators at RNAS Schofields in New South Wales.

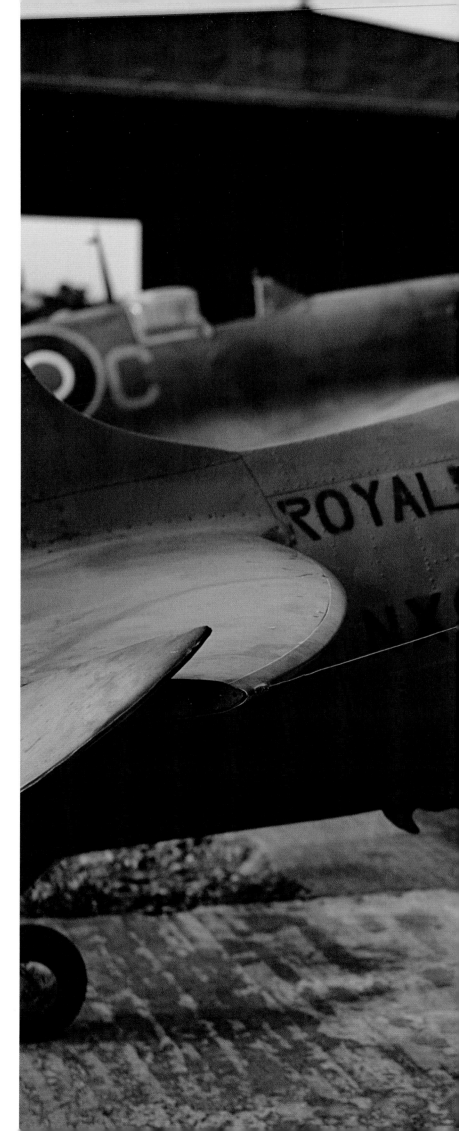

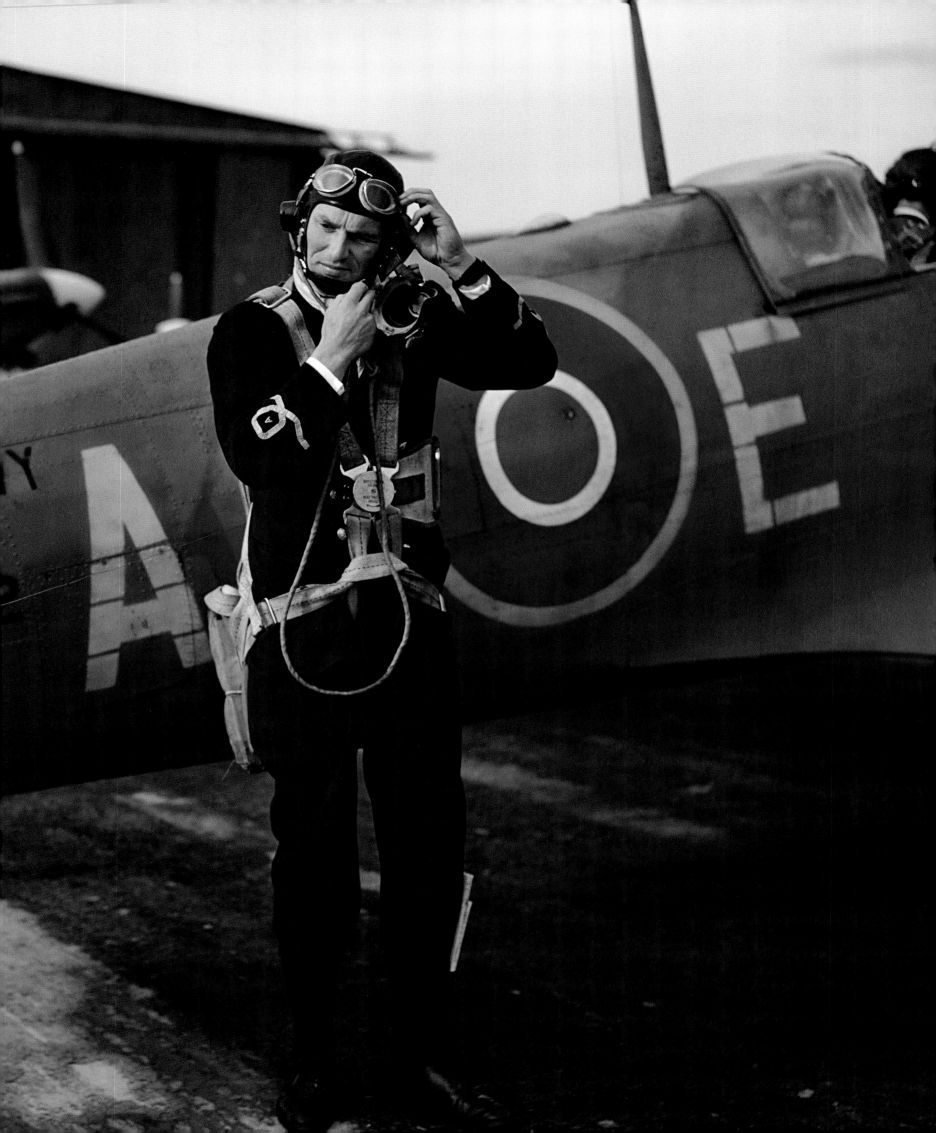

A Boeing Fortress Mk II of 220 Squadron, RAF Coastal Command, operating from the island of Benbecula in the Outer Hebrides, May 1943. Long-range aircraft played a vital role in winning the Battle of the Atlantic, although few were available at first as the bombing offensive over Germany was deemed more important. Obsolete RAF bombers such as the Whitley and Wellington were pressed into service as submarine hunters, but the most important was another American aircraft, the VLR (Very Long Range) Liberator. May 1943 was a turning point — 41 U-boats were sunk by Allied aircraft and naval forces. The U-boats withdrew from the North Atlantic, and were never a significant threat again.

IMAGE LIST

All images © IWM unless otherwise stated. Every effort has been made to contact all copyright holders. The publishers will be glad to make good in future editions any errors or omissions brought to their attention.

INTRODUCTION
TR 170

MEN AT ARMS
TR 2023, TR 2017, TR 103, TR 219, TR 212, TR 185A, TR 156, TR 62, TR 631, TR 939, TR 1244, TR 1402, TR 1529, TR 1799, TR 1711, TR 1848, TR 2410, TR 1596, TR 1662, TR 2313, TR 2052, TR 2393, TR 1580, TR 2568

PEOPLE'S WAR
TR 673, TR 1928, TR 1147, TR 248, TR 1443, TR 1693, TR 454, TR 459, TR 572, TR 300, TR 1783, TR 1169, TR 1274, TR 910, TR 1455, TR 1384, TR 642, TR 2665, TR 1427, TR 941, TR 1872, TR 1647, TR 2835, TR 2876

TWO AIR FORCES
TR 865, TR 139, COL 191, COL 186, TR 1091, TR 937, TR 11, TR 37, TR 186, TR 1127, TR 1795, TR 89, TR 1268, FRE 5722, FRE 5735, FRE 5545, FRE 6887, FRE 6075, FRE 7133, TR 975, TR 856, TR 1064, TR 1531, TR 2145, TR 2637

THE WAR AT SEA
TR 1282, TR 307, TR 325, TR 210, TR 312, TR 2619, TR 2882, TR 589, TR 491, TR 506, TR 512, TR 526, TR 94, TR 92, TR 1451, TR 1509, TR 1029, TR 2283, TR 1138, TR 285, TR 287, TR 1812, TR 1276, TR 1084

ACKNOWLEDGEMENTS

Thanks go to David Tibbs and the IWM Publishing team, Kirsty Macdiarmid the designer, Emily Charles, Sean Rehling, Stephen Walton and Robert Rumble, and everyone else who helped create this book.